Publisher's Acknowledgements
Special thanks are due to **Jay
Gorney Modern Art**, New York . We
would like to thank the following
authors and publishers for their
kind permission to reprint articles:
Harry N. Abrams, New York;
Blackwell Publishers, Oxford;
Bomb, New York; **Center for the
Arts**, Wesleyan University,
Middletown, Connecticut; *Flash
Art*, Milan; **Houghton Mifflin
Company**, New York; **MIT Press**,
Cambridge; **Robert Nickas**, New
York; **Klaus Ottmann**, Middletown;
Penguin Books, London; **Tinguely
Archiv**, Zurich; **Stephen Westfall**,
New York, and the following for
lending reproductions: **American
Fine Arts, Co.**, New York; **Mowry
Baden**, British Columbia; **Leo
Castelli Gallery**, New York; **Paula
Cooper Gallery**, New York; **Jay
Gorney Modern Art**, New York;
Galerie Isabella Kacprazk,
Cologne; **Galerie Metropol**,
Vienna; **Moderna Museet**, Statens
Konstmuseer, Stockholm; **Andrea
Rosen Gallery**, New York; **Holly
Solomon Gallery**, New York;
Sonnabend Gallery, New York;
Jeff Wall, Vancouver; **Sperone
Westwater Gallery**, New York;
Stedelijk Museum, Amsterdam;
White Cube, London; and **Witte
de With**, Rotterdam. Thank you to
Rodney Hill at Jay Gorney Modern
Art, New York, for his research and
organizational assistance.
Photographers: **Philip Amdal,
Rudolph Burckhardt, Geoffrey
Clements, Ken Cohen, Angela
Cumberbirch, Colin De Land,
Charles Erickson, Serge Gal, Ken
Heyman, David Lubarsky, Peter
MacCallum, J. Mud, Jordi Nieva,
Eric Pollitzer, Jessica Stockholder,
Alexander Troehler, Tom Van
Eynde** and **Stephen White**.

Artist's Acknowledgements
I would like to thank Iwona
Blazwick, commissioning editor,
Gilda Williams, Clare Stent and
Stuart Smith of Phaidon Press.
I would also like to thank my very
extended family, Jay Gorney, and
the many people who have given
me opportunities to exhibit and
supported my work.
I would finally like to express
my gratitude for all of the public
funding I have received and
especially thank the Canada
Council.

All works are in private collections
unless otherwise stated.

Phaidon Press Limited
Regent's Wharf
All Saints Street
London N1 9PA

First published 1995
© Phaidon Press Limited 1995
All works of Jessica Stockholder
are © Jessica Stockholder

ISBN 0 7148 3406 8

A CIP catalogue record of this
book is available from the British
Library.

Printed in Hong Kong

cover, **Making a Clean Edge**
(detail)
1989
Construction materials, garbage,
oranges, lights, paint
Approx. l. 576, h. 403.2 cm
Installation, PS.1, Long Island
City, New York

page 4, 1995
Acrylic and oil paint, acrylic yarn
on glass shelf, wicker chair, plastic
tub, light fixture and bulb,
crushed velvet, plastic piggy
banks, cloth, concrete, cookie in
resin, wood on wheels
$171.6 \times 153.6 \times 124.8$ cm

page 6, **Jessica Stockholder**
1992

page 42, 1994
Two fans, pink power bar, skeins
of acrylic yarn, flannel cloth,
silicone caulking, acrylic paint,
thread, glass shelf (detail)
h. $154 \times$ variable width \times d. 24 cm
Yarn element, $58 \times 24 \times 58$ cm

page 80, **Sweet for Three Oranges**
(detail)
1995
Approx. 40 Christmas trees, 50
kilos of oranges, 4 bird cages,
brick wall, air craft cable, butane
heaters, rope, roofing paper and
roofing tar, paint, light bulbs and
yellow electric cord, PVC piping,
angle iron
Room, 21×4 .9m
Installation, Sala Montcada de la
Fundacio la Caixa, Barcelona,
Spain

page 90, **Invitation card** (detail)
1995
Photocollage
10.2×14.4 cm
Exhibition at Jay Gorney Modern
Art, New York, March - April 1995

page 144, **Jessica Stockholder's
building hallway**
1993

page 160, **Wall Sandwich** (plan)
1985
Pencil, typewriting on paper
21×29.7 cm

Barry Schwabsky Lynne Tillman Lynne Cooke

Jessica Stockholder

Φ

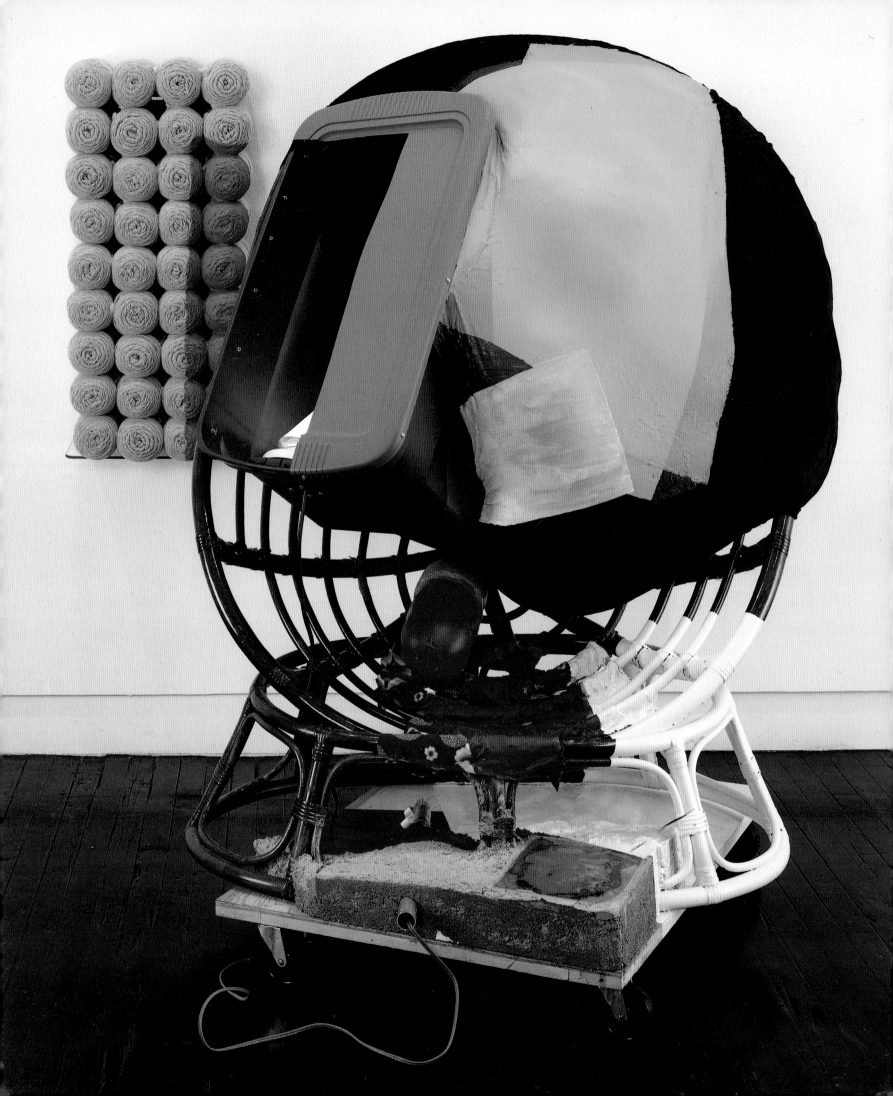

Contents

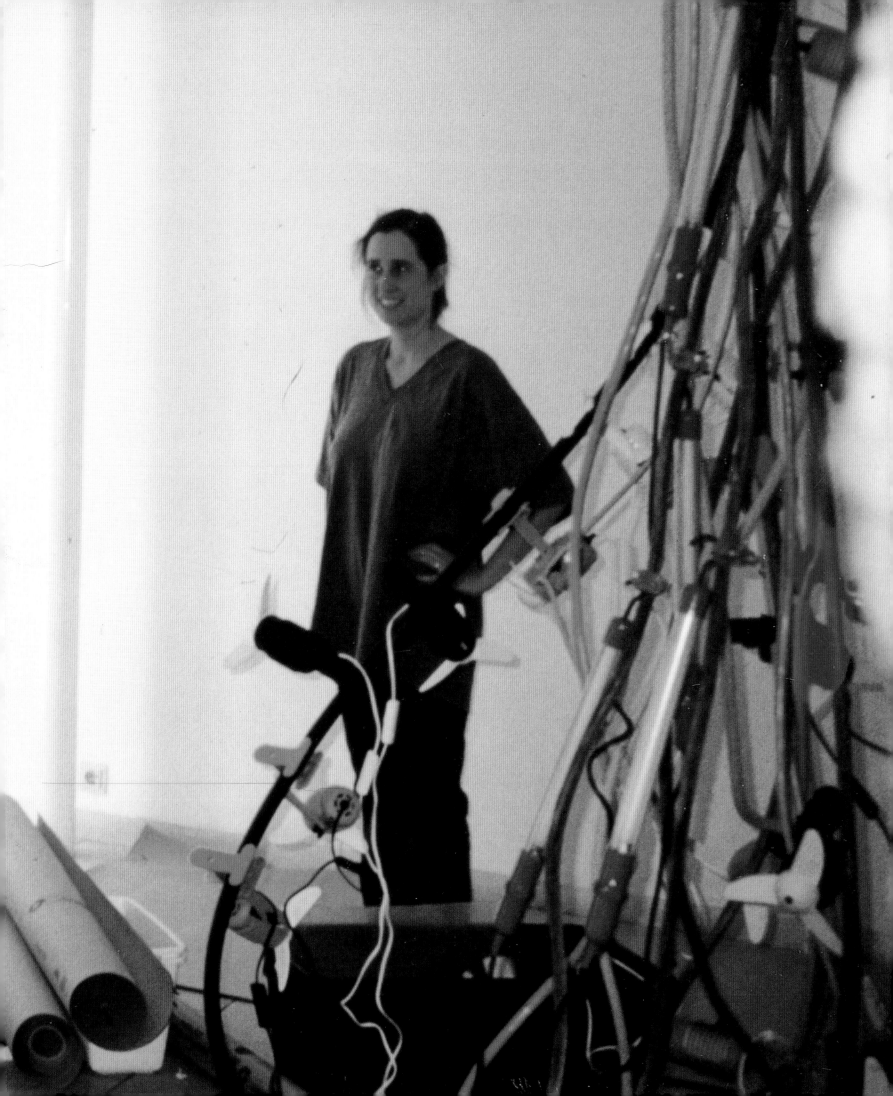

Contents

Lynne Tillman in conversation with **Jessica Stockholder**

Location 1: Stockholder's apartment in Brooklyn. Stockholder and Tillman are talking and looking at slides.

Stockholder **I started painting on unstretched canvas.**

Tillman Did you paint when you were a kid?

Stockholder **Yes. I remember getting into a mood where I just wanted to make something. It was always a frustrating experience. I felt that I lacked facility, that I was inept.**

Tillman How did you know what to measure against?

Stockholder **My mother painted. For a while, I painted next to her. I remember making one painting that was a sort of stage with figures on it. It was an orange and black painting.**

Tillman You still make stages – platforms, ramps.

Stockholder **In a journal I have from when I was a kid, I have a dream written down about yellow newspaper. I've used a lot of yellow newspaper in my work. This is unstretched canvas, with little bits of pieces of stuff stuck on it. Actually it's cloth, not canvas. There are different pieces of cloth stuck together, painted, then there are bits of acrylic paint – this was in 1980.**

Tillman Do you have a name for it?

Stockholder **I didn't title pieces until much later … These are made with pieces of cloth and stuff stuck together.**

Tillman Did you go to art school?

Jessica Stockholder's apartment

1980
Velvet, canvas, toilet paper, yarn, sequins
Approx. 100 × 170 cm

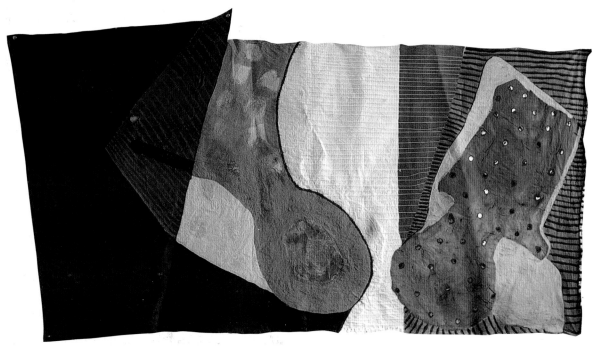

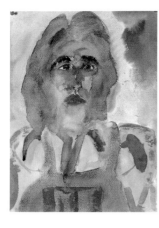

Self-portrait
1978
Watercolour on paper
53 × 26 cm

Stockholder No, I went to university. Earlier I studied with Mowry Baden, who's a sculptor. This is a very early one – a watercolour of me.

Tillman Looks more like a wolf man or a farmer –

Stockholder Overalls were in style then. Here's one I like very much.

Tillman That's beautiful. Like a Matisse.

Stockholder He's one of my favourite painters … These are all close to square or rectangular painting.

1978
Acrylic on paper
58 × 38 cm

Tillman Was this while you were studying with Baden?

Stockholder Yes. He's a friend of my father's. When I was fourteen, I had private lessons. He taught me to draw – line drawings of objects that became quite abstract. He taught me to appreciate the surprise of making something unexpected. He would talk about the drawing in terms of how it addressed the page. It wasn't about representing the thing that was on the table.

Tillman Most artists, writers too, recapitulate a number of different styles. It's about working with a language. You have to figure out what's already there, then see what you can do with it.

Stockholder Here's my Larry Poons. And this is one of the first paintings where I started to break up the pieces, so that there'd be space between the things on the wall.

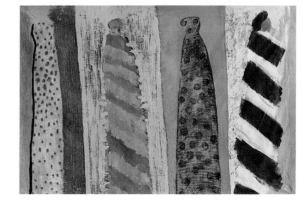

above, 1978
Acrylic on paper
Approx. 70 × 55 cm

below, 1979
Acrylic on canvas
Approx. 80 × 140 cm

Tillman How did that come to you: to begin using cloth and …

Stockholder Mowry spoke about the unstretched pieces not having integrity as objects.

Tillman Why was that?

Stockholder The cloth hanging on the wall was flimsy. He talked about the easel painting as a small replica of the wall it hangs on. He pointed to architecture giving meaning to the historical structure of painting. This way of thinking made a lot of sense to me. I later found similar ideas discussed by Brian O'Doherty in *The White Cube*. Though his view of painting's history is more cynical.

An unstretched canvas hanging on the wall doesn't provide a place to take off from the material and forget it's there.

Tillman Is it a neither here nor there state?

Stockholder For me painting is wonderful because it provides a place to forget the material, even while your attention is drawn to it.

Tillman How do you mean? – forget the material –

Stockholder I use material as a place to make fiction, fantasy and illusion. When this happens, attention is drawn to something abstract and separate from the material – the physical paint and canvas.

Tillman Do you use a material in order to forget it?

Stockholder I like there to be places where the material is forgotten; but I also love to force a meeting of abstraction with material or stuff. Colour is very good at this, always very ready to assert itself as independent of material.

Tillman Particularly when its use is idiosyncratic. In *Recording Forever Pickled*, in front of a kind of skeletal wall, a wooden structure, there's a wrapped armchair. What seems a coffee table is in front of the chair, but it's made of concrete. I think about the impossible living room. The space one can't talk in. The spaces or things one can't talk about. I think that piece is, again, a kind of stage, with an element of the absurd in it. And the yellow on the floor could be any other colour. One's attention is called to the yellow just as a colour. It's bright, challenging, odd.

Stockholder It couldn't be any other colour, because the colours are keyed to each other. There's plywood holding the crosses or Xs up. The back is painted violet, and this violet reflects onto the wall. Then the red –

Tillman The wall seems to disappear. I can't tell if there's space behind.

Stockholder I often use white to do that, because visually white sinks back into the wall of the gallery. When the viewer moves around to the edge of this piece, the reflected purple or violet between the wall I made and the wall of

Recording Forever Pickled
1990
Wood, styrofoam, paint, halogen lights, electric cord, concrete embedded with plastic resin-coated cookies and a red ball on wheels, one couch, one metal framed chair, about 12 clear plastic garbage bags filled with leaves, sticks, and twigs, 2 black garbage bags filled with the same, yellow green duct tape
Approx. 400 × 580 cm; room, 1120 × 580 cm
Installation, Le Consortium, Dijon, France
Collection, Le Consortium, Dijon

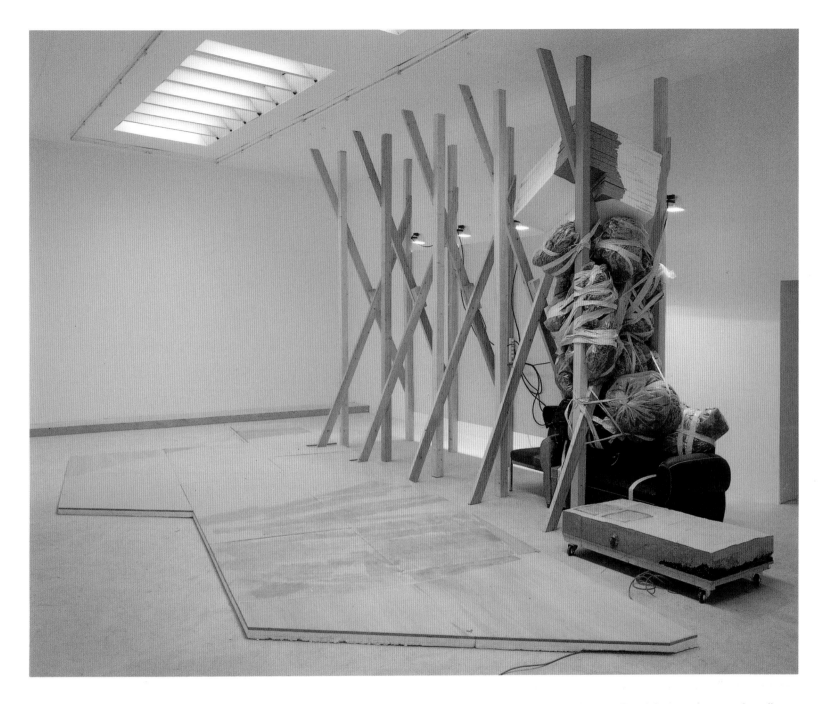

the gallery is seen as a volume of colour. The violet complements the yellow-orange on the floor. The colours are keyed to carry the eye around; they read across space. In this way the colour is very specific.

Tillman You could have set up a different set of colour combinations. But you call attention to colour by what seems to be an arbitrariness in the decision, since it's not linked to a 'natural' concern.

Stockholder **That's right. The colour is not descriptive of something else in the world.**

Tillman It has its own life as colour. You use it idiosyncratically, calling attention to it, which is painterly ...

Stockholder **I weave the fiction that the colour makes together with what the**

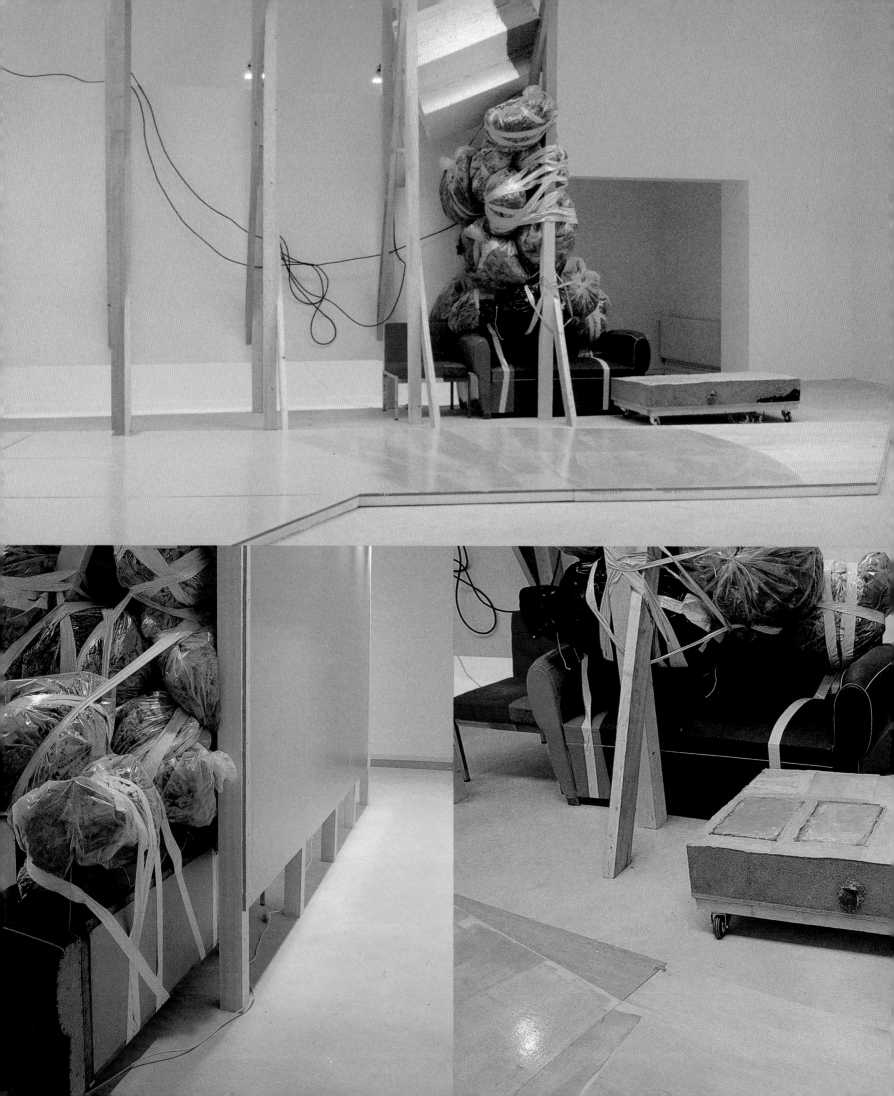

opposite, **Recording Forever**
Pickled (details)
1990

below, 1980
Wood, paper, paint on wall, wire
288 × 403 cm

objects are and suggest, along with a structure that I make.

Tillman You moved from painting on paper, to unstretched canvas, then to bits
of cloth, things stuck on cloth, to something that begins to fill a whole space.

Stockholder **I can show and tell you how that happened. In this work, I found
painted boards and stuck them to the wall. The little pink wiry thing comes
out from the wall onto the floor, and a piece on the edge goes up through the
ceiling. So, though this piece is still very rectangular and framed by the wall,
it pokes out a little bit, up through the ceiling and onto the floor.**

Tillman When was this?

Stockholder **1980.**

Tillman When you became more interested in the space between things,
objects started coming off the wall. You became interested in the space
between two objects – and the wall itself. Did you feel that you were involved
in a critique of painting and a critique of the institution of the gallery?

Stockholder **I don't think I work from a space of critique. My work isn't, in
the end, a critique of anything. It's more of an exploration. I work against
the kind of polarization that's implied by the word critique. I could critique
the institution, and I certainly have feelings of criticism about institutions,
but it's undeniable that my work depends on the institution that is art.**

Tillman That's a contradiction that everybody lives with – whatever system
one's in. The scientific, academic or literary community. You work within it.

Stockholder **I have always felt uncomfortable in museums and galleries.
There's a kind of a deadening in those places that I work in response to. I try
to bring the work closer instead of having it all framed off and removed from
me. Even so, I love what the art institution makes possible; there's a kind of
intensity and it's a place where you can express anything, and explore any
thing without hurting your neighbour. Art is elevated – presented as special.
This makes it possible to pay close attention to very wonderful mundane
things.**

Tillman Without that distinction, between art and something else –

Stockholder **It just runs into brushing your teeth.**

Tillman Warhol confounded that, problematized it. If you make a picture of
a soup can, you will think about what's outside the frame of that picture, and
maybe you will think differently about that ordinary can. Representing it takes
it out of the realm of the so-called ordinary.

Stockholder **I try to bring some of that specialness, or heightened quality,
from art-making to the ordinary. This work was outside at the University of
Victoria. The little pieces of wood are painted and hinged. There's a figurative
element too. This piece never was finished; it was just rearranged. I was**

thinking about the colour being thrown around, an idea I'm still interested in. The planes of wood were throwing colour back and forth or reading across to each other. The colours bridge the space at a speed that's much quicker than walking. So the interaction of the colour starts to feel abstract, as though it's not material. And me moving, I'm another kind of material.

Tillman The way you think about art relates to science, geometry, physics. Speed, light, volume. As a viewer, I'll use my frames of reference. The concrete wall has an object jutting out. It raises – projects – certain questions. My eye might be moving, because of the colour play, but I don't think I would be thinking that. There are different moments in it. It's arresting in terms of your process.

Stockholder **I begin in a very physical place, without a lot of words. When you were speaking about the colour in *Recording Forever Pickled* – how it doesn't refer to anything, that it is its own matter-of-fact thing. I thought, there's a kind of muteness in that. When I'm asked what my plans are for the future I look inside and find a mute feeling. There's a quiet – there are no words for what I'm going to do.**

Tillman In *Recording Forever Pickled*, what would a conversation be in an impossible living room? The spaces are what one can't talk about. Using the yellow you might also be signifying something that can't be spoken about.

Stockholder **It's interesting to consider that as a meaning of yellow. Manipulating material is a way to speak.**

1981
Plywood, 2×4 wood, metal, carpet, oil paint
288 × 460 cm
Installation, University of Victoria

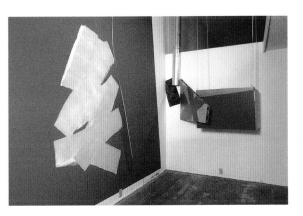

1982
Paint, wood, metal stove pipe,
carpet, rope, hollow core door
374 × 576 cm
Installation, Open Space Gallery,
Victoria

Tillman How did you move into installation?

Stockholder **Installation is a very poorly defined word. The earlier work started to elbow the space of the wall. It doesn't seem like such a huge jump to dealing with the space of the room. In 1982 Barbara Fisher invited me to put drawings in a show at Open Space Gallery in Victoria. I didn't want to put drawings in the show.**

Tillman And then she said: You can have this space to do anything you want?

Stockholder **Yes. This was the first time I consciously addressed the space rather than just the wall. I've kept doing it. It certainly doesn't make life easy! And installation has become so prevalent a part of art-making. People don't buy it for their homes, to be cute about it. You set up a challenge for yourself. There's not much of an art market in Canada. As an art student I wasn't thinking about selling work, and I had no place to store it, so I didn't think about keeping it.**

Tillman It's almost impossible for me to imagine – not keeping one's work.

Stockholder **I keep the slides. The process is what matters to me – making the work, how one work leads to another, and how showing the work and having people look at it and talk about it feeds it.**

Tillman That fits in with some of the art movements of the 60s and 70s which were responding to the object-oriented nature of art.

following pages, **The Lion, the Witch and the Wardrobe**
1985
Wood, plywood, concrete, plastic,
paint, floor paint, sawdust,
asphalt, bedsheet, tools, electric
light, newspaper, oil paint,
fluorescent lights, incandescent
lights
Work spans 2 rooms;
room 1, 1008 × 374 cm;
room 2, 576 × 576 cm
Installation, Artists Space,
New York

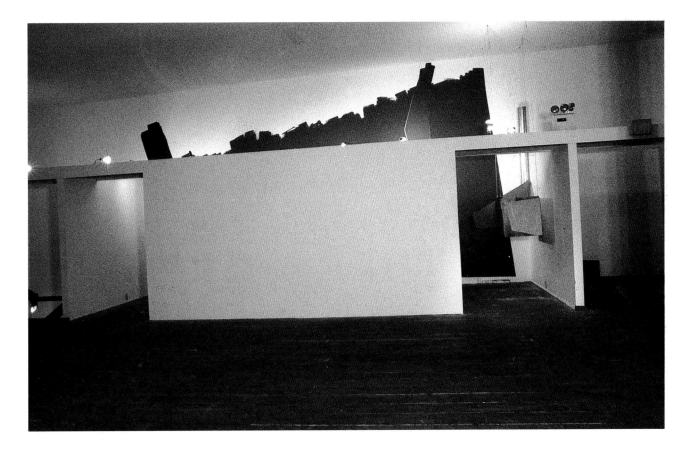

Interview

Stockholder **It was in the air. Mowry was very much involved with thinking about how art objects function politically within an economy; this was all part of the discussion around me.**

Tillman A curator says: Here are these walls. Instead you want to use the whole space. To do something that fills that space or speaks about space. Takes it up or shows some sort of relationship to it. That's intriguing not only formally, but also psychologically.

Stockholder **It's an attempt to make things immediate.**

Tillman I don't know that writing functions in that immediate way. Maybe it does. But the process of reception –

Stockholder **The way I read is probably more immediate than you would like!**

Tillman Maybe the way I perceive art is less immediate than you would like. I don't think about tactility, a word that crops up about your work. Some artists want the sense that this could be something you'd want to touch. In some way I guess I don't feel myself in the world physically. Although you push that. In the piece with a ramp, *The Lion, the Witch and the Wardrobe*, I understand it as something that goes nowhere.

Stockholder **How do you see that?**

Tillman Usually a ramp leads somewhere. Again you take something that has a function and use it in a way that calls attention to it as other than its function – ramps take you from one place to another. Now, it does take me from one part of your art work to another. But it's in such an absurd way that it speaks to me of a certain futility – about going anywhere. I'm a pessimist, but it did confront me, made a physical impression on me. I don't know if that means 'tactility'. I think of it as this object in the room –

Stockholder **–calling attention to itself as a thing, yes. That's what I like it to do.**

Tillman Your later work pushes that, off the wall. You even make your own walls. Architecture's 'the art or science of building'. Not one or the other – both. In a sense you can take your choice. Science and art relate to your work.

Stockholder **I once proposed a work for the San Francisco Exploratorium, a science museum with an artist in residence program. I proposed that it was a matter of scientific interest to what degree we brought information with us that coloured our vision when faced with art. They didn't go for it.**
 I began making art without much sense of the physical world and discovered how much it mattered to me through the process of working. It was a part of the world I was able to encounter entirely on my own terms.

Tillman It's also about making a place for itself, for oneself. In the world. If you enter a space, as you did at Open Space Gallery in 1982, and decide: no, I won't hang on the wall, I'll be this space. It's like making yourself, constructing yourself also.

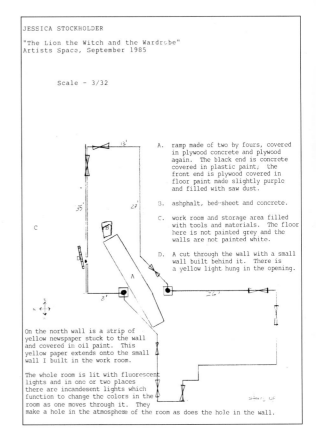

JESSICA STOCKHOLDER
"The Lion the Witch and the Wardrobe"
Artists Space, September 1985

Scale – 3/32

A. ramp made of two by fours, covered in plywood concrete and plywood again. The black end is concrete covered in plastic paint; the front end is plywood covered in floor paint made slightly purple and filled with saw dust.

B. ashphalt, bed-sheet and concrete.

C. work room and storage area filled with tools and materials. The floor here is not painted grey and the walls are not painted white.

D. A cut through the wall with a small wall built behind it. There is a yellow light hung in the opening.

On the north wall is a strip of yellow newspaper stuck to the wall and covered in oil paint. This yellow paper extends onto the small wall I built in the work room.

The whole room is lit with fluorescent lights and in one or two places there are incandesent lights which function to change the colors in the room as one moves through it. They make a hole in the atmosphere of the room as does the hole in the wall.

**The Lion, the Witch and the
Wardrobe** (plan)
1985
Pencil, typewriting on paper
21 × 29.7 cm

Stockholder **The work has always functioned as a place to affirm my subjec-
tivity. That we have intense subjective response to objects is curious. It can't
be denied.**

Tillman The way you treat that subjectivity resorts to, employs, a certain level
of abstraction to handle your own psychological needs. I don't feel, when I walk
into a room of yours, that I'm dealing with Jessica Stockholder's psyche. I feel
that it's all been mediated, thought through, worked through, so that your
use of colour may indeed go back to some psychological meaning to you about
colour. But it informs the work and has a resonance within the work that's not
specific to you.

Stockholder **That makes perfect sense to me. I'm trying to think about why
that's so, and why that happens. To turn something that's intensely personal
into something that's publicly available.**

Tillman It's one of the fascinations about making art, writing. In my writing I'll
use 'I', and it's usually not me. Yet there is the desire to write it, or just to write,
which is from oneself. You became engaged in the space between two objects.
That wall – maybe the wall was you, between you and the world.

Stockholder **When I began I experienced architecture as a kind of given.
Buildings were the world. A building was as much a given as the fact that
the ground is made of earth. Through my work, I've come to understand that
buildings are invented by other people as was our history, civilization and
society – it's all made by people, it's not a given.**

Tillman Buildings don't have to look like this.

Stockholder **Exactly. They all carry meaning. Galleries aren't neutral. They
signify a kind of neutrality that we gave them.**

Tillman You explode into that so-called neutral space with work that
is sometimes very theatrical. In *Edge of Hot House Glass*, there's a raised
platform. Had you ever done that before? Raised the floor?

Stockholder **It's not unlike *The Lion, the Witch and the Wardrobe*. But it's not
a ramp, it's a platform.**

Tillman There was no entry onto that floor?

Stockholder **No.**

Tillman You literally raised the stakes on your own practice, as if saying: Here's
a new floor, new ground. It's a huge piece, isn't it?

Stockholder **It's not one of the biggest pieces I've made, but it's big – the
platform's probably 20 by 20. The space was difficult – dark, almost a
basement in feeling with little lighting, dark, shadowy. Generally, I don't like
my work to be atmospheric. Theatrical was a bad word when I was in school.**

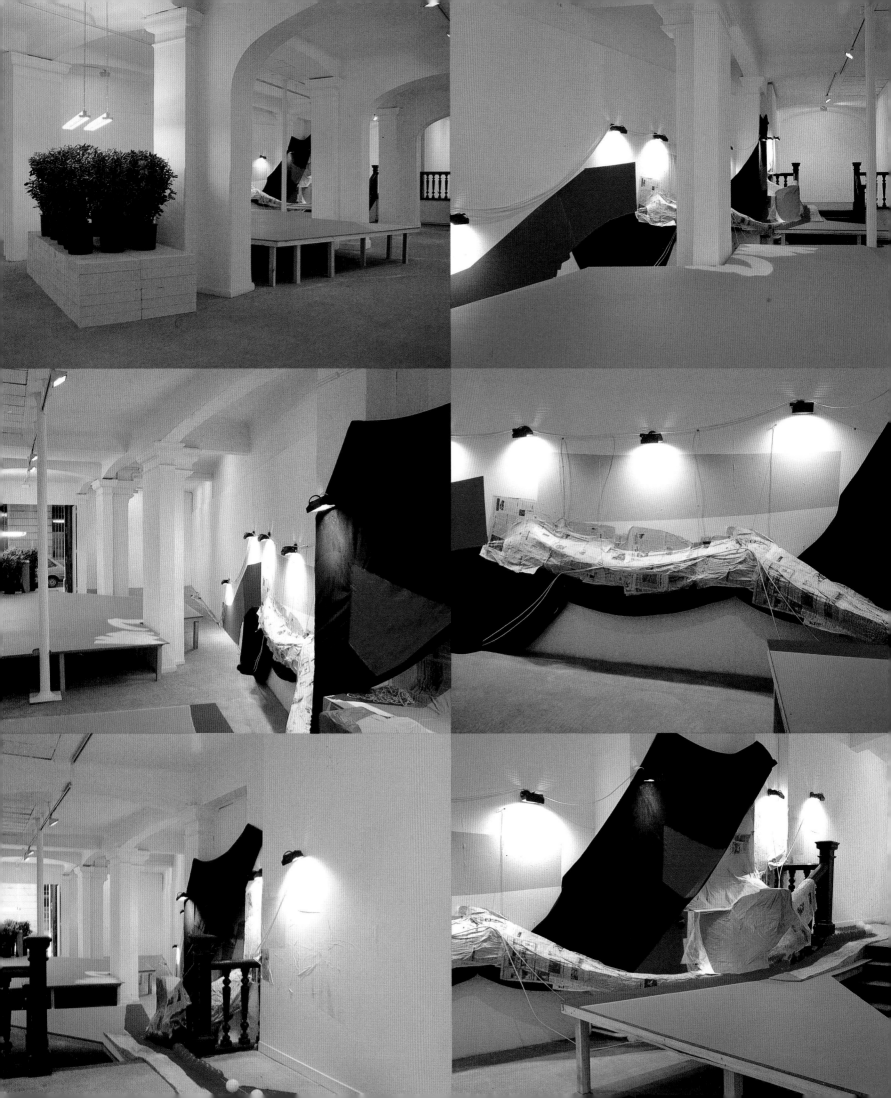

Edge of Hot House Glass
1993
Plants, grolites, areated concrete
block, halogen lights, paint, black
velvet, newspaper maché, cable,
beads, balls, concrete, building
materials
Approx. 11 × 12 m
Installation, Galerie des Arennes,
Nîmes, France

Tillman It's hard to avoid when there's what looks like a stage or a ramp.

Stockholder **But I like the work to be immediate. I don't like the work to be lit differently from the space you're standing in. It's not theatrical in that its audience isn't in a different space from the work. I struggle very hard to keep the work in the same place as the viewer. This particular space was hard for that reason.**

Tillman Is that opposed to some notion of illusion in a way?

Stockholder **No. It's that I want the illusion to coexist with my experience of the table next to my piece, or the staircase next to the work. I don't want there to be a divide. Many people like their experience of work to be heightened, separate from one's experience of having walked into the gallery. Gallery windows are often covered, galleries are often dark. I like the windows to be open, to have no drapes on them. I like to walk in and be aware of where I came from, to have that experience of having just entered into the gallery next to the experience of looking at the work. This space in Nîmes was hard for that reason. You didn't see the daylight that you'd just left behind.**

Tillman Is that why you moved the floor up?

Stockholder **I moved the floor up to try and counter the feeling of being sunk into this room. I contemplated having a place where the viewer could stand and not be able to move around. But I like the viewer to be able to move, so that there's choice. I like there to be pathways.**

Tillman You want a continuous experience between what's art and what's so-called everyday?

Stockholder **Fredric Jameson gave a wonderful lecture at Bard College this past summer (1994). The lecture was outside – we were all sitting on the steps outside a building because there was a power outage; behind Jameson was a backdrop of trees and birds; the sun was slowly setting, and the moon was coming up. And he delivered his very abstract, formal, and organized lecture just as he would inside, only in this new context it was a completely other thing. The contrast between the formed, abstract thing that he was delivering, and how independent it was of wherever he was, and the birds, and his lectern being messed with while he was talking – for me that was beautiful. That this abstraction that he's in the business of making coexisted with the trees, and the birds, and these things that are so easily romantic, was beautiful.**

Tillman We have all sorts of feelings about trees that have nothing to do with trees.

Stockholder **They have to do with us.**

Tillman We think about nature, place it in relation to our human lives. It has significance for us because we make it, or don't make it, significant.

Stockholder But I also think that it does exist separately from us, as distinct from Jameson's lecture, which doesn't. Jameson's lecture exists only in so far as he made it. He manufactured his lecture, which can exist next to a tree or inside a university building. In my work I manufacture something like that, like his lecture, that's very abstract and ordered, by me, and by the culture that houses me. But all that I make is meshed with, and sits on top of, stuff that is incontrovertibly there. I understand that we could talk – and philosophers do talk, ad infinitum, about whether in fact it's there if you don't see it. But I – and I imagine most people – have an experience of some things as really there, and other things as not quite there. I'm interested in how those two experiences mesh.

Tillman Your concern almost from the beginning was to deal with a structure that was already there. You didn't choose to ignore it.

Stockholder That's true both of the physical structure and the social structure that contains my process.

Tillman It didn't happen in a vacuum. You're not alone in that concern. The way in which you handle it has its own particularity, the way you try to encounter a space – it's fun even to use the word encounter when you use a structure like a counter. To me your work is filled with words, with metaphors, that I as a writer can immediately, and not the way you want me to, probably, translate. I'm beginning to be more aware of the physical world, of the built environment, let's say, than I was. I'm even more aware of birds. But it's taken me a long time.

Stockholder Me too. I start from a place that's not unlike what you're describing. Only I don't have the words. I don't trust the words.

Tillman I don't trust them exactly. I use them. I don't believe they say everything, but, obviously, I want to be working with them. Maybe I'm interested in visual material as much as I am because there may be some similar sources to making it, but it's translated into something I could never accomplish. Especially in three-dimensional forms. To me that's one of the strangest, hardest things to do.

Stockholder It's funny, in some ways, that's also true of me. I started on flat surfaces, with planar images. To make them three-dimensional was a challenge. I could conceptualize, and had a real facility with things on a page, graphically, but I couldn't, and still have difficulty, conceptualizing in three-dimensions. I don't begin installations knowing what they're going to be in the space. As my work grows, part of the challenge is to continue putting myself in a place where I am in the dark and required to respond immediately, where I can't predict the outcome.

Tillman Maybe that's why I find jokes in your work. One's a play on the truism that art is organized out of chaos. There's chaos in your art. There's clearly a mind at work organizing, with a system, responding to the space, but it's discomforting. Your work asks: where do I look first? It's not organized so that there's a front, or a frontal perspective. You don't have a vanishing point. At least I can't find it.

Richard Long
Stone Circle
1976
Approx. 156 Tennessee stones
637 cm diam.

Isamu Noguchi
Beinecke Plaza (with temporary installation by **Jessica Stockholder** and **Mark Holmes**)
1985

Stockholder **There isn't one.**

Tillman In Western art, the vanishing point, frontality, and other devices, organize it, so as to organize vision, the world – but there's another sense of organization in your work.

Stockholder **Part of the work is highly ordered and organized, and part of it just lays where it falls. To use a visual metaphor for this idea – objects in the place of ideas – if I use five different objects, parts of them will fit together in a very tight, formal way, and the rest will just hang out chaotically. Another way to visualize my order in chaos is to imagine a bunch of threads overlapping in one place. Where they overlap, things are tight and ordered. But the ends fly off in a million different directions, often having nothing more to do with each other.**

Tillman That's a scary way of working. There's not a contradiction but odd consequences. On the one hand you want the viewer's experience to be of the same order as the experience of walking down the stairs and going to a place. On the other hand – this may be what your experience of the world is – you make a disorderly organization. A disquieting, sometimes demented –

Stockholder **Yes!**

Tillman ... bunch of things.

Stockholder **Yes, it's amazing that things work as well as they do. I am not interested in making work that pretends the world is not like that. But I do appreciate the work of Richard Long. He'll place a bunch of stones in a circle, or a path. He works out in the landscape. His work is very cohesive, and ordered – round things, or square things – very unified. I think his work functions as meditation.**

Tillman Your art doesn't leave room for rest. It's not a resting place. In the way you were describing the Long work, one could, as in Noguchi's, imagine standing, looking, and feeling a sense of quiet.

Stockholder **I miss that in life!**

Tillman Maybe that's why he does what he does. He wants ...

Stockholder **– to make it.**

Tillman Maybe it represents what's missing in his life. Or what he thinks life –

Stockholder **– needs.**

Tillman You might want that, but insist instead: I don't find it anywhere. I don't know that I can make that, in order to say this is as it should be.

Stockholder **Though I agree there's no quiet place in my work that compares**

with the quiet of Noguchi or Long, there are places in most of my pieces where you as viewer are definitely outside, looking at a quieter, static whole.

Tillman You said you allow pathways. There are exits.

Stockholder **And points of detachment. In *Where It Happened?* (1990) and in *Mixing Food with the Bed* (1989), you enter and just at the gallery door the piece is in front of you as if it were a stage set or a painting. Then you walk through it, and it's chaotic and formally difficult to get a handle on. Having walked through and turned around, you are definitely not in that piece anymore.**

Tillman How do you know for sure?

Stockholder **You're standing on the normal gallery floor. White walls are around you. You can, from this point of view, make a distinction between the elements of the piece and the gallery. So you have detachment.**

Tillman But then what is the shape of it? That's often what I wonder about your work: What is its shape? One walks into a space in which you've installed an art work, where the viewer's given a place somewhere in the room to feel distance from it. I don't know if it's detachment.

Stockholder **I don't make environments that you walk into in which the**

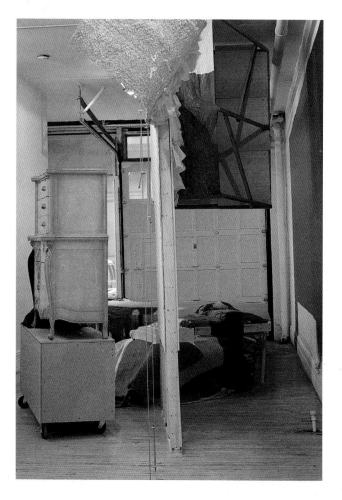
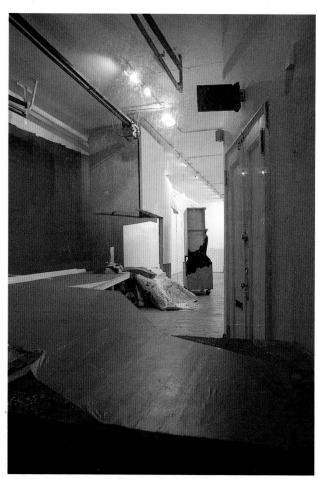

Where It Happened
1990
Wood, concrete, plaster, styrofoam, carpets, wall paper, newspaper, wire lath, papier maché, a yellow chest of drawers, sheet rock, wheels, asphalt, roofing tar, lemons
Installation, American Fine Arts, Co., New York

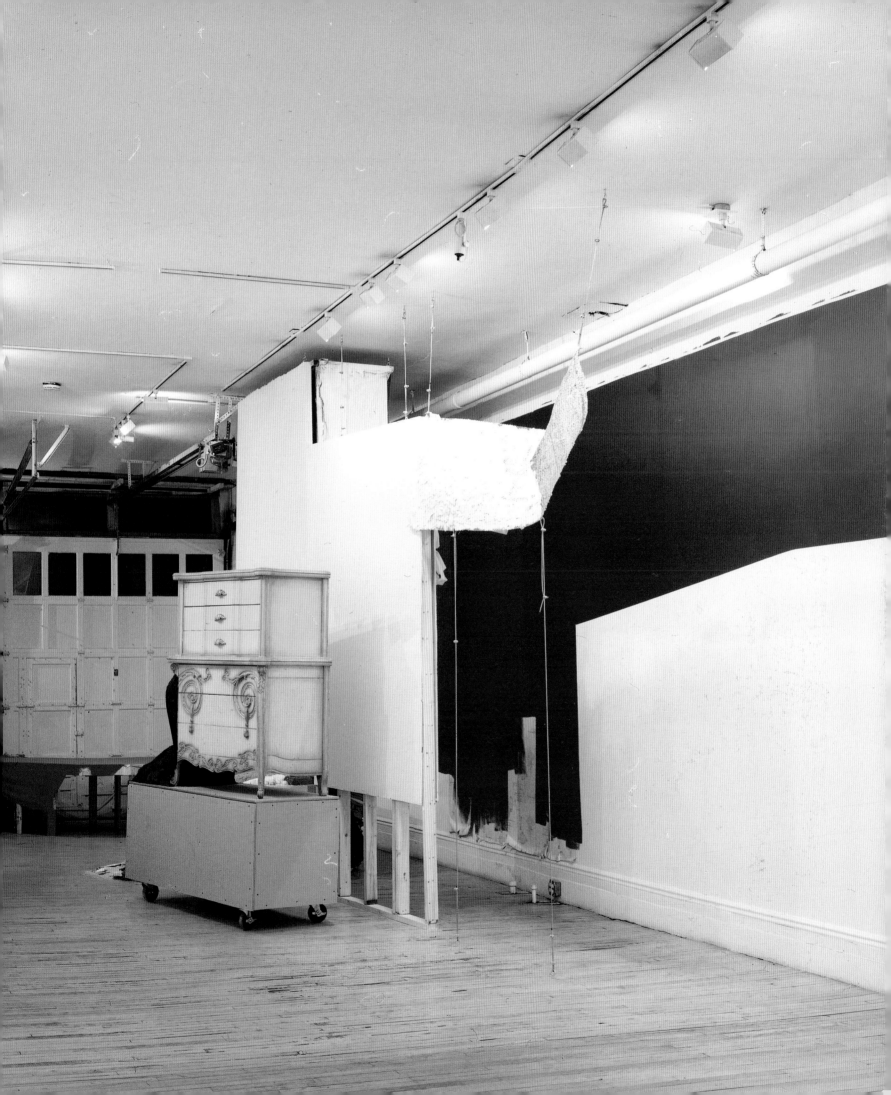

**space or place has been disguised. My work isn't like wallpaper. You always
know there are two elements – the building and the work. But just where
the building begins or ends, and where the work begins or ends, isn't clear.**

Tillman There's an issue about boundaries.

Stockholder **Absolutely.**

Tillman What are the boundaries? On the other hand, you do leave some
breathing room within that questionable symbiosis between thing and
person or between art and so-called life.

Stockholder **That matters to me tremendously.**

Tillman In *Installation in My Father's Backyard* you hung a red mattress on the
side of a barn –

Stockholder **Garage.**

Tillman Garage, sorry. The garage wall, part of it is grey and there's some blue.
You've painted the grass and flowers, or shrubs, in front of that wall. It's a real
mattress?

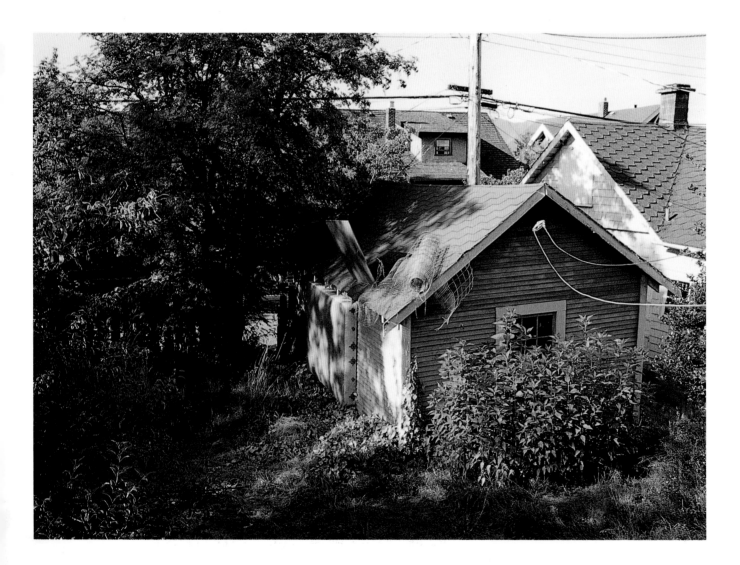

**Installation in My Father's
Backyard**
1983
Cupboard door, mattress, painted
grass, chicken wire
Private residence, Vancouver B.C.

Stockholder **It's a double or a queen-size mattress spraypainted with fluorescent paint – a little bit transparent so the markings of the mattress show through. There is a blue, or purple, cupboard door that's mounted on top of the garage with a roll of chicken wire.**

Tillman It's compelling and weird for many different reasons.

Stockholder **Let's hear.**

Tillman You make a mattress red which underscores sex and sexuality. Then you confound the built, the garage, with the object itself; and the ground is grass which you paint. You put something on the grass that makes it unnatural. That seems to have some reference to a family structure, to the idea that the family is considered a natural unit, though each unit is different – has its own colour. But it has a basic structure we recognize: father, mother – or lack of – and children. Then your use of the blue on the roof and door are in relation, reflecting each other: blue grass, blue door. A door opens and shuts and could be an obstacle. Also an entrance or exit. Many meanings. Then there's wire, which is an aggressive element. If you landed on it, if it touched you it wouldn't –

Stockholder **It would not feel good.**

Tillman The piece is also deeply site-specific.

Stockholder **I enjoy your reading, but I can't say whether I agree or disagree. The way I came to making this piece has none of that conscious information in it.**

Tillman Tell me how you did it.

Stockholder **I found this mattress in the garage and painted it red as the complement to the grass. The backyard is more or less rectangular, so it's similar in shape to the mattress and garage. The lawn is brought into a dialogue with the mattress, and with the history of painting, because paintings are rectangular too. Here I'm making a painting – only it's also a back yard. The red of the mattress called to the colour of the berries in the tree, heightening colour that's already there. I painted the grass with a hard-edged form, kind of rectangular so it has a formal relationship to the door, and to the mattress. I never know exactly why I choose materials. Your analysis makes sense, but part of my interest is to work with materials that are in some way randomly selected – to put them together so that they speak for me. I have some faith that I will be able to speak through what is at hand.**

Tillman A mattress is so redolent. One couldn't go to one's father's house, take a queen-size mattress out of the garage and hang it without having some awareness that it referred to a father-daughter relationship, the Oedipal, the family.

Stockholder **I can see why you might say that, but I don't think about that stuff when I'm working. In order to avoid having my personal history, which drives the work, making the work cliché or diminished, I don't spend a lot of time thinking about it. I think about the form that the work takes. I make sure that in the end the experience is right – that the work is active.**

Tillman The formal elements are first what one's conscious of: you've used two rectangles – all of that is there. But I think what makes the work have resonance is that the formal is logged into this narrative, through its metaphors …

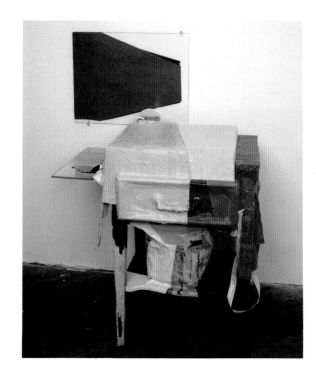

Stockholder I don't mean to say that I'm not aware of the psychological. But I don't feel as if I can control it or the narrative.

Tillman I don't think one can – not control one's being drawn to, driven to, taking up the material. Why one's driven to tackle a particular formal problem, why write it in this way – there are psychological issues involved that formal concerns don't conceal.

Stockholder And formal concerns are not interesting unless they carry this other information.

Tillman In some way, for me.

Stockholder For me also.

Tillman It seems that you use two kinds of titles, one kind seems to refer more to narrative.

Stockholder Narrative is something I'm trying to find a way to talk about now, though I'm not sure 'narrative' is the right word. There is a kind of building or layering of meaning that results from the literary content of the objects I use, but the structure is not linear. There is no beginning, middle or end. My aim is to throw the net as wide as possible, even while there are focused areas of literary meaning that develop here and there.

Tillman Some of your titles are long and specific, about the thing itself, about naming itself. For example, *Yellow sponges, Plexiglas, small piece of furniture, newspaper maché, plastic, oil and acrylic paint, cloth, small blue light and fixture, glass on the wall, 1990*. All the elements are named, yet the piece is not merely an aggregate of those elements. The pieces with the long titles are more, it seems to me, object oriented and can be taken in by standing in front of them. They seem to be more about painting, the limits and possibilities of painting.

Stockholder The titles consisting of a long list of objects are titles by default. My intention was to leave these pieces untitled. I always request that there be no title – and that the word 'untitled' not be used. In many cases the list of materials is used instead of a title. People just can't get their heads around the space being blank where they're used to seeing a title. But I'm not unhappy about the conversation this has given rise to. When I do use titles, I often work with the words in a way that feels parallel to the way I work with objects. I like the title to work alongside the piece rather than lead you down a path.

Tillman My interpretation's by default then, too, I guess. Some of the titles signal that the piece will be more narrative, about time and space, like *The Lion, the Witch and the Wardrobe*. That long ramp seems to be about space as well as about the time it might take to walk on it, if you were to walk on it.

1990
Yellow sponges, Plexiglas, small
piece of furniture, newspaper
maché, plastic, oil and acrylic
paint, cloth, small blue light and
fixture, glass on the wall
Furniture, h. 76 × 70 × 58 cm;
glass, 48 × 37 cm
Collection, Museum of
Contemporary Art, Nîmes

Stockholder **Even walking alongside of it, that takes time.**

Tillman Even if it's immediate in feeling, it also requires duration, which is about narrative, so that if you want the viewer to be physically in that space with that piece, the viewer must be active. To go from point A to point B.

Stockholder **And in the process of going from point A to point B, there are places where the work becomes very ordered and static, as a painting is static and separate from you. In that process, the memory of one side, or one view, of the work informs the viewing of the next side. If I'm looking at something that's red, and I know the other side of it's black, my memory of the black part functions in my forming of the composition, as if that black were visible. Do you understand?**

Tillman I think so. It relates to issues about narrative and psychology. If black is the memory, the unseen colour in back of the memory, it's present no matter if it's in the past or if it's visually present in the moment.

Stockholder **That your memory is equal to what you're viewing in the present is fascinating.**

Tillman It's another kind of dialectic in your work. On the one hand you want the experience to be in the present – you want the viewer to come in and have this experience. On the other hand, you're very aware that no one comes into a space without memory.

Stockholder **How those two things merge is most exciting. It's a struggle. It's not a modern struggle; it's an ancient struggle, actually to be present for the moment and what that means. I'm sure that's part of Richard Long's struggle too.**

Tillman I could imagine he might think, or someone making work that allowed for contemplation in one place might say: you are present, I am.

Stockholder **Or he would hope to be providing the opportunity to be present.**

Tillman Now, what is that desire about?

Stockholder **I think it has something to do with providing a place to experience will. If you can actually be aware of a moment and aware of yourself existing immediately, separate from, or in addition to, your history or memory, and culture, and all that makes you you, then there's room for choice.**

Tillman To give one some sense of agency – that you are somehow able in that moment to recognize yourself and another object's being there. But your work doesn't make presence in the world easy. It's not about a unity or a unified presence.

Stockholder **Well, I think it is and it isn't. But this takes us to the next stage – in the next location.**

Tillman Which you're choosing.

Stockholder **Right.** *(Laughs)*

Location 2: THE STUDIO

Stockholder's studio is located in the Williamsburg section of Brooklyn.
Stockholder and Tillman are looking at photographs.

Studio view
Summer, 1994

Stockholder **These photos are of a piece I made in the spring (1994), *House Beautiful*. The white is the wall of the gallery; the work spans three rooms. The carpets are stretched with cables to the walls, floor and ceiling.**

Tillman You couldn't take one photograph of the piece?

Stockholder **No.**

Tillman Craig Owens once said that the history of art was the history of slides of art. This piece would need at least two to represent it. I don't know immediately where the work begins or ends, or if, in the photograph, it is right side up or upside down. It returns me to the place we left, or left off, last week. Even though you use brightly coloured materials, which are often supposed to mean 'happy', you very contradictorily propose to this happiness a discomforting sense of disorientation and dislocation. You're not using the ramp in this one, but you are taking the viewer on an excursion. And there isn't a single, unified form.

Stockholder **Spatially, this isn't one of the most difficult pieces I've made. There is a green carpet on the floor; it is similar to the ground; you can walk over it or along it. The rectangular volume of yarn is a literal volume of colour; we know that the colour goes right through; it's not like a painted surface, or an object that has been painted. The yarn is a solid volume of colour contrasted to the flat areas of colour; we know the flat areas of colour are flat skins of paint on top of the carpets but they have an illusion of volume. Colour seems to project into the air in front of it. The fan which I painted green – like this green on the carpet – blows the air filled with colour.**

Tillman *House Beautiful* contains puns. Carpet/ground, a household fan/ audience. Hanging the carpet so that it refers to background/foreground, craft, laundry. To women's work and again to a stage set. Is it a Persian carpet?

Stockholder **It is a one hundred percent polypropylene Persian carpet. I used it because it was easily available and inexpensive. I would love to use real Persian carpets.**

Tillman What would be the difference for you?

Stockholder **A real Persian carpet is truly a rich experience.**

Tillman If it were a real Persian carpet, you'd be aware of that. You hang it now

opposite and following pages,
House Beautiful
1994
Wood, hinges, hardware, seven
rugs, braided steel cable, fan,
chandelier, green carpet, 100 balls
of yarn glued together with
silicone caulking and paint
Approx. l. 13 m, width and height
variable
Installation, Le Consortium,
Dijon, France
Collection, Le Consortium, Dijon

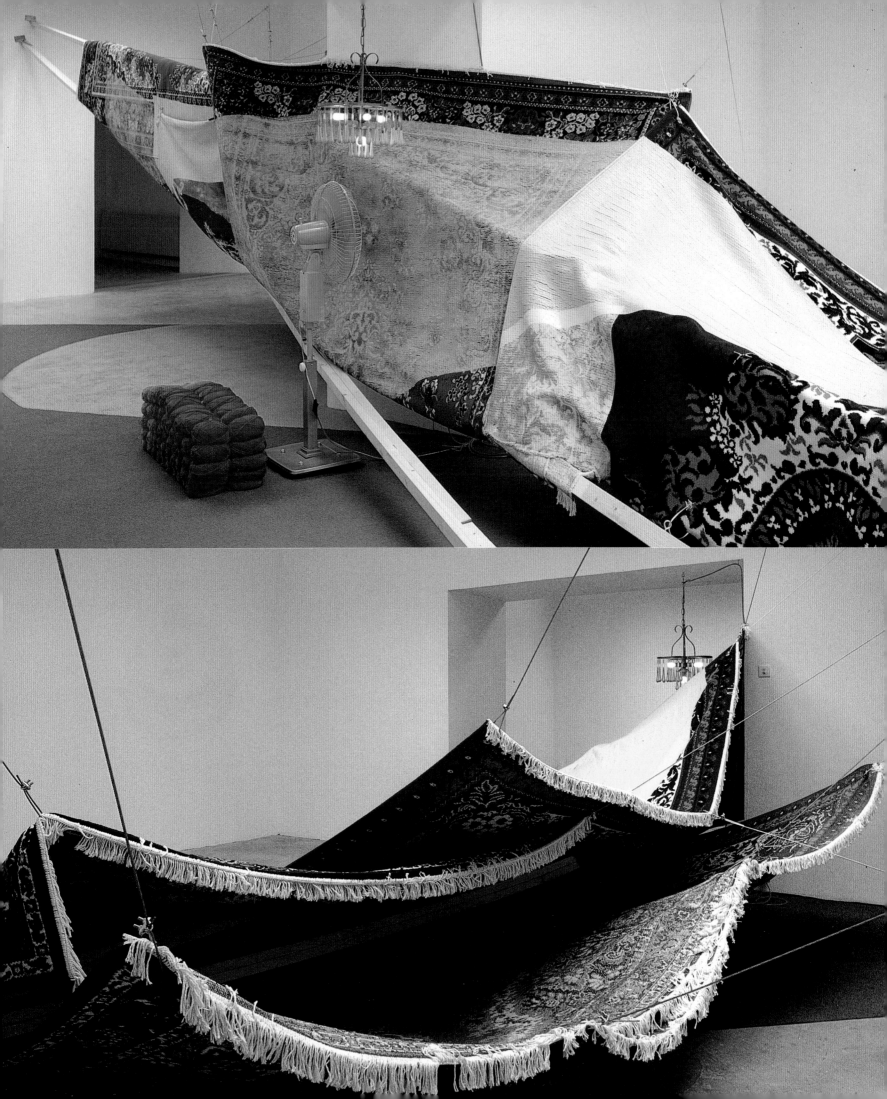

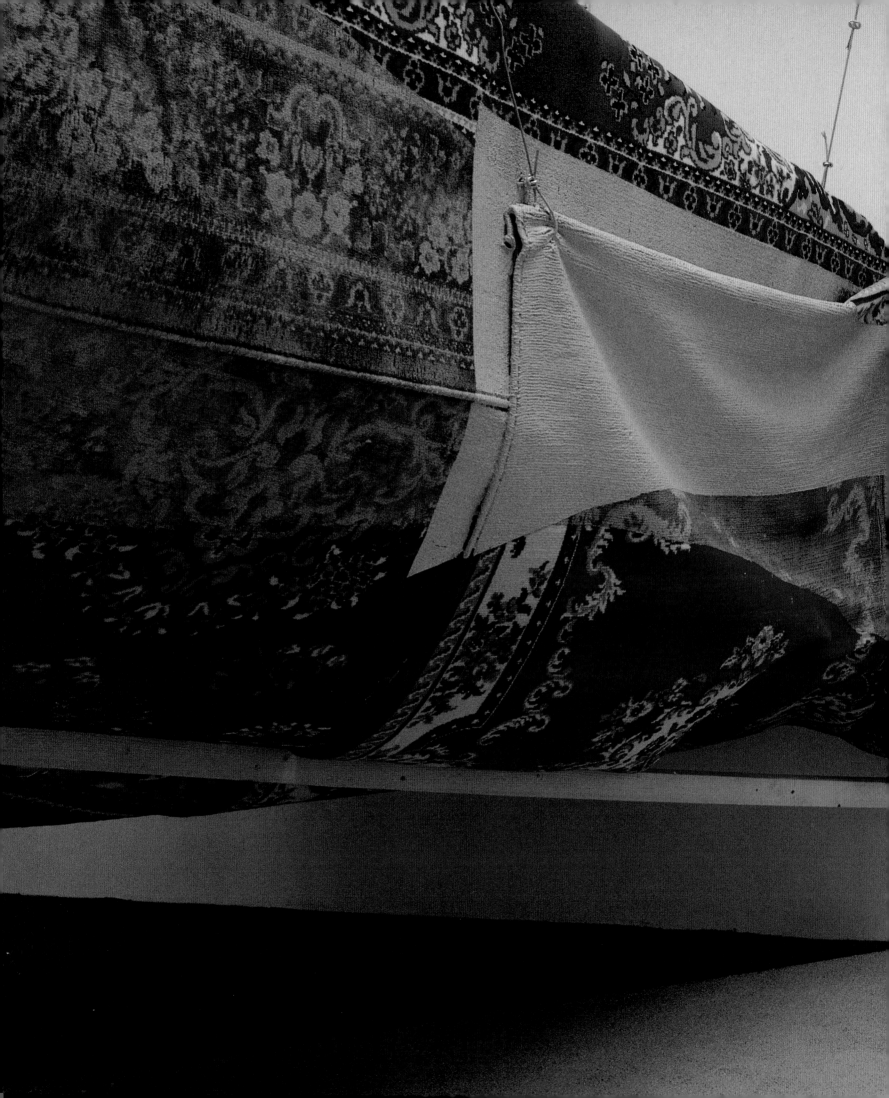

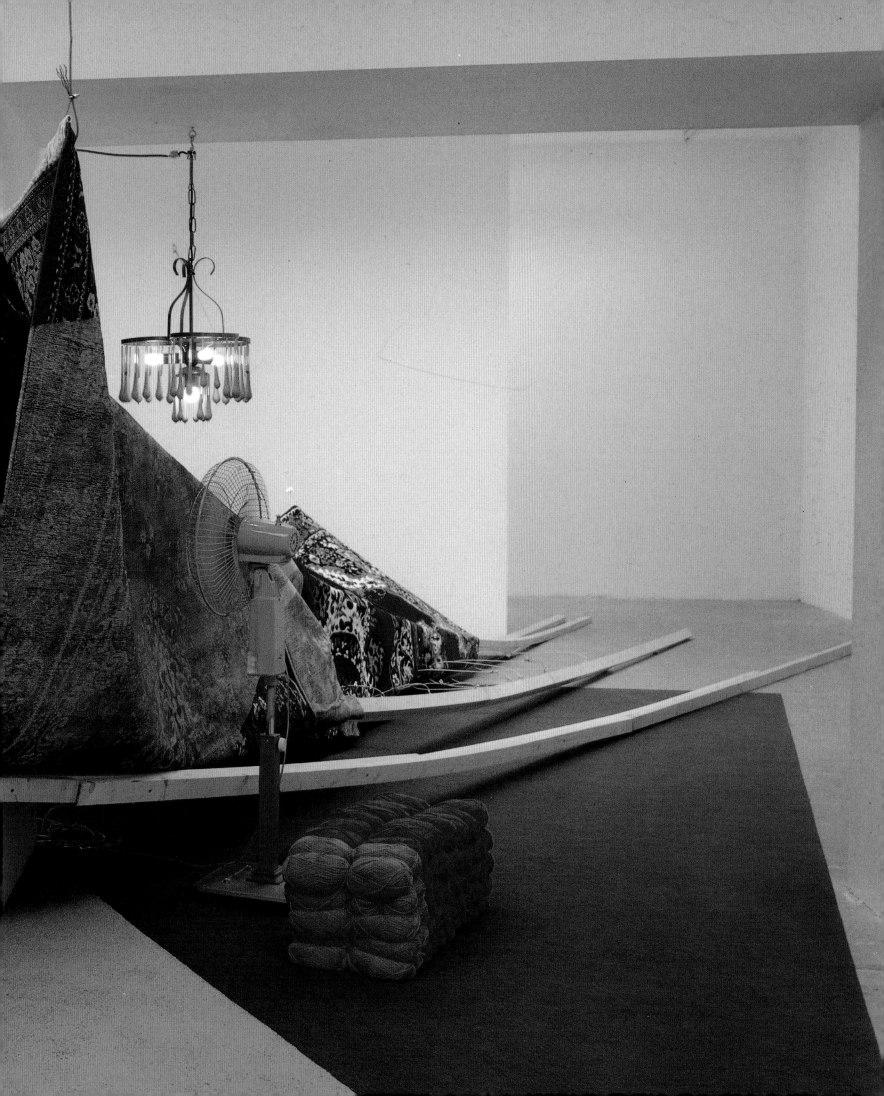

like laundry. Persian carpets are a form of art, people hang them on their walls. If you had a real Persian carpet, it would have a different valance, wouldn't it?

Stockholder **The other day Jay (Gorney) asked me, 'If you had a lot of money, would you use expensive things instead of cheap things?' We were talking about the fact that my work isn't about junk. This is an issue because critics have often written about my work that way. It's about things – some of them are junky, some of them are new and some of them are old.**

Tillman Why isn't it about junk? It's not that I thought of it as junk. Why do you think people see it that way?

Stockholder **Because I take objects out of their normal context, and there's a dishevelled, jumbled quality to the way I use them. Things are jumbled when they are thrown out. Perhaps that's how people arrive at that.**

Tillman Is it because you take everyday, ordinary material, and then don't use it in its expected way? In other words, because you make things no longer have their necessity, their function?

Stockholder **Perhaps that combines with the fact that the way in which I put things together doesn't adhere to a standard craft. When I use wood and nails and glue, the craft doesn't match the craft that one uses making cabinets. When I sew, the craft isn't the same as when you put together a garment. The work isn't about being well crafted, but the way the thing is made is important. Ways of making are meaningful – as significant as the meaning we attach to objects.**

Tillman That's different from the issue of junk. When John Chamberlain, in the sixties, took a car and crumpled it up, was it about junk or disaster?

Stockholder **People have discussed his work in terms of disaster and also more formally. In contrast to my work, his is formally very consistent; he lays out a formal language using one material. It's easy to forget that he is using crushed cars and see his work in terms of volume and shape. In my work the formal language is much more varied, and there is a question as to whether or not one should look at what the objects are. They are much more in your face than in his work. I don't think he invites you to think very much about cars.**

Tillman If those carpets had been ancient Persian carpets, would you have done the same thing? Ancient Persian carpets are valuable in and of themselves.

Stockholder **They have two kinds of value, a value in terms of the pleasure they give and a monetary value. If I were to use them instead of polypropylene we would be very aware of how I had taken away their previous value. This brings up all kinds of questions that I haven't had to deal with.**

Tillman Hard questions, whether one would take something rare and ruin it – but you're not doing that.

Stockholder **I feel curious about what you said a while back about the colours all being upbeat and happy in contrast to this structure that leaves you in a place of discomfort.**

Tillman That's one of the most peculiar aspects of your work – you construct a controlled situation that recreates the discomfort of being disoriented within and by the familiar stuff of our lives.

Stockholder **I've being reading Anthony Vidler's book on the architectural uncanny; I think that is what he would call uncanny, to take these familiar objects and make something unfamiliar with them.**

Tillman 'Uncanny', from *unheimlich*, 'unhomed by' – great word. One could also say your work is about de-familiarizing ordinary objects or feeling unfamiliar in familiar circumstances. I don't see junk in relation to your work. The word 'junket', going on a junket, comes up. Or junking certain notions about familiar objects, loosening them from the familiar grip. Many of your materials are 'traditional' women's materials: cloth, bright colours, wool. You use objects from a domestic space, couches, for example.

Stockholder **Things from a domestic space are associated with women, that's perfectly standard but it's a little odd. Men inhabit domestic spaces too.**

Tillman Too often the divide is women/domestic or private space, men/public space. Your work isn't traditional 'women's work'; but you take risks by using what some might consider benighted materials – junk to some, maybe because it's from the home. You do it in such an aggressive, peculiar, uncanny way, it's not about protecting the home or simply valorizing that space. It allows the domestic other interpretations. Your use of ramps, rooms, carpets, raised floors – things spill over and out. It's not a contained or containable world. In your play with the domestic, the so-called private sphere is always either threatened by or merging with the public, and the distinctions between public and private are blurred.

Stockholder **And between femininity and masculinity.**

Tillman When one walks into *House Beautiful*, will she or he feel that the carpet is masking or covering anything?

Stockholder **No, since what you first see as you enter the room is the structure around which the carpet is wrapped. There's nothing hidden. There are many things or actions that build on each other and inform each other, but I don't like to create mystery about what is actually there.**

Tillman It seems to say that something doesn't have to be hidden or covered in order for it not be apprehended. This work is hard to apprehend: it builds, it moves, you have to walk with it, there are many elements. How do you apprehend this? It's not that you're hiding anything, not that a mystery is something hidden, but a complexity that can't be understood even when seen. The turquoise – what did you think when you were doing that? Is that paint?

Stockholder **Yes. Why do you ask?**

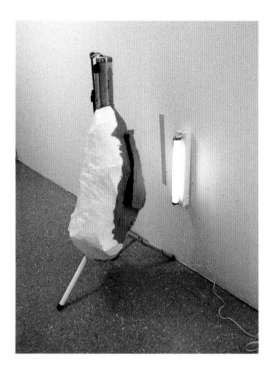

Tillman It's like a swimming pool. It suggests many allusions, from Narcissus, to ideas about thought, art and reflection – the green chandelier in it is a light, after all – to an art reference, David Hockney's swimming pool.

Stockholder **Hockney's pools.**

Tillman The turquoise appears to be an exit, a moment of escape.

Stockholder **It's more abstract, lighter than anything else.**

Tillman Your work's often concerned with exits and entrances, giving the viewer a number of them. It's a relief here in several senses – a rectangular relief that's on the floor, a painting on the floor, a relief from the piece and its insistence to move on. One can stop at the turquoise. Would you call it a moment?

Stockholder **A pause.**

Tillman A pause that refreshes. Why did you title it *House Beautiful*?

Stockholder ***House Beautiful*** **the magazine is about controlling the structure and surface quality of one's environment. This work is about that too, but from a very different point of view. The materials I use here could be from a house – in a sort of turned upside-down manner. The title refers to taste and structure.**

Tillman It also challenges the idea of taste.

Stockholder **I think about taste a lot. *House Beautiful* the magazine reinforces and puffs up the notion of good taste, as if there's a right way to do it. My work opens that up to question and proposes that there is no right way to do it, that there's a lot of meaning apparent in the decisions that people make.**

[LT and JS are walking around the studio and look at a piece.]

Stockholder **In 1987 I made my first piece at this furniture-like scale. It had a light pointed at the wall, so there was a circle of light on the wall, seen in relationship to the object in front of the wall. These smaller works activate the space between the wall and the thing in front of it, creating an event but in a more limited or proscribed way than the installations do. I titled the first six *Kissing the Wall*. Since then, almost all of the smaller pieces have had a relationship to the wall.**

Tillman An immediate, probably off the wall response to it: because the green rope is tied to the wall, what comes to mind is 'the tie that binds'. A relationship, about art to the gallery wall, and an interaction between two things – tense because the green rope is taut. The green rope ties what looks like a lounge chair and a kind of picket fence, to the wall. One side of this stuffed chair is very brightly coloured, a patchwork pastiche. A crazy quilt, and it's painted. What is the material?

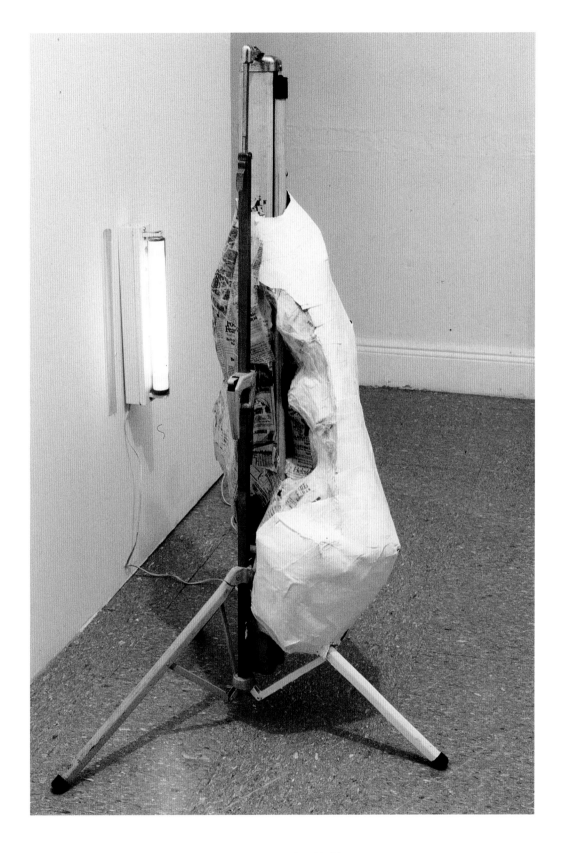

Stockholder **The red is fabric, there is a white shirt glued to the sofa with
paint on top of it; there's plastic, and the rest of it is painted colour.**

Tillman The couch or sectional's sort of grotesque. You've built an armature
around it, indicating a fence to me. Sectional plays on 'sexual'. Your work
takes 'real' things and makes a mockery of that reality. Is Mother the
sectional/couch? Is the art/wall Mother? It's the green rope – I can't help

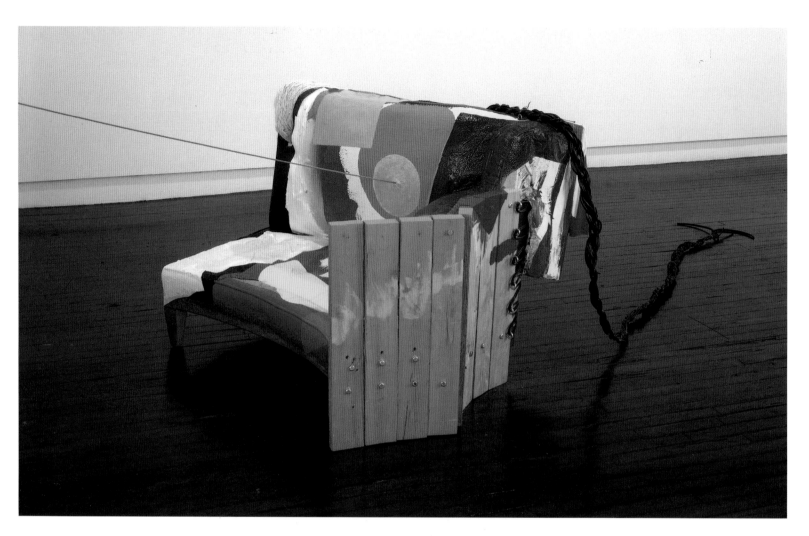

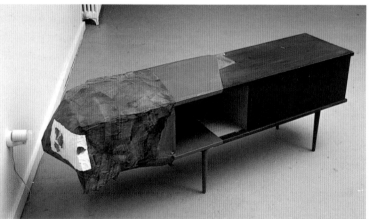

1994
Oil and acrylic paints on pink
couch with wood, hardware,
electric wiring, newspaper maché,
plastic, twine, clothing, string,
nail
112.8 × 146.4 × 432 cm

Kissing the Wall Out of Sequence
1989
Small low table/cupboard, green
newspaper maché, enamel paint,
orange peels, small light fixture
on the wall with a small orange
light bulb
70 × 190 × 50 cm

thinking of ties, dependency, the umbilical cord. Then the gap between wall
and chair could represent a formal relationship of art viewer to gallery wall.
The strangely painted couch could stand for the spectator and the spectator's
relationship to seeing paintings and drawings on a wall. One formative
relationship – mother/child – leads into other relationships, like what is a
viewer's relationship to a piece of art?

Stockholder **And what is the relationship of the piece of art to context?**
Does a particular context support art, like an umbilical cord from the mother

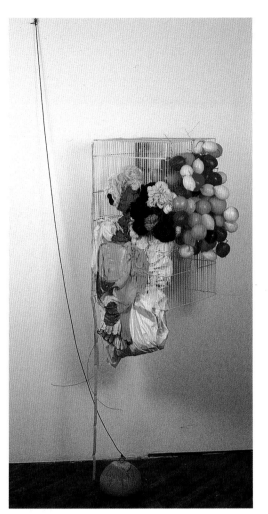

1994
Two elements: no 1, bird cage,
plastic shower curtain, clothing,
plastic fruit, hinge, balls of yarn,
wire, ribbon; no 2, string, concrete
and eye hook
188 × 84 × 60 cm

The Nether Mead, Prospect Park,
Brooklyn, New York

supports the child? What do buildings mean to us? What about independence? All of these are questions in the work.

(Stockholder and Tillman move to another work.)

Stockholder **In this smaller piece, one part is a cast concrete inflatable ball; the ball served as the form for the concrete.**

Tillman It's attached to the wall under a bird cage, but not attached to the bird cage. Birds, flight, imprisonment … Being imprisoned would be pretty weighty. But the cage is open, so again, there's an exit. It reminds me of Buñuel's film *The Exterminating Angel*. The characters can't leave a room when there's nothing physical stopping them.

Stockholder **And there is a shower curtain and a piece of flowered clothing attached to the bird cage; there is also paint, silicone caulking, and yarn.**

Tillman Oranges …

Stockholder **… apples, plums, lemons and peaches.**

Tillman Because there are so many, it's like a growth.

Stockholder **This yarn piece is very much like a growth. It's quite beautiful and sort of hideous. An accumulation of things in a cancerous sort of a way.**

Tillman Cancer is what I thought of immediately, a wild cell division.

Stockholder **There's bias tape hanging down the back with a few threads and a few wires. For me that implies frivolity – it might be ribbon – and also leftovers, bits and pieces from something just finished or not quite done.**

Tillman It's funny to use concrete as a 'concrete' object in the midst of this fantasy, this phantasm.

Stockholder **Exactly, a phantasm, all these things coming together produce something quite fantastic; and then the concrete is a real heavy, simple, known quantity that weighs it down to the floor.**

Tillman Some of your pieces are human scale, and some are much bigger.

Stockholder **I love shifts in scale – shifts in point of view.**

Location 3: The Nether Mead in Prospect Park

Stockholder and Tillman are sitting on portable chairs which they carried from Stockholder's apartment.

Tillman We're looking at scenery – trees and grass, a park, a baseball diamond.

Stockholder **I thought this would be a good place to come because it**

provides a vantage point that's unusual in a city. The vistas are so long here. How my relation to things changes here has something to do with my work. This place is more reminiscent of the landscape in Vancouver than any place else in NYC.

Tillman How does this intersect with your interest in architecture, and how your work is architectonic? How does your interest in landscape turn into a built environment?

Stockholder **Architecture is a landscape we make. I often experience architecture and landscape as if they weren't made, as if they just happen to be there framing my life process. The landscape we're looking at is made. But in general, there is more about landscape that exists before us and without us than in architecture.**

Tillman Most landscapes we see are built.

Stockholder **There is a difference between the Vancouver of my childhood and this part of the world. In Vancouver there were, and there still are, more places where you can view a landscape which hasn't been manipulated by us. It has been less touched.**

Tillman An idea of wilderness, something untouched by human beings. But you want to touch things, you want to move the environment around.

Stockholder **The landscape in Vancouver provides a particular spatial experience which is wedded to my work. The way the water meets an island, or another piece of land, and forms a horizon line below the one made by the tops of the mountings meeting the sky – that particular horizon line has something to do with the kind of space that I am interested in. I'm also very interested in the difference between what we make and what is.**

Vancouver landscape

Tillman When you see things in terms of art, you're thinking how nature is like art. Of course, things confirm our beliefs, most of the time, since we look for that.

Stockholder **Are you less comfortable at this angle, looking at nature instead of at art?**

Tillman I have some agoraphobia, some fear of open spaces, empty, six-lane highways – not crowded cities. There's something strange about the distance between us, this long space between us, and the trees. In that space there could be an incredible amount of horrible things happening.

Stockholder **The work you called 'raising the stakes' –** *Edge of Hot House Glass* **– had a second title,** *The Body Repeats the Landscape,* **a quotation from Jane Smiley. In that work I became aware of something that carries through my work. I saw it as a very large body. There was velvet, there were beads; but things didn't cohere. They did at moments but always threatening to come apart at the seams. It was as if you, the viewer, were very small, looking at a giant body. The body as a landscape. I think this has**

something to do with having been a child, very small and growing.

Tillman Some more than others – physically, mentally, emotionally.

Stockholder **That physical experience, that shift in point of view, happens to everyone. In a way, the landscape changes on us. Perhaps our first experience of landscape is of the big bodies holding us.**

Tillman I don't know that, as a viewer, I would have thought of the landscape as a body, although I might have thought of a body of land, an island jutting into the space. I don't know if I can reverse my position. I would become the thing that a body would normally be looking at. A sort of reversal of positions.

Stockholder **It's not that the work is a body. It's about the experience of the body as landscape. I'm interested in conveying an experience having to do with the difficulty of having things cohere – the feeling that sometimes things are too close so you can't see the edges; or things are so large that you can't see the edges – a lack of definition, or a possibility for expansion lurking in the background of everything we make.**

Tillman Maybe that's from having grown up in surroundings that were majestic, the physical situation in which you lived in Vancouver. I was in Vancouver once and remember looking up suddenly, and seeing towering mountains around the city. It did draw off the city itself; it surrounded it, giving it this odd feeling of temporariness. I felt very much aware that the city was something that had been built in the middle of something that had been around much longer.

Stockholder **Vancouver is located – there is a sense of place that's missing here in New York.**

Tillman Though Manhattan is bordered on both sides by rivers. When I was a kid, it was very hard for me to understand how all the big buildings could be on a little island. Obviously rivers are flat. They're not towering over Manhattan; Manhattan towers over the rivers.

Stockholder **New York hasn't been constructed to call attention to the rivers and not much is made of the water front. I miss that. Growing up in Vancouver with American parents involved feeling confused about my place culturally and nationally. Perhaps the particularity of the landscape became more important for that reason.**

Tillman You're very much in a place when looking at your work, it's about positioning you there. I guess that's the physical sensation of it – it's not as if you are just looking at an object which lets you think only in the abstract. You have to do both, you look and think abstractly and are aware that you are standing somewhere.

Stockholder **It's nice to hear you say that. That's why I wanted to come here.**

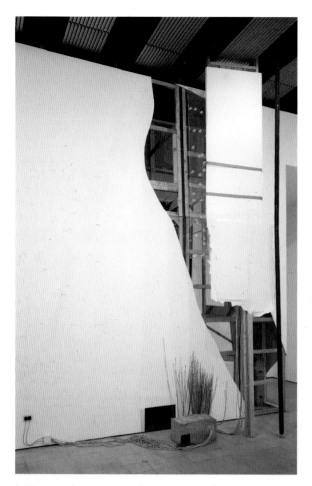

Fat Form and Hairy:
Sardine Can Peeling
1994
Refrigerators, paint, green tarp,
aircraft cables, sweaters, garbage
cans, pillows, concrete, wool,
styrofoam, building materials,
green lights, electric cable,
Plexiglas
Between 2 gallery spaces, ceiling
h. 240 cm and 180 cm
Installation, Hayward Gallery,
London

I

Although I'd like to think that art speaks for itself
and that an acquaintance with the artist should
not affect our view of her work, my experience tells
me that's not always so. In Jessica Stockholder's
case, what seemed most salient in her work before
I met her was its outrageousness, its sense of
fantasy and prolific inventiveness. What matters
to me more now – and I'm sure I'm influenced in
this by my sense of the artist as a person, of her
careful presentation of self to world – is just the
opposite: its orderliness, its discipline, its sense of
reality. Before I saw that this work was marvellously
inventive; now I know that it is also acutely obser-
vant; it is a deep attentiveness that allows for
the effortlessness, the verisimilitude with which
Stockholder disposes all this *stuff*, a deployment
of materials that neither insists on nor denies
the intentionality involved. Not that freedom
and discipline, fantasy and reality are as mutually
contradictory as we sometimes imagine: listen to
the ecstatic dialectic between improvisation and
structure in a great jazz performance. I don't now
think my early sense of the effect of Stockholder's
work was wrong; but it was one-sided. The artist's
personal reticence and matter-of-factness harbours
the secret core of fantastication and joyous sub-
versiveness which we know from her art – but the
art, in manifesting the latter, delivers in a concealed
way a core of quiet fidelity to the real.

 And yet as soon as I use that word – 'real' – I
feel moved to qualify it, compromise it even, in any
case to place it within quotation marks. The 'real'
that Stockholder's work addresses is in the first
instance the place and time in which it finds itself,

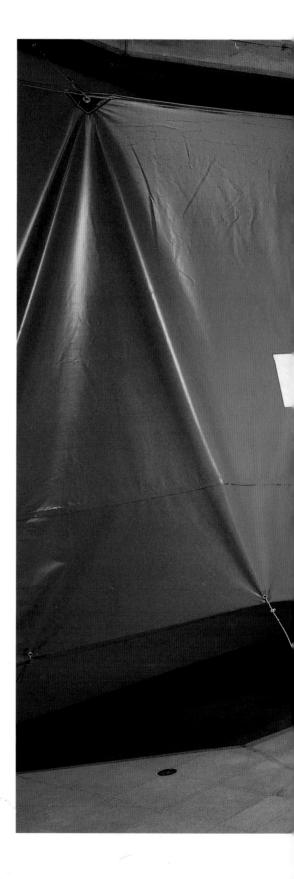

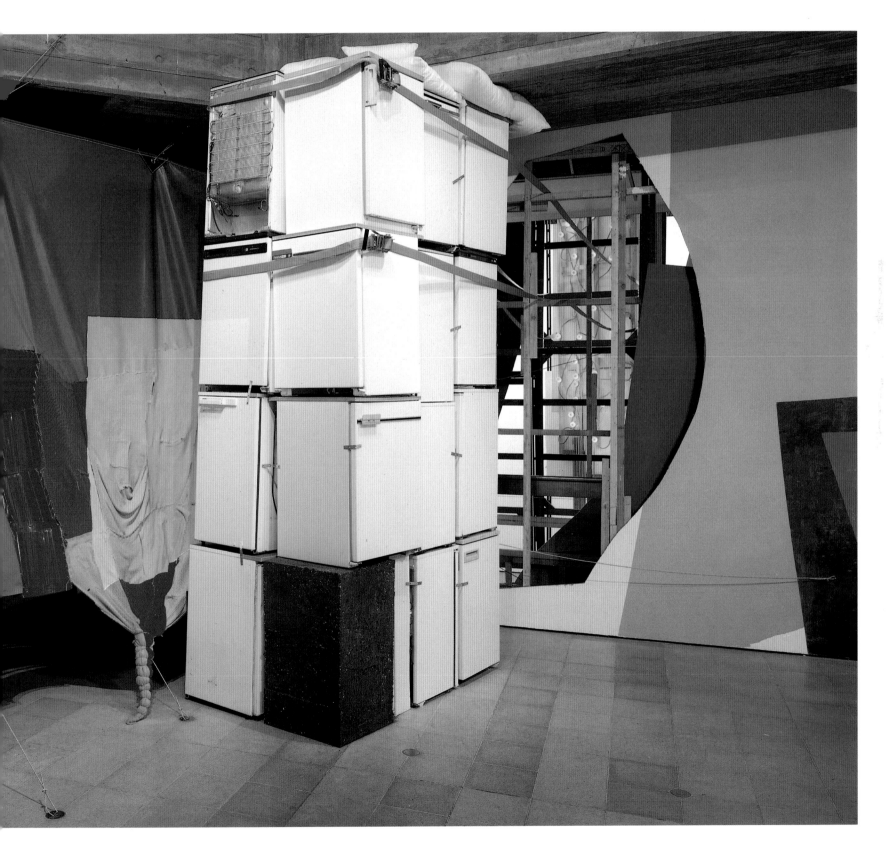

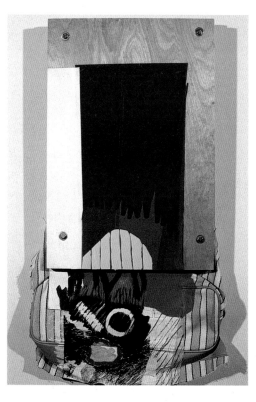

above, **Chicken on Glass #2**
1991
Glass, paper, safe-t contact
cement, acrylic paint
52 × 29 × 1 cm

below, 1991
Plywood, cloth, paper, paint,
litho print , hardware
77 × 41 cm

most immediately, the architectural situation of its installation. In this essay I will concentrate on Stockholder's large-scale installations, but they are not in themselves completely definitive of her art, which could be said to consist of three groups or series, whose identities rest most obviously on issues of scale but more specifically on the kind of space addressed. The installations are environmental in scale and are created in and for specific gallery or museum situations – quasi-public spaces. The more or less self-contained assemblages reflect the scale of the human individual rather than an abstract 'public' but also that of the artist's studio; these seem to function not only as relatively portable and saleable commodities but as 'essays' through which the artist can work out in a more private way with the forms and materials that concern her. Finally there are Stockholder's collages, which unfortunately I will not have occasion to discuss at all. These are even more fully self-contained than the assemblages not only because they are considerably smaller but above all because they are flat and because their supports – often rectangular or nearly rectangular sheets of glass – give them a feeling of 'framedness' that her other work, with its dishevelments and seepages, resists. These collages correspond neither to the public space of the museum nor the working space of the studio, but to the intimate scale of the average urban apartment. In any case, the address of Stockholder's work to its architectural setting is relevant even with her smaller assemblages, whose specific character always derives in large part from their specific relations to the floor and particularly to the wall, despite their having been designed for

no one wall or floor in particular. It's no accident that Stockholder gave to a number of these works the name *Kissing the Wall.* But the real is more than just a given. As that title implies, the real allows itself to be seduced by the work of art. It changes, reveals its unreality with respect to the supreme fictions of art.

II

Some thirty years ago the American critic Harold Rosenberg could still credibly insist that, in modern art, 'movements' were the source of 'continuity of style, … interchanges of ideas and perceptions among artists rather than local "schools" such as are familiar to art historians: instead of "the Venetians" or "the Flemish School", our era presents practitioners of aesthetic "isms"'.[1] Yet the intervening decades have radically changed this picture. After the emergence of Colour Field painting, Minimalism, Fluxus and Pop Art early in the 60s and then of Conceptual Art toward the end of the decade, the idea of the art movement seems to have lost its elan and to have become more of a marketing ploy than an authentic artistic phenomenon. At the same time, the idea of regionalism seems to have gained a new force – in tension with a contrasting, partly market-based internationalism. The great modernist movements tended to present themselves as universally valid, as culminating points in a total history of art. But now, when what have been called 'grand narratives' (Jean-François Lyotard) or 'final vocabularies' (Richard Rorty) have become increasingly suspect, cultural relativism and the incommensurability of local histories thereby became more attractive ideas.

So perhaps it's not surprising that when Jessica Stockholder and I began the discussions that would form part of my raw material for this essay, one of the first things she said was, 'We should talk about Vancouver'. And yet this is not because her work is part of the 'micro-narrative' of art in Vancouver. Far from it, although the curator who casually wrote of her work as being 'so typically American' might be just as far off.[2] I think rather of a remark made by fellow-Vancouverite Jeff Wall: 'I'm a Canadian and so I'm into the magic of sobriety'.[3] One of the most salient things about Stockholder and her work is that they escape any merely local definition. Although she grew up in Vancouver, she was born in Seattle, her mother is an American citizen (as was her most important teacher in Vancouver) and she maintains dual Canadian and American citizenship. After leaving school, she lived briefly in Toronto, but quickly made her way to New York and although that has remained her base, her career as an artist has been a determinedly international one.

Still, even when escaping local definitions seems important, it is worth knowing what the escaped-from definitions actually might be. The Vancouver-based curator Jo-Anne Birnie Danzker has noted three basic responses to their local situation among artists there in the 1970s, that is, when Stockholder was living and studying there:

– to apply European and American painting

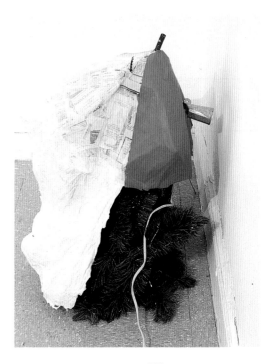

1988
Kissing the Wall #3
Fake Christmas tree, papier maché, paint, a light
Approx. h. 30 cm

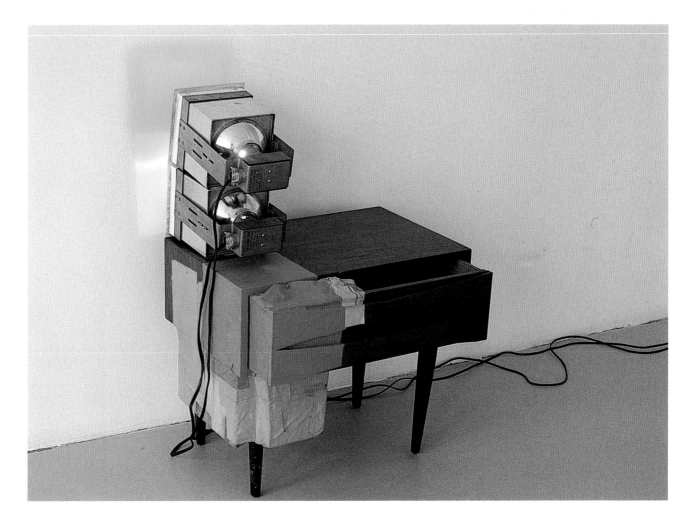

1988
Kissing the Wall #4 Red and Green
Small piece of furniture, one red and one green light, paint, newspaper, styrofoam
Approx. h. 24 cm

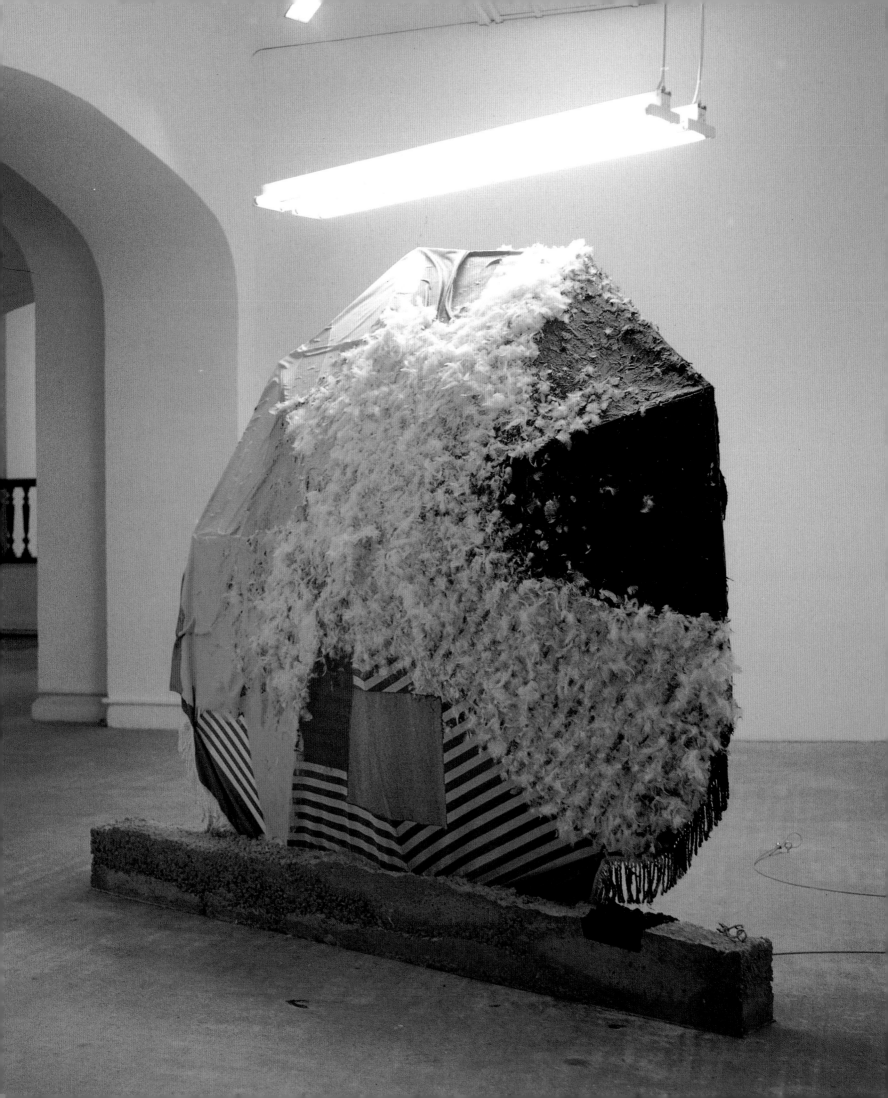

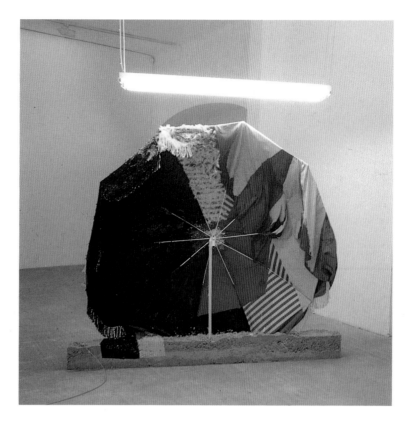

*traditions to local subject matter (the British
landscape tradition, surrealism, abstract
expressionism, 'naive art', realism, New image
painting);*

 *– to reject traditional artistic media and
utilize 'new' media such as photography, film,
video, radio;*

 *– to embrace a-historicism, the mass media,
stereotypes, instant identities, career and lifestyles
associated with 'frontier' cultures;*

 *– to apply a strong historical and art-
historical approach (including citation) to
new media with an emphasis on rationalism,
conceptualism, structuralism and ideologically
rigid positions.*[4]

 What is striking – aside from the fact that
such approaches were hardly specific to Vancouver
but rather near-universal *except* where there was
some strongly countervailing local tradition – is
how thoroughly removed Stockholder's work appears
to be from any of these options. Although her work
is art-historically informed, it is neither governed
by any strict intellectual or ideological stance, nor
does it simply re-apply a 'found' style. When asked,
'Do you relate more closely to an American or a
European painting tradition', Stockholder replied,

 *'I relate more to an American tradition,
though probably to both. Matisse, Cézanne and the
Cubists certainly are important to me. I also feel a
strong affinity to Clyfford Still, Frank Stella, the New
York School hard-edge painting and Minimalism, as
well as Richard Serra.'*[5]
That's quite a range of 20th century art, but overall
it implies a distinct bias towards artists whose work
emphasizes physicality, whether of the surface of
a painting or of the artwork as three-dimensional
object – and therefore, perhaps, towards a
'materialist' understanding of artistic modernity.
Cubism especially should be important to
Stockholder in this regard, because the Cubist
papier collé and collage in particular are seen
as initiating the tendency of modern art to admit
bits of unmediated reality into art, to include
real things cut out of their original contexts and
grafted onto the artwork rather than depicting
or transcribing them by conventionally artistic
means. Cézanne was the Cubists' great precursor –
and that of Matisse as well – in using the application
of paint to canvas to elicit what Clement Greenberg
called 'a two-dimensional, literal solidity' more
than 'a representational one'.[6] By the same token,
it is surprising that Stockholder does not mention
any of the artists who, in the late 1950s, around the
time of her birth, began re-exploring and indeed
amplifying art's appropriation of everyday reality;

I am thinking in particular of the American artists Jasper Johns and Robert Rauschenberg, but also of others such as the French *Nouveaux Réalistes* and the Zero group in Germany. Rauschenberg's omission may seem especially curious, not only because critics have often mentioned his work as a precedent for that of Stockholder, but also in light of Scott Watson's suggestion that for the Vancouver art scene, 'the capital of America was *not* New York, but Black Mountain and its own revisionist "post-Modernism" springs from this connection with Robert Creeley, John Cage and Charles Olson' – and therefore, one would think to add, Rauschenberg.[7] Yet there is a clue in this omission; for the art of the 60s which Stockholder cites – Stella, hard-edge painting, Minimalism – claims a relation to the literal, the quotidian, the non-aesthetic as well, but in a less overt, less representational, one might even say more formal and less sociological way. In any case, the story to which Stockholder's work relates is mainly a New York story, but as recounted from the inquisitive yet unromanticizing viewpoint of an outsider.

III

The relation of Stockholder's work to Minimalism in particular deserves to be more fully investigated – and when I speak of Minimalism, I mean not only a set of works by a particular group of artists, but also the ideas that circulated around those works and the polemical thrust of those ideas in relation to others current at the time of the movement's inception. Donald Judd was not only one of the leading artists of Minimalism, but, as a frequent contributor to *Arts Magazine, Artforum, Studio*

International and other publications, its principal critical spokesman as well. 'Half or more of the best new work', Judd declared in his 1965 manifesto 'Specific Objects', 'has been neither painting nor sculpture'.[8] In general, Stockholder's work appears to fit comfortably into certain aspects of the paradigm established by Judd thirty years ago: although its historical roots are more in painting than in sculpture, just as with Judd's work, it is three-dimensional; its materials are employed in a direct and sometimes aggressive fashion, without illusionism and so on. Replying to Judd, Michael Fried declared that 'concepts of quality and value … are meaningful … only within the individual arts' so that this art that is neither painting nor sculpture is merely 'theatre' and that 'theatre is now the negation of art'.[9] Putting aside for now the question of why one would assert that theatre negates art – the statement is odd on the face of it, since theatre is ordinarily thought of as an art form in its own right – we can see that Stockholder's art is thoroughly theatrical, in the sense that, as Fried claimed of Minimalist art, it does not claim to enclose itself in its own autonomous presence, but rather solicits the participation of the viewer or 'beholder' as a real body in real time.[10] No wonder her installations have been compared, for their makeshift, ephemeral ambience, to the funky and chaotic sets for the 'Happenings' of artists like Jim Dine, Allan Kaprow, or Carolee Schneeman in the early 60s .[11]

But there is a contradiction in Judd's text: on the one hand it asserts that 'because the nature of three dimensions isn't set, given beforehand, something credible can be made, almost anything'

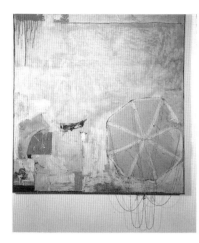

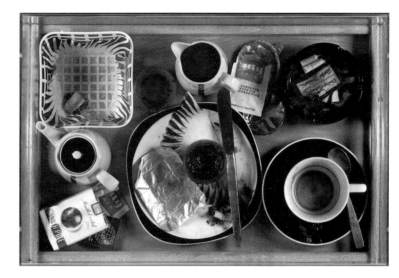

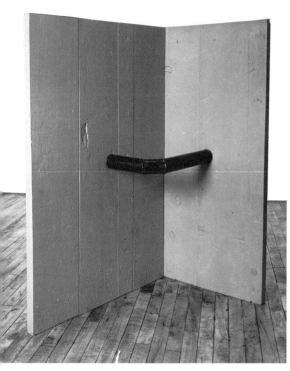

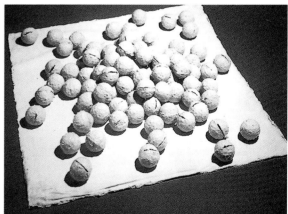

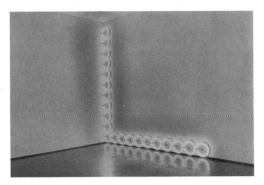

above, **Dan Flavin**
Untitled
1974
Cool white fluorescent light
2 wall pieces,
145 × 145cm, 145 × 312 cm

1990
Wool blanket, table, barbecue,
oil and acrylic paint, fluorescent
light, night light, 2 speaker boxes,
wool, styrofoam, newspaper,
paper, glue
70 × 72 × 74 cm

(an implication of almost limitless possibility emphasized by Judd's reference to a broad range of work from the Pop sculpture of Claes Oldenburg to the shaped canvases of Frank Stella, from the gruesome environments of Edward Kienholz to the light icons of Dan Flavin). On the other hand, its narrowing demand, contradicted by so much of the art Judd cited, is that the work be 'not scattered but asserted by one form', which of course was more specifically characteristic of his own work and that of the other artists who came to be called Minimalists. It would not be long, of course, before the emergence of various forms of 'post-Minimalism' – Process Art, Conceptual Art, 'Eccentric Abstraction' and Land Art – emerged from the rich context of Neo-Dada, Assemblage, Happenings, Fluxus, Pop Art and others. Among these, the Minimalist stance, with its theoretical and formal perspicuity, had arisen to take the lead in the reaction against formalist/modernist doctrine as embodied by Clement Greenberg, Michael Fried and the colour-field painting and constructed sculpture they championed.

The post-Minimalist art that began to emerge later in the 60s was often notably 'scattered' and not 'asserted by a single form'. In contradiction to the prescriptions of Judd and, to a great extent, of Judd's ideological opponents Fried and Greenberg, this scatteredness nonetheless forwarded the injunction against composition, against the adjustment and comparison of part against part, which was the major desideratum of Minimalism. But much of the horizontal, floor-oriented sculpture of the 70s – and again of recent years – was covertly pictorial, with the floor functioning as a surrogate for the vertical picture-plane. Stockholder's work, though painterly, is not pictorial in that sense. Her work may have a greater affinity for another aspect of post-Minimal art – for its contentious stance towards architecture, towards its own built environment, a stance embodied most vividly and iconically in Gordon Matta-Clark's dissected

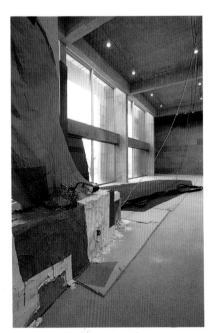

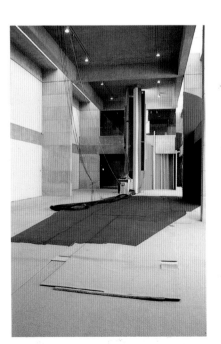

left and opposite,
**Untitled Seepage; Sandwashed
Sundried & Shrinkwrapped**
1991
Lumber, sheetrock, plywood,
carpet, electrical cords, escalator
sleeve, bicycle, paint, mirrored
tiles, plaster on metal lath, wine
glasses in plaster, newspaper
maché hung on curtain rods,
fluorescent lights, theatre light
Space , approx. 960 × 384 cm,
with a smaller space approx.
576 × 144 cm jutting off from the
larger forming an L shape. Ceiling,
h. 360 cm
Installation, Ezra and Cecile Zilkha
Gallery, Wesleyan University,
Middletown CT

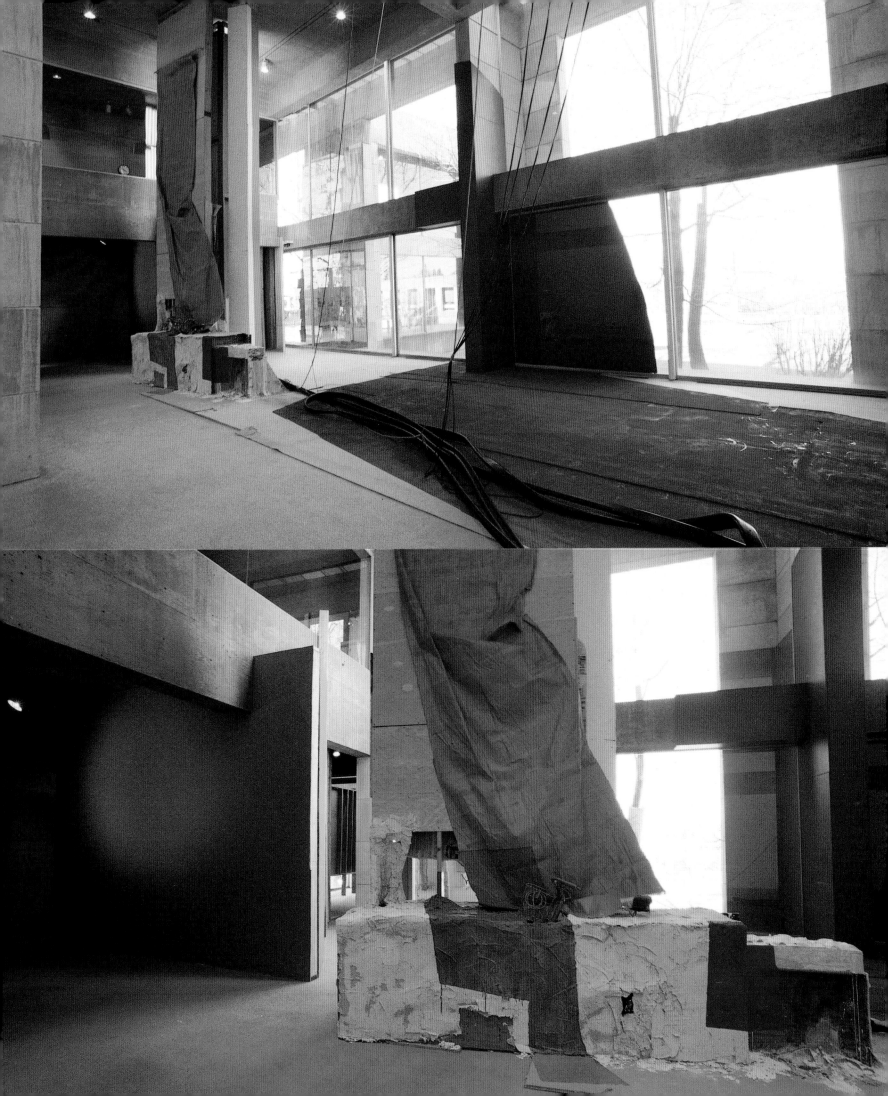

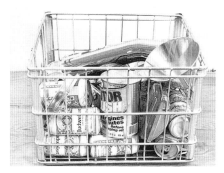

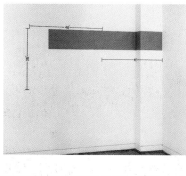

houses; more understatedly in work like Mel Bochner's measurement pieces (1969-71), which, in an otherwise arbitrary gesture suggestive of dismantling or rebuilding, display the rooms they inhabit under the condition of being temporary and contingent.

In fact, the implications of Cubist collage led in two possible directions: towards a rhetoric of anti-illusionism, anti-pictorialism and therefore towards abstraction, literalism and thus Judd's Minimalism; but also towards the breaking of the 'frame' and towards a stylistic and material heterogeneity and impurity that could never rule out representation, illusion, or any sort of pictorial device whatsoever – above all to that 'art of radical juxtaposition', the Happening, to which the affinity of Stockholder's work has been acknowledged. Stockholder has resolutely chosen both directions at once. What she has retained from Happenings is the primacy of materials employed, as Susan Sontag put it, 'for their sensuous properties rather than their conventional uses'; what is eliminated is the idea of the performer and therefore, more importantly, the idea of an audience as a group of spectators bound together through their shared experience of the work in a limited span of time. And since the 'classic' stance of the Happening towards the audience was one of aggression ('In the Happening this scapegoat is the audience', writes Sontag), Stockholder's abdication of audience is equally an abdication of aggression.[12] Like the otherwise utterly different art of Cy Twombly, as analyzed by Roland Barthes, Stockholder's is an exploration of the notion of the 'Event' but since it is 'without goal, without model, without instance … it follows that any aggression is somehow futile'.[13]

IV

Stockholder's work is always open, accessible and obvious – but only bit by bit, never all at once. As wholes, or ensembles, her installations are complex, contrary and mysterious. They depend on memory, on reconstruction. This is so in the obvious sense that Stockholder's large-scale installations are impossible to perceive in a single synoptic glance or even, usually, to contain, in retrospect, a single synthetic image, however complex. They absolutely demand the temporal dimension of narration or discourse in order to be understood as wholes – also because they are conceived for specific exhibition spaces, constructed on site and disassembled after a few weeks or months, never to be seen again except in photographs.

Stockholder's work was initially received, to a great extent, as part of a new trend in the New York art world – as part of a reaction against the slick 'commodities' that had been favoured by such art stars of the mid 80s as Jeff Koons and Haim Steinbach. Such 'neo-geo' art was, in essence, a canny synthesis of the formal absoluteness of minimalist sculpture with a sensibility reminiscent of Pop Art. For all the 'criticality' certain proponents wished to claim for it, its success testified to the obviousness with which it rested on the inherited 'good will' of the canonical art movements of the 60s. Its glamour, which was often undeniable, was that of mannerist self-enclosure.

Towards the end of the 80s, as the limitations of this art became more apparent, critics, collectors and dealers began to cast about for a plausibly

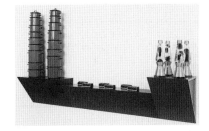

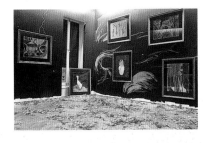

contemporary art that appeared to do more than celebrate its own saleability. One solution was to look away from art whose subject was the perfectly self-contained manufactured object, for one that would engage the living, suffering body as a fragile, imperfect, fragmented construct, utterly devoid of imaginary unity – this is how the work of Robert Gober and Kiki Smith was received, for instance. A second solution was to look for a formal reversal rather than a change of subject; to look for an art of dispersions and blurred boundaries, an art open to contingency and awkwardness, one difficult to commodify. It was this desire that, towards the end of the 80s, created an opening for Jessica Stockholder. Along with the work of Cady Noland (who also showed at American Fine Art, Co., in New York) and subsequently Karen Kilimnik, Thom Merrick and others, Stockholder's work was seen to herald a renewed possibility for rawness, improvisation and the unfinished. 'Scatter art', a term that had been coined to describe some of the 'anti-form' art of the 1970s, was returned to circulation.

The conditions of art's reception never fully correspond to those of its production, but in this case the gap between the work's motives and the immediate need it may have appeared to fill is especially glaring. No more than in the cases of the other artists I have mentioned was Stockholder's work developed as a reaction against the commodity art of the 80s, but in addition hers has been resolutely ambivalent about the constitutive role of 'subject matter' in a way that some critics have found disquieting. Perhaps this discrepancy accounts for the recurrent critical nervousness about Stockholder's 'formalism', a term that in the criticism of recent years has taken on connotations nearly as reproachful as in the Soviet Union forty years ago. More daring than most was the critic who recognized the formalist component of Stockholder's work as something worth polemically exaggerating, seeing precisely that as responsible for her 'decisive revisioning of a range of precedents'.[14]

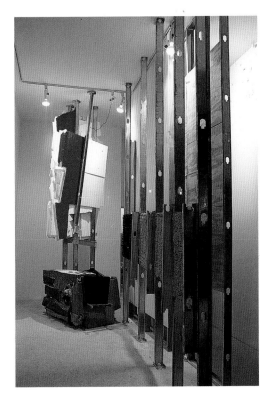

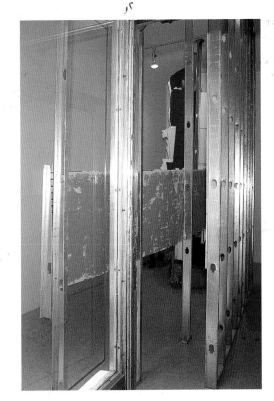

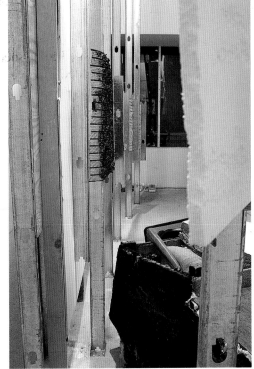

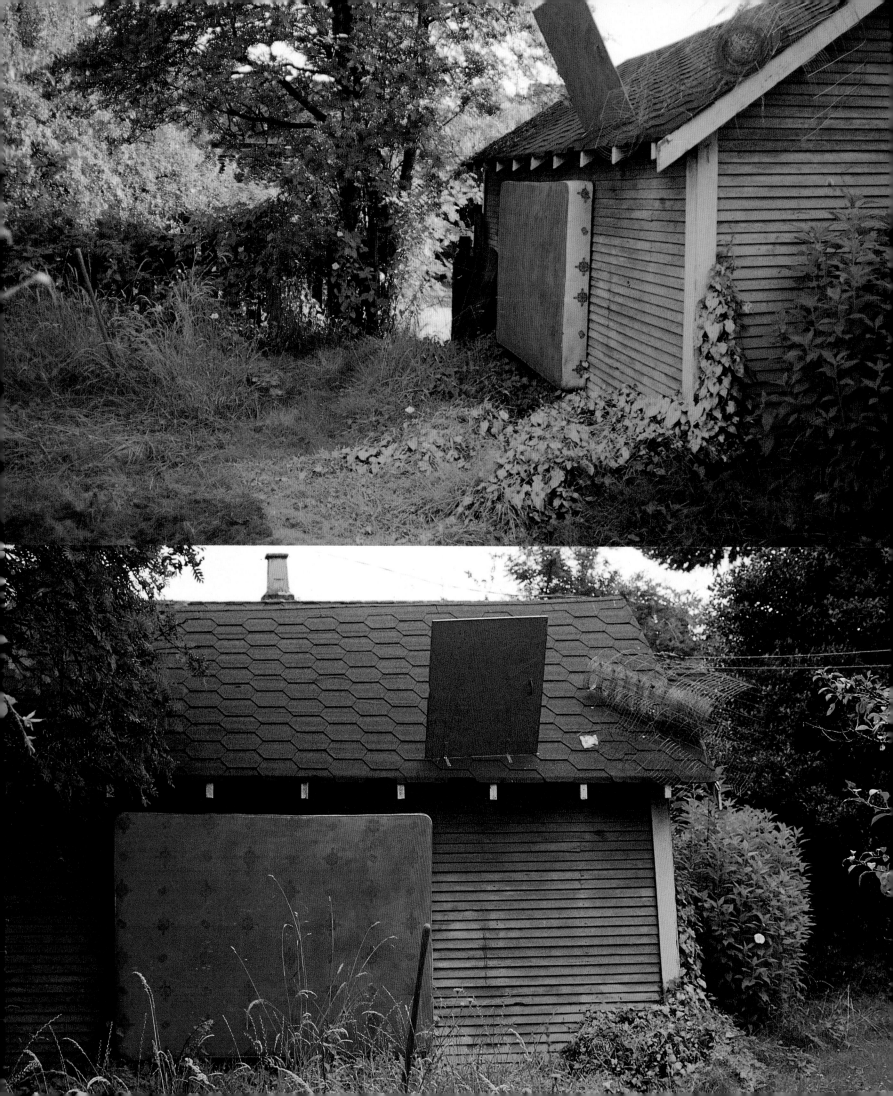

In fact, the work Stockholder has produced in New York since 1985 shows unusual continuity with what she was doing as a graduate student at Yale (1983-85) and even earlier in Vancouver; for instance the installation Stockholder made in her father's backyard in 1983, which primarily consisted of a double mattress painted red and affixed to the side of his garage and a sort of blue 'shadow' painted on the grass nearby. Above these, from the sloped roof of the garage, a cupboard door leans over at a right angle to the roof, while rolled chicken wire unravels at the roof's edge. The artist writes of this work that, *'It plays against the yard as other works play against architectural space. The blue grass calls to the red berries of the tree; the red mattress calls to the green grass. The play in the yard is alive and open in contrast to the dark closed interior of the garage'.*[15]

Although this work is considerably simpler than installations Stockholder would be doing within a few years and while she has not since worked with open, outdoor spaces, the basic assumptions on which her art is still based today are already in place. It is an art that exists in relation to architecture; it combines quotidian domestic objects with conventionally artistic materials such as paint; it proceeds by means of a dialectical interplay of qualities that may seem to exist in simple contradiction but often end up turning each other inside out, exchanging attributes.

Furthermore, Stockholder's is an art that synthesizes or at least conjoins what might be called allegorical and abstractionist ('formalist') modes. The red-painted mattress demands to be seen as a piece of household paraphernalia with all the associations attendant on it as a familiar everyday object. The reversal of expectations brought about by its being situated outdoors rather than indoors, vertically rather than horizontally and painted the colour of blood and rubies may cause us to wonder about implications of disrupted domesticity (remember that this yard belongs to the artist's father) or 'murdered sleep' (Stockholder's parents are both literary scholars, her mother a specialist in Shakespeare, so one imagines that allusions to the Bard might come as second nature to her, part of the atmosphere of her upbringing). All this takes one far from any immediate sensate experience one may have of the work; this is what I mean by allegorical. On the other hand the mattress, in part thanks to the very same displacement from its usual context that gave rise to allegorical considerations, also becomes more visible than it might ordinarily be as an object of a certain mass and volume, that is, as a sculptural entity. Having been painted it may be seen as taking part in an arrangement of colours and textures of a sort calculated to elicit sensations sufficiently heightened as to justify the figurative language which describes the red of the mattress 'calling' to the green of the grass. The work's abstractionism consists in its mobilization of formal or phenomenological considerations which necessarily call for the bracketing out of those referential and contextual aspects which are essential to the comprehension of its allegorical dimension. What is already impressive in this early work is not simply that it calls on both of these putatively incompatible modes of comprehension, but that it calls attention to their mutual implication

Flower Dusted Prosies
1992
Cardboard boxes, 5 × 10 cm,
10 × 10 cm, hardware, sheetrock,
paint, cloth, cables, fluorescent
fixtures and tubes, concrete,
mirrored tiles, vinyl composition
floor tiles, paper, wool, cushions,
newspaper maché, roofing tar
Room, 774 × 252 cm; ceiling,
h. 156 cm
Installation, American Fine Arts,
Co., New York

in the same originating displacement. It is not exactly true that 'Stockholder is simply more interested in the fundamental way meanings are generated – in how differences are perceived and read – than in revealing a specific social subtext'.[16] Rather, her work does not support our ability to make this distinction, to operate in one signifying mode (let's call it formal) without taking the other (let's call it semantic) into account. The risk this early work takes – one it does not necessarily overcome – is in its still fairly schematic develop-ment of these two modes and of their intertwining.

That risk is not one easily ascribed to most of Stockholder's work of the past half-dozen years. Living in New York, I have been able to see just four of Stockholder's major installations: *Making a Clean Edge* (The Institute for Contemporary Art/ P.S. 1 Museum, Long Island City, 1989), *Where It Happened* (American Fine Arts, Co., 1990), *Recording Forever Pickled Too* (Whitney Museum of American Art, 1991 – a rare example of a second chance in Stockholder's oeuvre, since this was a 're-make' of *Recording Forever Pickled*, made for Le Consortium, Dijon, 1990) and *Flower Dusted Prosies* (American Fine Arts, Co., 1992). To give some sense of what is involved in Stockholder's installations, let me describe the experience of the one I have seen most recently, relying not only on my memory but on photographs of the work. The massive con-structed portions of *Flower Dusted Prosies* (the work also involved painting, as well as other materials, on some of the gallery walls), though at points quite near the wall, never actually touched it, leaving a sometimes cramped path around the heterogeneous conglomeration of stuff that occupied the space. It

was a work designedly just a bit 'too large' for the space it occupied; it had the effect of crowding the viewer to the margin of the space.

In fact, my use of the word 'viewer' is only accurate to the extent that it represents this figure pressed to the work's margin but never expelled. I retain this conventional usage for want of a better alternative, for it is not at all clear that the main task of the (shall we say) user of this work involves vision independently of other modes of cognition, though neither does it reject this ability. Certainly there is much to be seen here – perhaps too much. Mere viewership seems inadequate to the challenge the work presents; or perhaps it might be described as the virtual reward promised to anyone capable of negotiating the piece on levels both more physical and more intellectual. I remember, at the opening, being inexorably drawn around and around the space by my desire to 'know' the work, to encompass it and feeling somehow pleasantly stymied in this desire. I told the artist, then, that the piece gave me the feeling that I was always at the back of it, walking around to find a front that I eventually concluded did not exist. I am happy that she recog-nized this description as accurate to the extent that she subsequently described it as a piece that 'feels as if it is all back'.[17]

Entering the room, one was faced with the edge of a wall and therefore a choice of paths: left (north) or right (south). Left was more inviting, or rather right was less inviting, for two reasons: the left side of the wall was finished and painted red while the side to the right comprised exposed wood beams, so that the left was implicitly promised to be the 'face' of the piece, the right its back; and

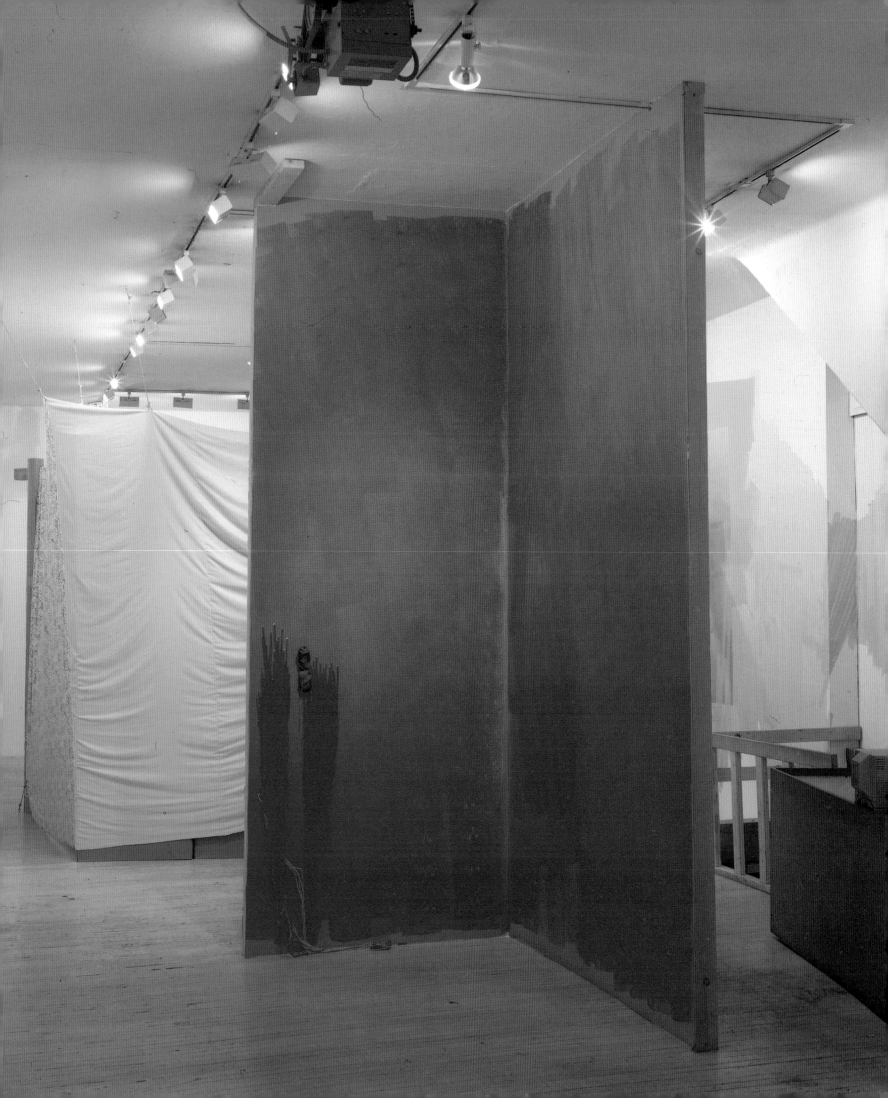

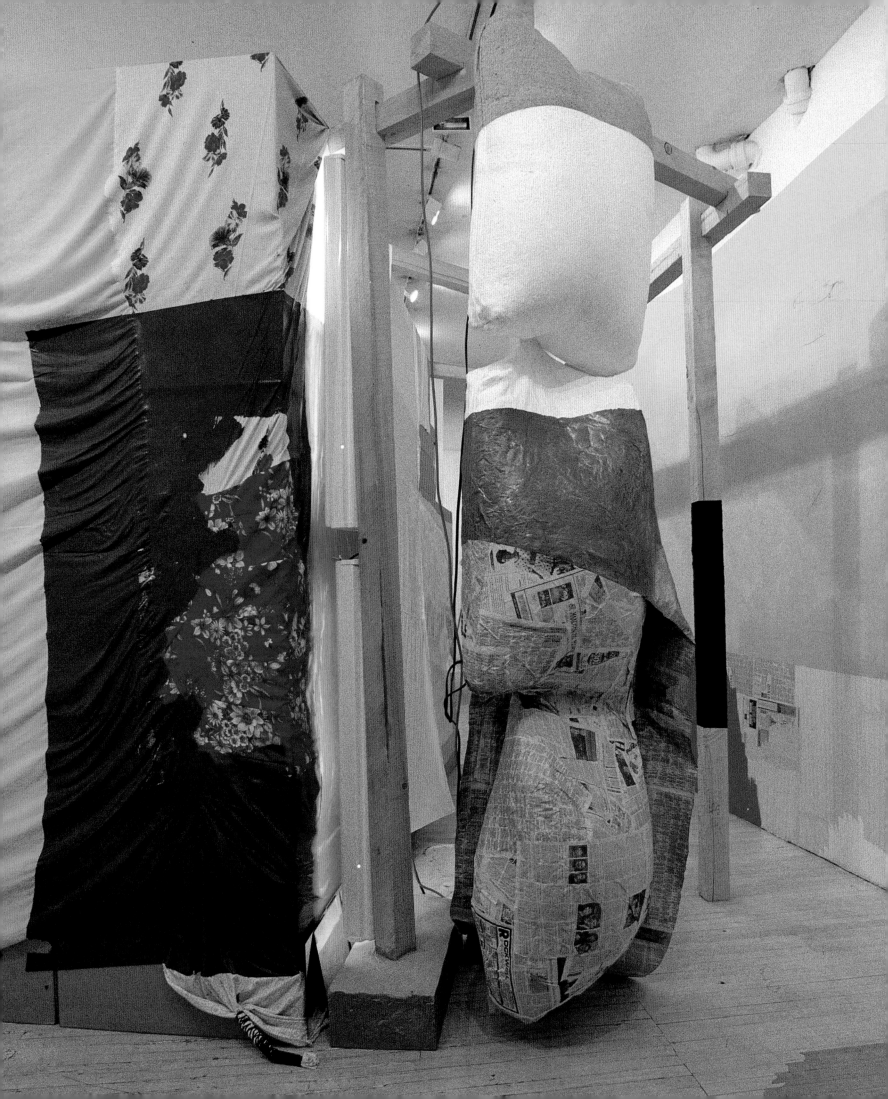

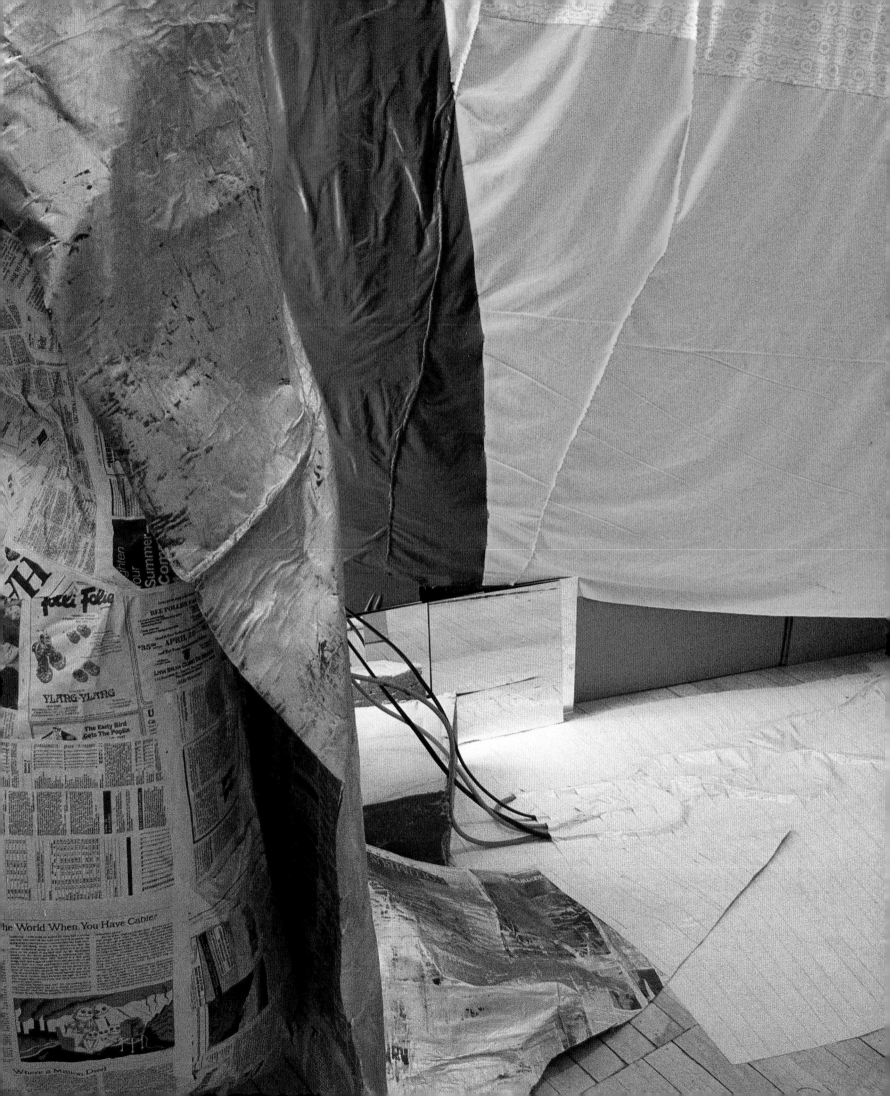

then the right path offered a particularly narrow squeeze past the gallery receptionist's desk, whereas the path to the left was relatively spacious. So one took the left path and turned to face a bare red wall, flatly painted with little variation or evidence of the painter's hand except at its very top and bottom, near the floor and ceiling. Another such red wall jutted out at a right angle pointing towards the gallery's north wall.

Here, at last, one began to find something like an event: two bunches of red yarn hanging down in tangled skeins from small holes in the wall down to the floor and between them two rolls of green yarn. The soft red loose yarn and the soft green bundled yarn on the hard red wall suggested comparisons of similarity and difference; one might have thought as well about the difference between the wall as a facade of colour on the one hand and the yarn as coloured through and through on the other. The holes from which the red yarn poured, in any case, aroused curiosity about the other side and so one stepped around the wall to see that, like the first one, it was unfinished on the other side, nothing but wood beams supporting sheetrock. Expectation and disappointment? Not exactly, for what had one expected? Anything might have been possible, but this eventuality was the one suggested by what one already knew of the first wall. Here one found oneself in an open space between structures.

The first conspicuous thing about the second construction of *Flower Dusted Prosies* was fabric: several sheets of differently coloured or patterned material – most prominently a solid turquoise one – hanging from the ceiling. The fabric did not hang down quite as far as the floor and so through the gap one could glimpse brown cardboard – large boxes, apparently. Continuing around to the left, passing more fabric (a flowered print now), one noticed that some of this material was actually draped over a simple structure made of more wooden beams, a structure built at an angle to the stacks of cardboard boxes. But were they empty, or filled (and with what?), stashed behind or beneath all that cloth? Storage! That which is kept in reserve ... At last one began to have a thematic clue to the work.

But there was more to see. Behind the piled boxes, on a wall separating the gallery's office area from the exhibition, there was a geometrical pattern made of vinyl wall tiles. The work led into the office area, or rather called attention to the fact that this other space was there without quite leading one into it, because here the yellow and red paint applied directly to much of the gallery's south wall trailed off. (So did the newspaper pages also covering some of the lower part of this wall beneath the paint but were revealed here as the colour diminished). But nearing the receptionist's desk, the wall painting came to an end, and at the front corner of the rear structure (the one with the cloth and boxes and wooden beams) there was one more element. This had been noticeable on the walk to the back of the installation, but was in itself unimposing: a sort of column, made of large cushions of the sort that might be part of a couch, covered with newspaper (but bare at the very top) – in turn partly painted white and blue – a distinctly clumsy and awkward thing, almost distasteful or even ugly.

I have omitted many details from my account

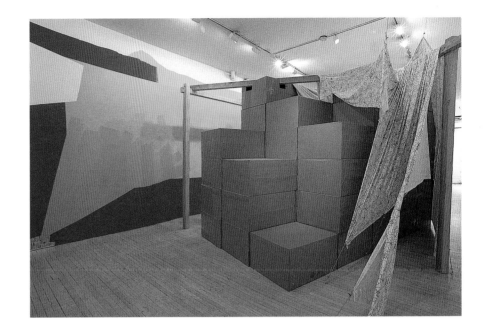

of *Flower Dusted Prosies*, for like all of Stockholder's installations, it synthesizes every degree of scale from the vast to the miniscule and no description could hope to exhaust all of them, except perhaps at the cost of exhausting both critic and reader as well. But there is one element in the work which it would be especially unfortunate to pass over in silence. I mean its title. There is a special Stockholder way of titling which is quite distinctive. Like the works themselves, the titles appear to be assemblages from different sources, distinct registers of linguistic usage: *Mixing Food with the Bed*, *Recording Forever Pickled*, *Skin Toned Garden Mapping*, *Growing Rock Candy Mountain Grasses in Canned Sand* ... such titles suggest absurd experiments, bizarre cuts and elisions among contradictory realms of experience. *Flower Dusted Prosies* is a phrase comparatively compact in its effect, although equally enigmatic. Most striking is the nonce word 'Prosies', presumably a portmanteau of 'prosy' and 'posies'. The latter word already presents a certain ambiguity, since a posy is both a poetic motto or legend (originally the word was written *poesy*) and a bouquet or nosegay – connecting back with the first word of the title. A 'prosy', then, must be something like the opposite of a posy, a bouquet of ordinariness. And 'Flower Dusted'? If one is to make sense of the notion of flower dust, it must refer to pollen, 'the mass of microspores in a seed plant appearing usually as a fine dust', which allows the flower to reproduce but which is feared by the hay-fever sufferer as cause of his or her seasonal misery. *Flower Dusted Prosies* are the prosaic version of things otherwise poetic or flowerlike – of 'flowery' things in both

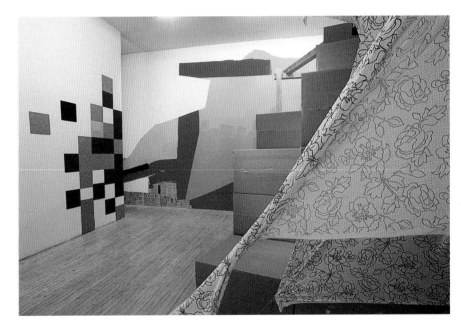

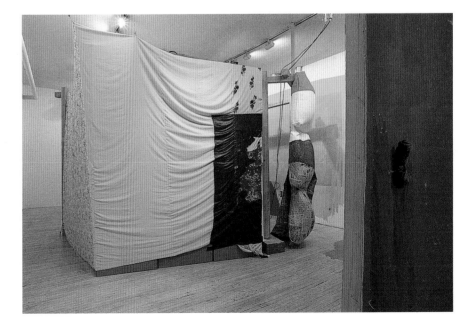

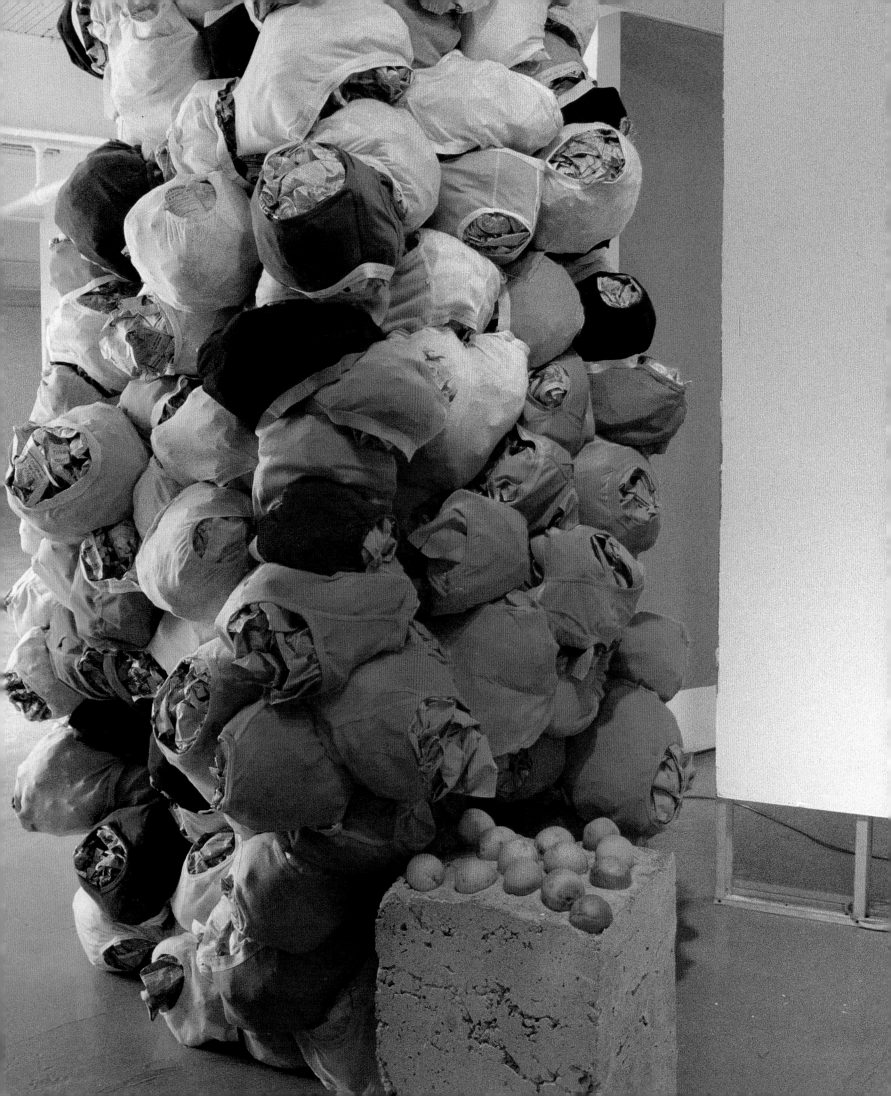

senses of the word, perhaps – but whose very common-ness has become fertile or fecundated. This dense title wants to have things both ways, clearly, just as the work itself does: Stockholder is continually concerned to evoke the kinds of effects that result from the deployment of 'obvious' dualisms in such a way that these contaminate or exchange qualities with one another – the kind of effect that unveils the 'prosy' in 'poesy', for instance, or vice versa.

We have seen something of how these interchanges of qualities operate in particular works like the 1983 backyard installation and *Flower Dusted Prosies*. It would be just as instructive to follow certain recurrent dualisms from work to work to see how they are variously inflected. Since Stockholder's work refers both to painting and to sculpture, it would be interesting, for instance, to see how it figures the dualism *vision/touch*. The distinction is a venerable one and most important to the ideological battles of the art of the 60s; thus Robert Morris called in 1966 for 'clearer distinctions between sculpture's essentially tactile nature and

the optical sensibilities involved in painting'.[18]

Stockholder's work almost always involves the use of paint, but paint is not usually the most painterly element in her work. (This has been starting to change somewhat.) She typically uses paint – whether oil, acrylic, or enamel – as a vernacular material just like any other. It tends to be laid on evenly and opaquely, as a house painter would do it, as a material covering a surface. But this paint hardly ever succeeds in covering the surface. Either it only covers it partially, or else it sits on some material that, because of its texture or for some other reason, just isn't the sort of thing that can be covered over by a coat of paint: the suspended hay bales of *Indoor Lighting for My Father*, the grass of *Installation in My Father's Backyard*. At the same time, it can be precisely this inartistic, uninflected and vernacular employment of paint that modifies an object in such a way as to subtract it from the realm of the ordinary. For instance, *Kissing the Wall #1* (1988) is among Stockholder's simpler works even by the standards of her smaller assemblages; it takes as its sub-

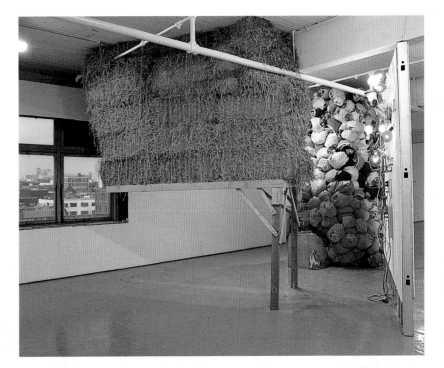

Indoor Lighting for My Father
1988
Newspaper, men's and women's underwear, cement, styrofoam, oranges, hay, lighting
Room, approx. 430 × 276 cm; ceiling h. 134 cm
Installation, Mercer Union, Toronto

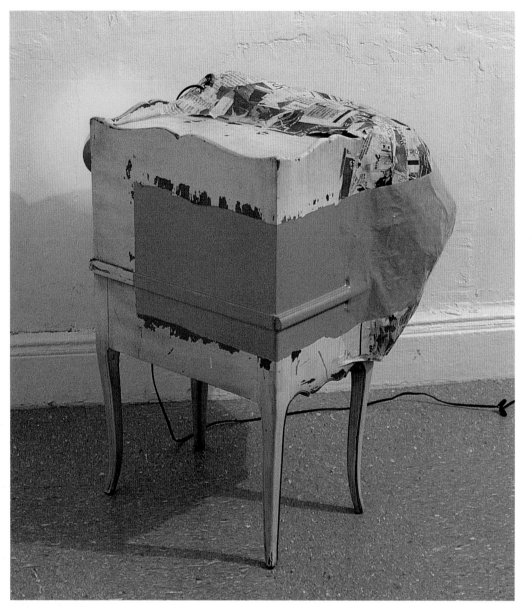

Kissing the Wall #5
1990
Metal strapping, spools of thread
and wool, plastic cord, cloth,
wood, chair, oil and latex and
acrylic paint, fluorescent light,
paper, glue
72 × 86 × 130 cm

structure a single object, a small piece of wooden domestic furniture, a night table perhaps, whose dingy white paint has been worn away in spots. What had been the front of this object – it is not the front of the artwork Stockholder has made of it – has been covered over with a large bulbous wad of newspaper. The battered, cast-off night table, its hard rectilinearity, mitigated by the restrained curves of its legs and decorative mouldings – a wan but effective compromise between functional efficiency and comfortable, anthropomorphic familiarity, mediated by the demands of cheap production – has become the host for a fungal or cancerous growth. It is embodied in the unreadable newspapers representing everything that takes place outside the domestic enclosure for which the night table is a metonymy. They stand not only for the events of the public realm, but also for all that is ephemeral; yesterday's news, in comparison to the relative stability of such durable goods as furniture. Now this object is turned away from the wall at an angle, so that the face it presents to the world is not a plane but a corner, formed by the back and one side of the night table. Painted across these two planes and around onto the swell of the newspapers is a roughly rectangular zone of olive enamel. In connecting and crossing between the wooden surface and the newspaper, it simultaneously equalizes and effaces them by rendering both as mere 'grounds'. It also highlights their difference at a more profound level than that of immediate appearance. The tactile qualities of the painted area show up as completely different, despite the fact that the paint itself has not changed or been

Kissing the Wall #1
1988
Small piece of furniture, enamel,
a small incandescent light,
newspaper with glue
Approx. h. 30 cm

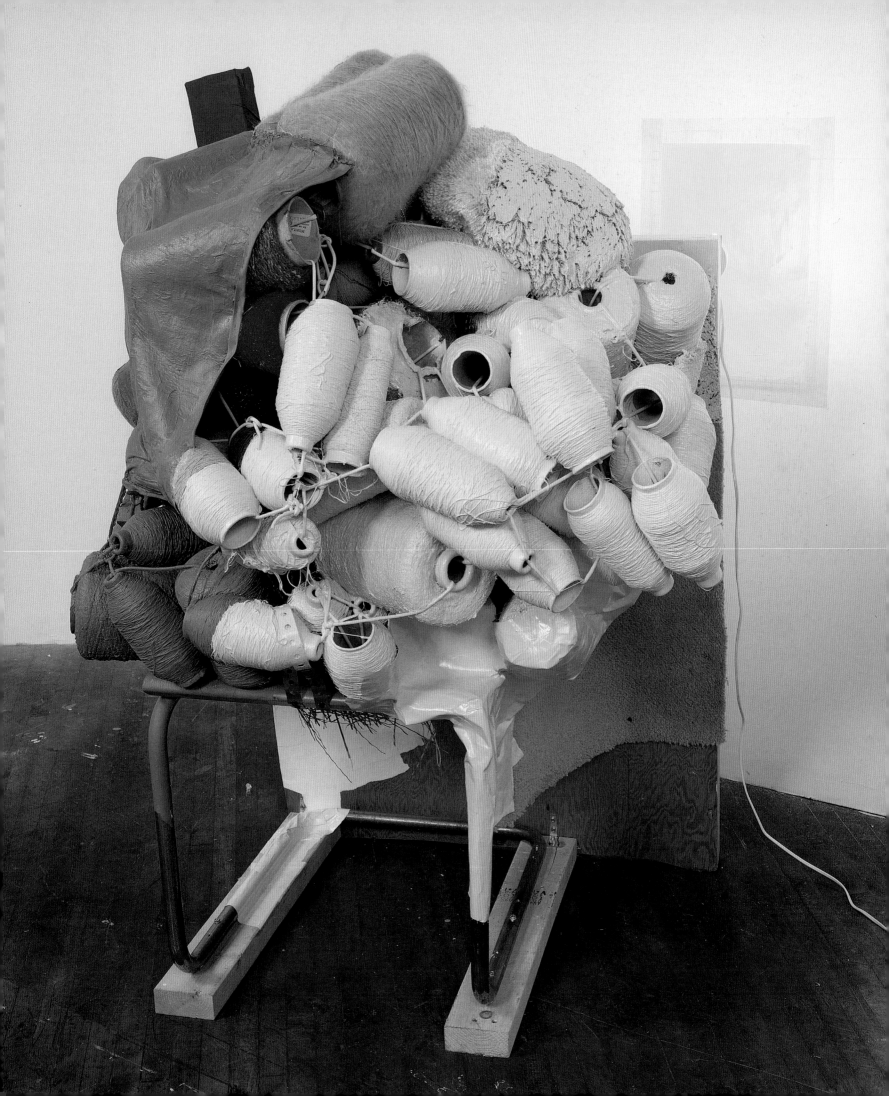

Mixing Food with the Bed
1989
Construction materials,
newspaper, cloth, concrete mixed
with hair, paint, bricks, stoves,
refrigerators, bathtub
Installation, The Mattress Factory,
Pittsburgh

applied any differently. The paint displays what it nominally hides. An incandescent light attached to the night table's other side, the one facing the wall, sheds a circle of greenish light on the backing wall. This light turns the wall into a ground (rather than a mere background) for the object that stands before it, just as the object itself is used as a ground for the green enamel. Establishing a kind of pictorial atmosphere for the object, the light claims the space between the night table and the wall. The assemblage touches the wall, not physically, but optically.

What is tactile? What is optical? *Kissing the Wall #1* shows us that colour – whether embodied as paint or as light, whether opaque or transparent – can be a tactile value more than an optical one. Likewise, Stockholder's work shows that three-dimensional objects can function optically as well as sculpturally. They may be used as elements in an essentially pictorial composition, as when an arrangement is flattened either by sheer distance, for example in *Indoor Lighting for My Father*. Or else the optically recessive and advancing properties of strongly coloured objects may be cancelled out by their actual positions in three-dimensional space. This effect also contributes to the pictorial tendency of *Indoor Lighting*, as the optically recessive turquoise of the forward hay bales balances the optically advancing red-stained underwear bundles seen behind and below it. Stockholder not only uses colour to 'flatten' objects, but she uses three-dimensionality to expand or 'swell' colour. Her use of yarn, such as we have seen in *Flower Dusted Prosies*, is one of the more common instances of this.

V

Stockholder's work is not autobiographical in any narrative sense, but it is always concerned with intimacy. *Installation in My Father's Backyard* suggests the possibility of taboo-breaking by exposing the business of the paternal bed to the eyes of the outside world. An installation made five years later, *Indoor Lighting for My Father* (Mercer Union, Toronto, 1988) insinuates the opposite. A gaze penetrating to the interior here reveals, above all, a floor-to ceiling 'column' made of 500 pairs of men's and women's cotton underwear – one area of the column, like the mattress in the 1983 installation, has been painted red – stuffed with crumpled newspaper. I wonder what the artist's father thought of a work dedicated to him that consisted most prominently of underwear? Not that she could be accused of washing the family laundry in public. But surely there is some sense of displaying that which is normally hidden here.

The recurrence of the father in Stockholder's titles may have another significance. I wonder if she doesn't consider her own commitment to art – her detour from the wholly verbal and intellectual world of her parents – to be in some way a gift from her father, for it was he who, when she was 14 years old, hired his university colleague, the sculptor Mowry Baden, to give private drawing lessons to his daughter. And since Baden remained Stockholder's mentor for a good many crucial years thereafter, he must be a sort of father figure as well; it would be worth re-reading Stockholder's work for its commentary on his attempt to repudiate what he calls 'stand-off-and-look-at-it' art through provoking 'the self-awareness generated

Mowry Baden
Lariat Calais
1987
Steel, aluminium, plastic
489 × 324 × 252 cm

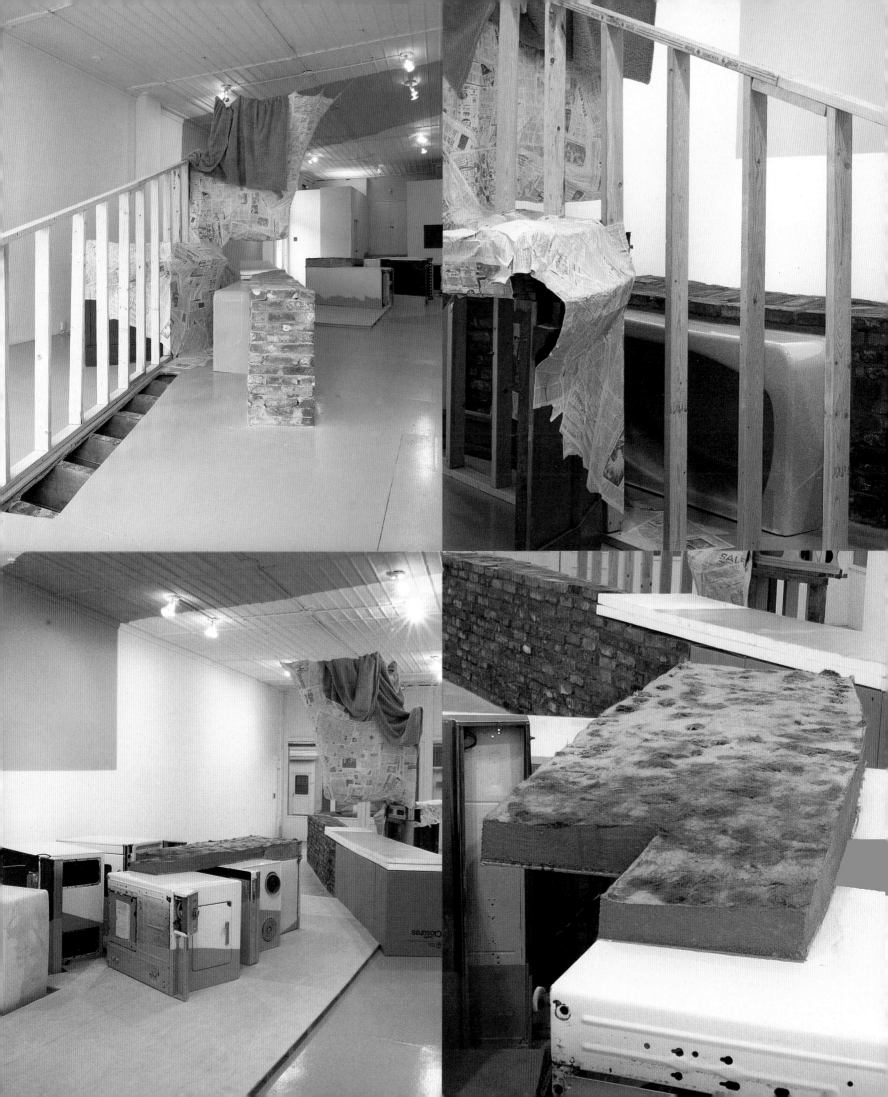

Skin Toned Garden Mapping
1991
Red carpet, 5 × 10 cm, paint,
roofing tar, refrigerator doors,
hardware, yellow bug lights and
fixtures, cloth, and vinyl
composition floor tiles, concrete,
tinfoil
Space, 452,160 square cm.
Installation, Renaissance Society,
Chicago

in the completion of a specific task' – an art of proprioception.[19]

Placed towards the rear of the first gallery space at Mercer Union, this installation was deliberately distanced and pictorialized, framed by the architecture and 'seen apart and separate' by viewers entering the gallery. But Stockholder arranged for what she calls 'a more intimate and time bound experience'[20] to become available to those proceeding to the corridor linking this space to the one behind it. Viewing the installation from there, those who thereby behold the work from its backside enjoy the closest view of the underwear and crumpled paper ('time bound' indeed, in so far as the dailies are confined by the 'unmentionables' they so unaesthetically stuff).

A subsequent installation evokes the early *Installation in My Father's Backyard* by its title: *Mixing Food with the Bed* certainly sounds like a recipe for a stained mattress – it was installed at The Mattress Factory (!), Pittsburgh, in 1989. But in this case other objects of domestic necessity are actually displayed: no bedding, despite the title, but more than enough stoves and refrigerators to prepare the food – and a bathtub to clean off in afterward. These refrigerators will reappear, multiplied in number but in the guise of their doors alone, in *Skin Toned Garden Mapping* (The Renaissance Society, Chicago, 1991), where they will gather to form a sort of crazed wall. Nearly everyone has a refrigerator in our culture, but it's not the kind of object we think of as having 'personal' resonance the way a bed does. At most, the refrigerator door may be what gets in your way when you're dying to know what's to eat. Seeing a

hundred of those doors, all bare, may evoke a bad dream on an empty stomach. That's one way the work may become, as Stockholder once put it, 'a site for the personal to be mixed with, compared to, or made into concrete reality'.[21]

VI

The street I live on – just a few blocks away from where Stockholder lives – is called Prospect Park West. It's the main shopping street for my little Brooklyn area and it divides, or once did, an almost exclusively Irish neighbourhood to the East from a predominantly Latino one to the West. It used to be the scene of gang wars between youths from the two communities, but that was before I moved here, back when Prospect Park West was still Ninth Avenue. Sometime since the change of name that was supposed to make the street sound more attractive and the minor improvements accompanying it, such as the pleasant brick sidewalks, the boundaries have been growing blurrier and the ethnic mix more complex. The area is more relaxed, though if the city fathers had gentrification in mind it hasn't worked and the street remains a bit rundown, many of its storefronts vacant, some of them now housing sweatshops instead.

Down this street there is a store called Bargain Land. It is not a grocery store, although it sells some packaged food items, not a stationery store, despite carrying a range of paper goods and school supplies, nor a hardware store, even though some of its stock would be at home there too. It fits into no particular category. Many of the products stocked there sport obscure and unfamiliar brand

Bargain Land

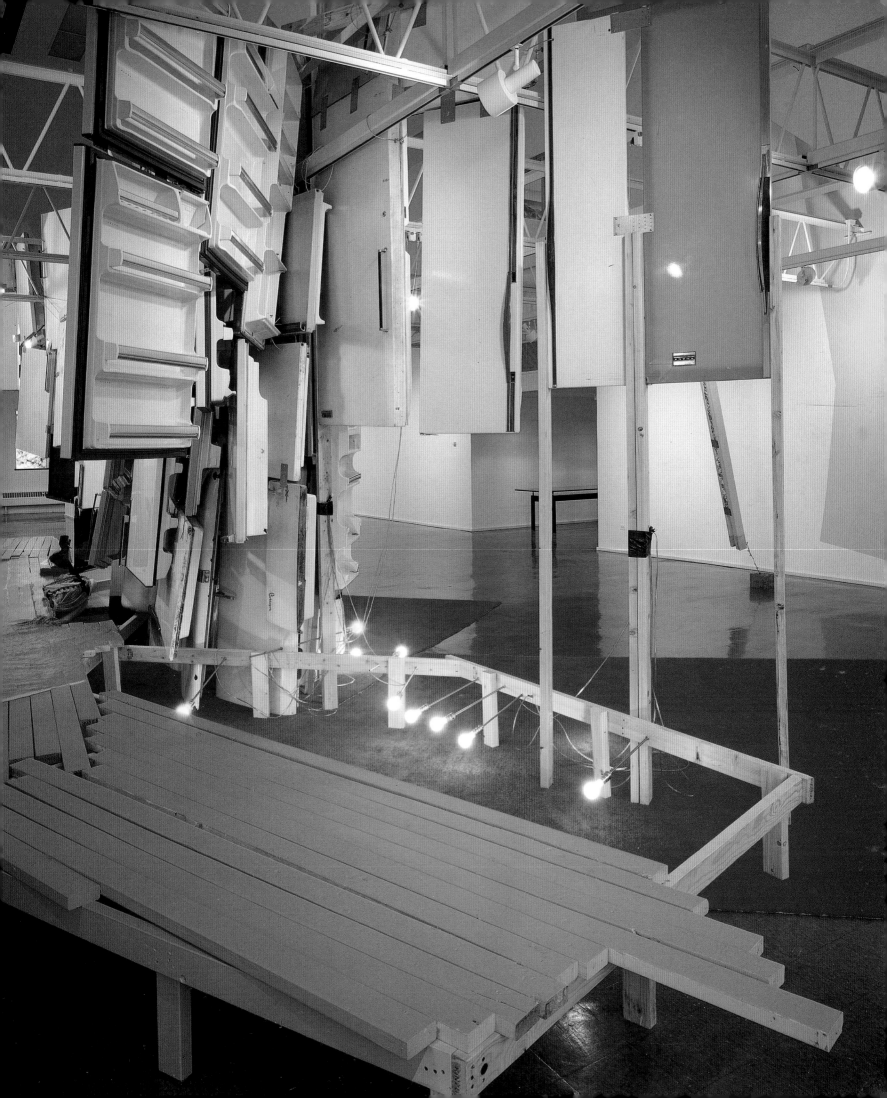

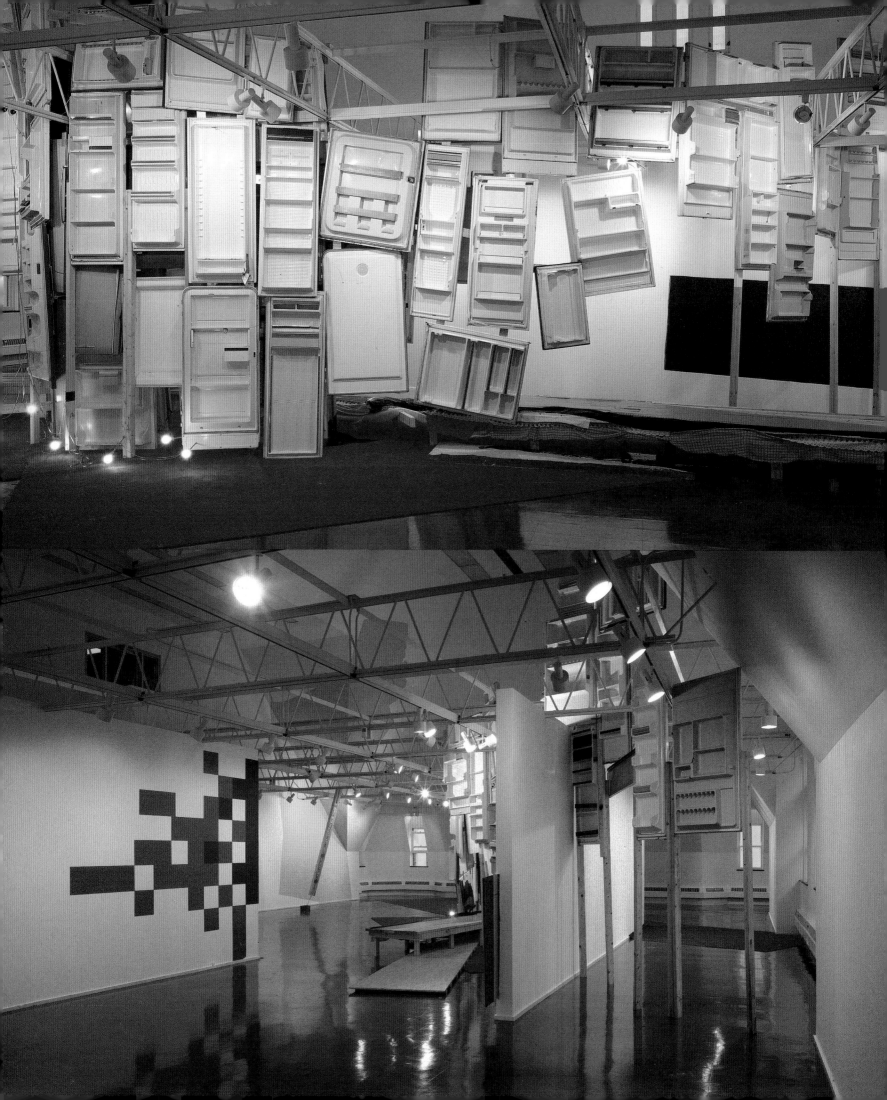

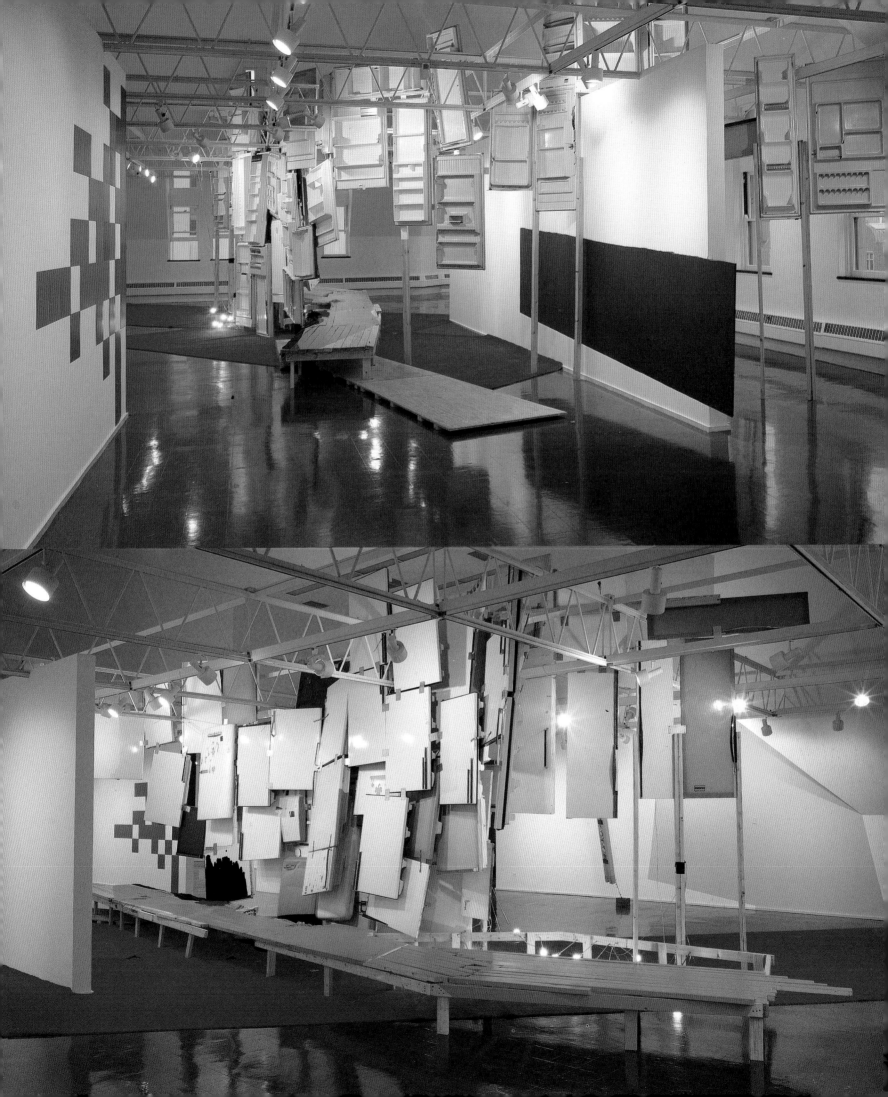

names; others are the products of foreign subsidiaries of national brands; Canadian Q-Tips, South American shampoo. I have bought extension cords, roach traps, manila envelopes, paper towels, hair conditioner, underwear, an ironing board cover and who knows what else there. The place is chockablock with the miscellaneous ordinaria of plebeian existence. It exists in profound syntony with the art of Jessica Stockholder, whose art materials are always liable to include such potential Bargain Land wares as bed sheets, yellow bug lights, tinfoil, electric wiring, mirrored tiles, plastic fruit, wine glasses, duct tape, plastic garbage bags, toilet paper, cookies, dried fruit, cardboard boxes and underwear as well as more specialized materials that must be sought elsewhere in that vast Bargain Land which is our demotic late-capitalist economic system: hay, refrigerators, plywood, styrofoam, bicycles, carpet, theater lights, sheetrock, asphalt, couches, chairs, newspaper, fresh fruit, bricks, stoves, bathtubs, steel studs, movie seats, concrete, sandstone, spandex ... Stockholder does not overtly comment on the system that makes all these things available for her use, neither in critique nor in celebration. Rather, she translates its flavour into a work of dreamlike abandon.

Something that interests me about Bargain Land is the relation between its inside and its outside. With a quantity of each item on hand, the shelves combine storage and display into a single function, but everything is available: you can reach out and pick up the thing you want. Nothing unusual in any of this, of course. But where things get more complicated is with the store's long, two-part display window, where it beckons to the

outside. The window reduces the place to a picture of itself, but to a modernist picture rather than a classical one. In the window one sees the following: the space of representation is quite shallow, with a background consisting of an overall decorative pattern or, often enough, a couple of patterns that meet and clash; in front of this, a selection of the items for sale in the store, not singly but in quantity, as though these were overstock items for which there is no space in the store proper or its basement storage space; and then the foreground, signs attached to the window pane. Finally, one should add that there is a projection in front of the 'picture plane', a rocking horse kiddy ride.

What is striking about this window is that it does not represent the store's contents through their spectacularization, as would be the case in a more upscale enterprise, but more through a kind of seepage. Always changing, sometimes jam-packed, sometimes nearly bare, in its random layerings and juxtapositions, its collisions of colours, patterns and textures. To see a neighbourhood storefront as 'art-like' is not to see it 'abstractly', 'formalistically', 'aesthetically' only; it is also to see it metonymically and allegorically, to see it as an 'unconscious place' (to borrow a phrase from the photographer Thomas Struth) representing processes that are going on in its immediate surroundings and in the wider world whose productions are continually being routed through it.

I had meant to photograph the window I've been talking about, but since I started writing this the display has changed again. It no longer exists except in my memory of it and perhaps never did exist except in memory; I'm no longer entirely sure

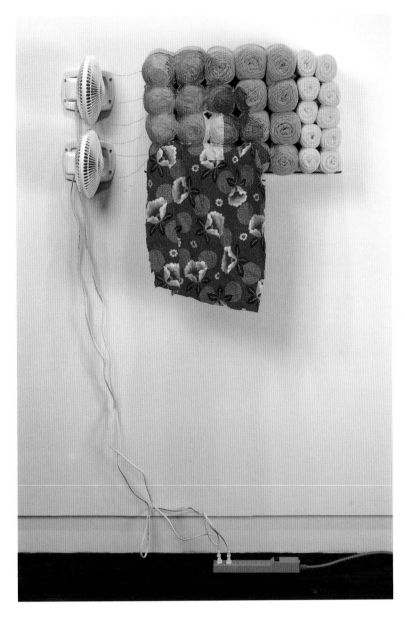

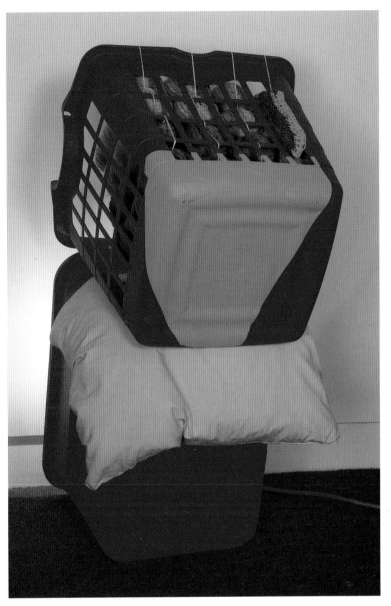

that the image I've given of it here is not a conflation of several states of its development over a period of time. An artist, it is said, creates a world of her own, or her own way of looking at the world, which it becomes the viewer's privilege to enter. No doubt. And yet the power of the artist is not simply that of producing an alternative reality into which we may plunge as into a pool, but of saturating the world we all share with her way of seeing it, so that it can no longer be set apart as a personal vision but as a

revelation of 'things as they are', to use Wallace Stevens' phrase. I couldn't have seen Bargain Land as I do if I hadn't steeped myself in the art of Jessica Stockholder. At the same time I wonder whether I could make sense of her art if I wasn't immersed in a world in which places and processes like those represented by Bargain Land are prominent.

I spoke before of how Stockholder's work has been seen as part of a reaction against the 'Neo-Geo' and commodity-fetish art that was so

1994
Two fans, pink power bar, skeins of acrylic yarn, flannel cloth, silicone caulking, acrylic paint, thread, glass shelf
h. 154 × variable width × d. 24 cm.
Yarn element, 58 × 24 × 58 cm

1994
Two red plastic laundry baskets, oil paint, acrylic yarn, silicone caulking, light fixture, chromalux full spectrum bulb, orange cord
96 × 67 × 50 cm

Ken Lum
You Don't Love Me
1994
Laminated C-print on sintra,
lacquer, enamel, aluminium
173 × 230 × 5 cm

Ian Wallace
Untitled (In the Street I)
1988
Acrylic and photolaminate on
canvas
230 × 230 cm

Jeff Wall
Coastal Motifs
1989
Cibachrome transparency on
lightbox
119 × 147 cm

prominent in the mid to late 80s. But like that work, Stockholder's turns out to be in good measure about the commercial culture which determines so much of what we see and how we live and which provides the materials out of which her work is constructed. The difference is that their gleaming fetish objects – icons of what Fredric Jameson called the 'hysterical sublime' and its 'hallucinatory exhilaration'[22] – accepted the media masters' presumption of control (not for nothing were advertising moguls like Jay Chiat and Charles Saatchi among their prominent collectors). On the other hand Stockholder's work assumes the position from which the products of commercial culture are unspectacularly received and idiosyncratically redeployed, an oblique and decentred position that reflects Prospect Park West more than Madison Avenue. As such it is congruent with what has been recognized as a 'new rhetoric' in urbanism that abjures the 'impulse to romanticize the dystopian' found in critics like Jameson and artists like the postmodernists of the 80s and which recognizes the 'realm of smudged boundaries ... the interstices of the city, the forgotten bits between', amounting to a recovery of the periphery.[23]

I think I understand why, in beginning to talk about her art, Stockholder wanted to talk about Vancouver. In making her way from Vancouver to Brooklyn, she has migrated from one kind of periphery to another. I've never been there but the Vancouver I think I know from the work of artists like Ian Wallace, Ken Lum and Jeff Wall feels very familiar; peripheral cities like Vancouver and

peripheral segments of great urban centres, as Brooklyn is to Manhattan, are the sites at which contradictions and shifts in changing global markets and changing global cultures are allowed to display themselves relatively unsupervised. Just as, in his classic 'Homes for America', Dan Graham was able to describe suburban tract housing developments in the language that had been developed for discussing Minimalist sculpture, so my description of Stockholder's installations converges on that of the contemporary urban fringe.[24]

I wanted to underline and defend the 'formalism' of Stockholder's work; and that work has led me, abruptly but not illogically, by one of the sudden changes of perspective which is one of the typical formal features of her installations, to touch on broader social forces that our stereotype of formalism would have us ignore, but which circulate incessantly through her work. As the artist herself has written, 'There is an attempt to bring the city inside the gallery, not to erase fiction, but to inform and expand it; and perhaps shed light on the city'[25]. One of her commentators puts it that 'her meditation on how we build and perpetuate visual order can lead us at least to the fringes of meaning' – which we are now in a position to translate into the urban periphery – 'where anxieties about the orders we implicitly condone enter the field of vision'.[26] A little formalism, it has been said, takes you away from everyday life, but a lot of formalism sets you right back into it. And here we are.

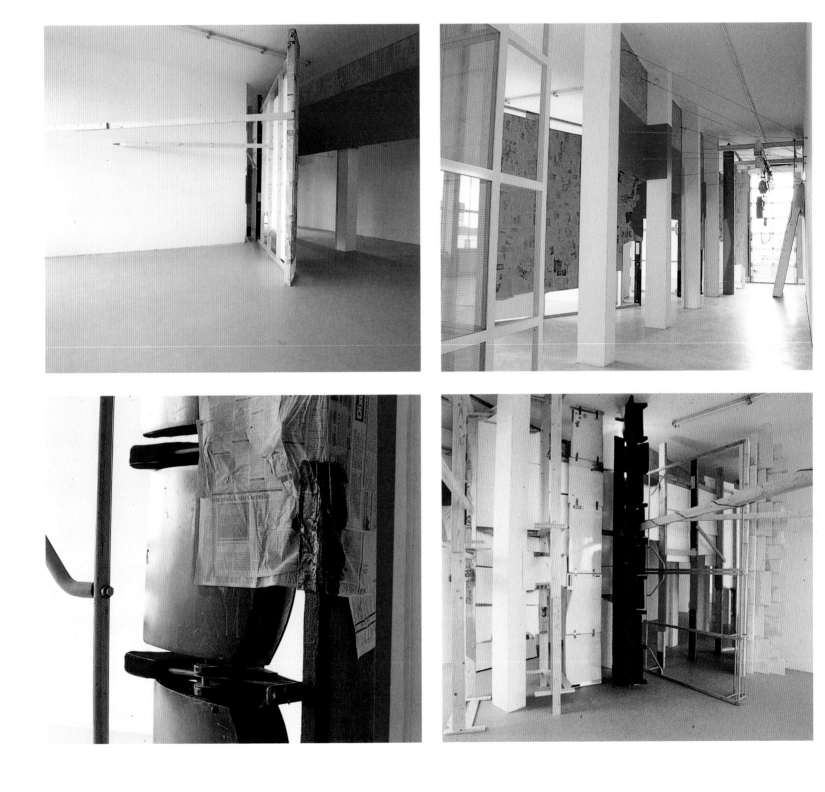

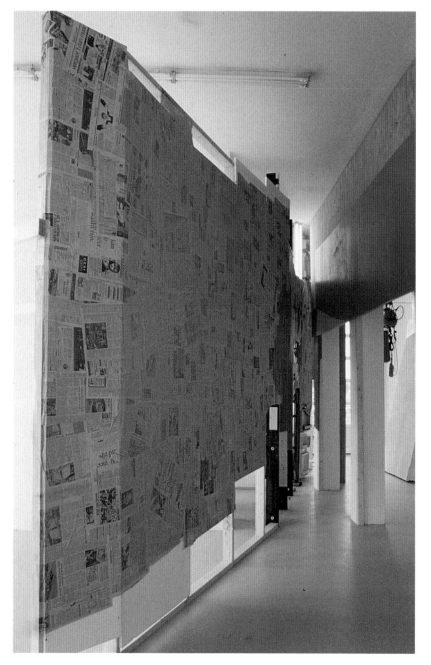

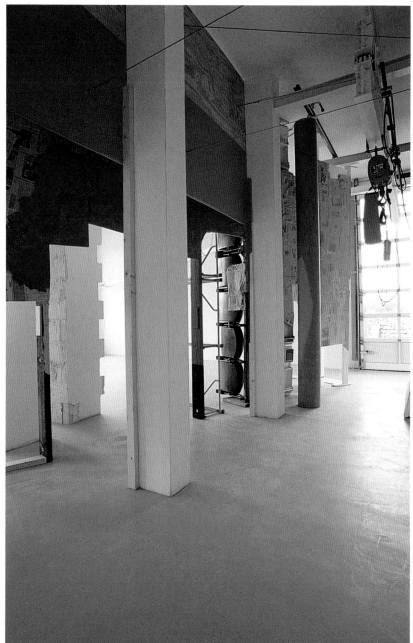

1 Harold Rosenberg, 'On Art Movements', *The Anxious Object*, University
 of Chicago Press, 1982, pp. 237-38

2 Friedrich Meschede, 'Images After a Journey', *Jessica Stockholder*
 Westfälischer Kunstverein, Münster; Kunsthalle, Zürich, 1992, p. 27

3 Bill Jones, 'False Documents: A Conversation with Jeff Wall', *Arts
 Magazine* LXIV, New York, May 1990, p. 54

4 Jo-Anne Birnie Danzker, 'Vancouver: Land- and Culture-Scape', in
 Vancouver: Art and Artists 1931-1983, Vancouver Art Gallery, 1983,
 p. 216

5 Interview with Klaus Ottmann, *Jessica Stockholder. The Broken Mirror:
 Part Three*, exhibition brochure, Ezra and Cecile Zilkha Gallery,
 Wesleyan University, Middletown, Connecticut, 1991

6 Clement Greenberg, 'Cézanne', *Art and Culture*, Beacon Press, Boston,
 1961, p. 55

7 Scott Watson, 'The Generic City and Its Discontents: Vancouver
 Accounts for Itself', *Arts Magazine* LXV, New York, February 1991, p.
 62. The comparison between Stockholder and Rauschenberg is most
 fully developed by Jack Bankowsky, 'The Obligatory Bed Piece',
 Artforum XIX, New York , October 1990, pp. 141-45 and a year later is
 already treated as conventional by David Pagel, 'Jessica Stockholder',
 Arts Magazine LXVI, New York, October 1991, p. 89. An important
 essay, discussing a number of the aspects of Rauschenberg's work
 which will be relevant to Stockholder's as well, is James Leggio,
 'Robert Rauschenberg's *Bed* and the Symbolism of the Body', in *Studies
 in Modern Art 2: Essays on Assemblage*, ed. by John Elderfield, The
 Museum of Modern Art/Harry N. Abrams, New York, 1992, pp. 79-117

8 Donald Judd, 'Specific Objects', *Arts Yearbook* VIII, New York, 1965,
 reprinted in his *Complete Writings 1959-1975*, The Press of the Nova
 Scotia College of Art and Design, Halifax, 1975

9 Michael Fried, 'Art and Objecthood', 1967, *Minimal Art: A Critical
 Anthology*, ed. Gregory Battcock, Dutton, New York, 1968, p. 142

10 Although John Miller writes that for Stockholder 'the gallery
 space serves as an expanded canvas, not as a minimalist-derived
 "theater",' ('Formalism and Its Other', *Jessica Stockholder*,
 Witte de With Centre for Contemporary Art, Rotterdam; The
 Renaissance Society at the University of Chicago, 1991, p.
 38), it is impossible to make the distinction hold.

11 Jerry Saltz, 'Mis-appropriation: Jessica Stockholder's Sculpture with

No Name', *Arts Magazine* LXIV, New York, April 1990, p. 21; Jeanne
Siegel, 'Jessica Stockholder', *Arts Magazine* LXIV, New York, Summer
1990, p. 77

12 Susan Sontag, 'Happenings: An Art of Radical Juxtaposition', 1962,
 Against Interpretation and Other Essays, Farrar, Straus & Giroux, New
 York, 1966, pp. 263-74

13 Roland Barthes, 'The Wisdom of Art', 1979, *The Responsibility of Forms:
 Critical Essays on Music, Art and Representation*, trans. Richard
 Howard, Hill & Wang, New York, 1985, p. 177; 'Cy Twombly: Works on
 Paper', 1979, ibid., p. 174

14 Bankowsky, *Artforum*, op. cit., p. 141

15 *Jessica Stockholder*, Witte de With, op.cit., p. 29

16 Bankowsky, *Artforum*, op.cit., p. 142

17 *Jessica Stockholder*, Westfälischer Kunstverein, op.cit, p. 22

18 Robert Morris, 'Notes on Sculpture, Part 1', *Continuous Project Altered
 Daily: The Writings of Robert Morris*, The MIT Press, Cambridge,
 Massachusetts, 1993, p. 3; originally published in *Artforum* IV, New
 York, February 1966

19 *Mowry Baden: Maquettes & Other Preparatory Work 1967-1980*, Art
 Gallery of Greater Victoria, Victoria, British Columbia, 1985, pp. 5-6
 (See also *Mowry Baden: Sculpture*, Alberta College of Art Gallery,
 Calgary, Alberta, 1989)

20 *Jessica Stockholder*, Witte de With, op.cit., p. 19

21 Eva Schmidt, 'Interview with Jessica Stockholder', Westfälischer
 Kunstverein, op.cit, p. 42

22 Fredric Jameson, 'The Cultural Logic of Late Capitalism', 1984,
 Postmodernism, or, The Cultural Logic of Late Capitalism, Duke
 University Press, Durham, North Carolina, 1991, pp. 33-34

23 Elizabeth Wilson, 'The Rhetoric of Urban Space', *New Left Review* 209,
 UK, January/February 1995, pp. 146-60. This essay extends analyses
 begun in Wilson's book *The Sphinx in the City: Urban Life, the Control of
 Disorder, and Women,* Virago Press, London, 1991.

24 Dan Graham, 'Homes for America', 1966, *Rock My Religion: Writings
 and Art Projects 1965-1990*, The MIT Press, Cambridge, Massachusetts,
 1993, pp. 14-23

25 *Jessica Stockholder*, Witte de With, op.cit., p. 19

26 Bankowsky, *Artforum*, op.cit., p. 145

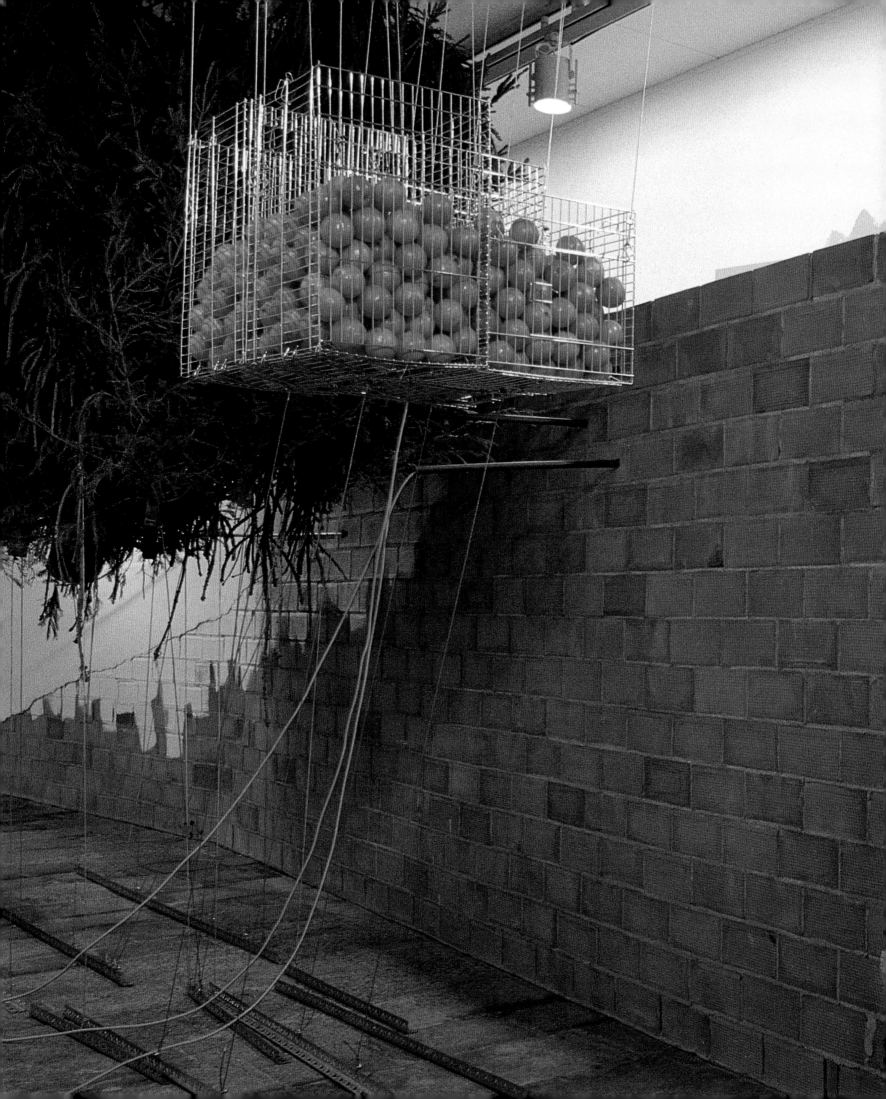

Contents

He hangs in shades the orange bright,

Like golden lamps in a green night.

Andrew Marvell, *Bermudas*

I

In 'orange' several things meet, economically, succinctly. Not only does the word imply both the colour and the fruit, but in the fruit, its namesake, the colour, takes concrete and abstract form: an orange approximates to a perfect orb, a luminous sphere. That its near complement blue – a colour and a condition, but not a thing – holds little fascination for Jessica Stockholder in comparison to the lure of the reddish-yellow hue is perhaps no accident – for at the core of her art the concrete and the abstract, the material and the immaterial, the literal and the fictive intersect.[1]

At once colour accents and pure forms, a string of orange balls meanders from the perimeter of *Edge of Hot House Glass*, metamorphosing in the process, turning first yellow then crimson, while simultaneously growing in scale as it approaches the inner reaches of the work. Its slow arabesque and clear shapes contrast with the more unruly flat collaged elements, swathes of newspaper and painted planes, over and against which it moves. At the opposite end of the platform from this 'necklace' of giant beads four potted plants, their leaves shiny and dark, stand like sentinels marking the far boundary. The leap of the imagination required to encompass this installation, to fuse one disparate and dispersed part with another, makes possible the wedding of the orange balls – surrogate fruit – with the ornamental bushes, now read as expectantly bare. Such connections while never preor-dained are nonetheless encouraged in Stockholder's work and override, as Jack Bankowsky notes, the denotative sense of the individual components. Thus, he claims, Stockholder 'skips across the surface by the most improbable syntagmatic routes, dragging a nebulous cargo of dissembled meaning in her wake'.[2] The act of traversing the installation, of moving through real space in actual time in order to comprehend it fully, can never be separated from the metaphorical journeys that accompany physical circumlocution. If on the one hand the balls seem to seek the plants as natural affiliates, they equally turn their support, a manufactured 'landscape', into a body. It is in part by establishing such elusive textures of connectives as this that Stockholder achieves a resolution, a resolution that far from

Sweet for Three Oranges
1995
Approx. 40 Christmas trees, 50 kilos of oranges, 4 bird cages, brick wall, air craft cable, butane heaters, rope, roofing paper and roofing tar, paint, light bulbs and yellow electric cord, PVC piping, angle iron
Room, 21 × 4 .9m
Installation, Sala Montcada de la Fundacio la Caixa, Barcelona, Spain

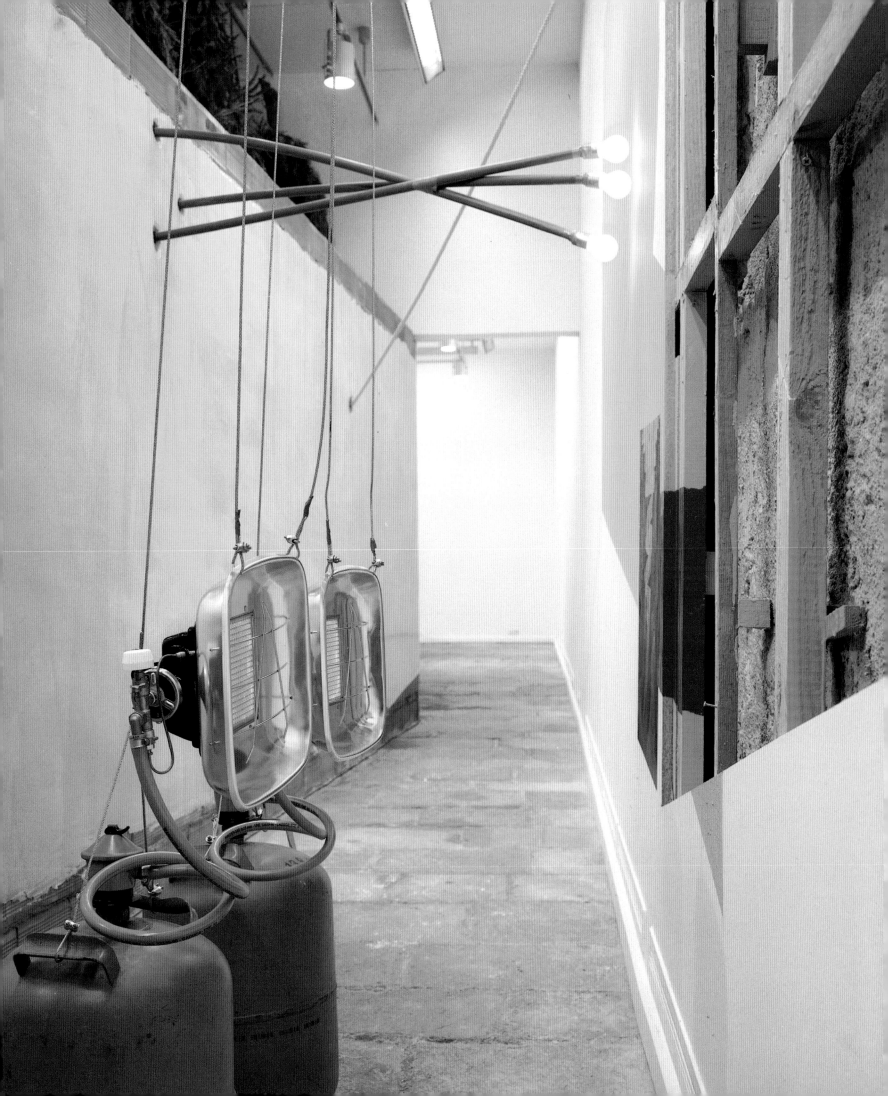

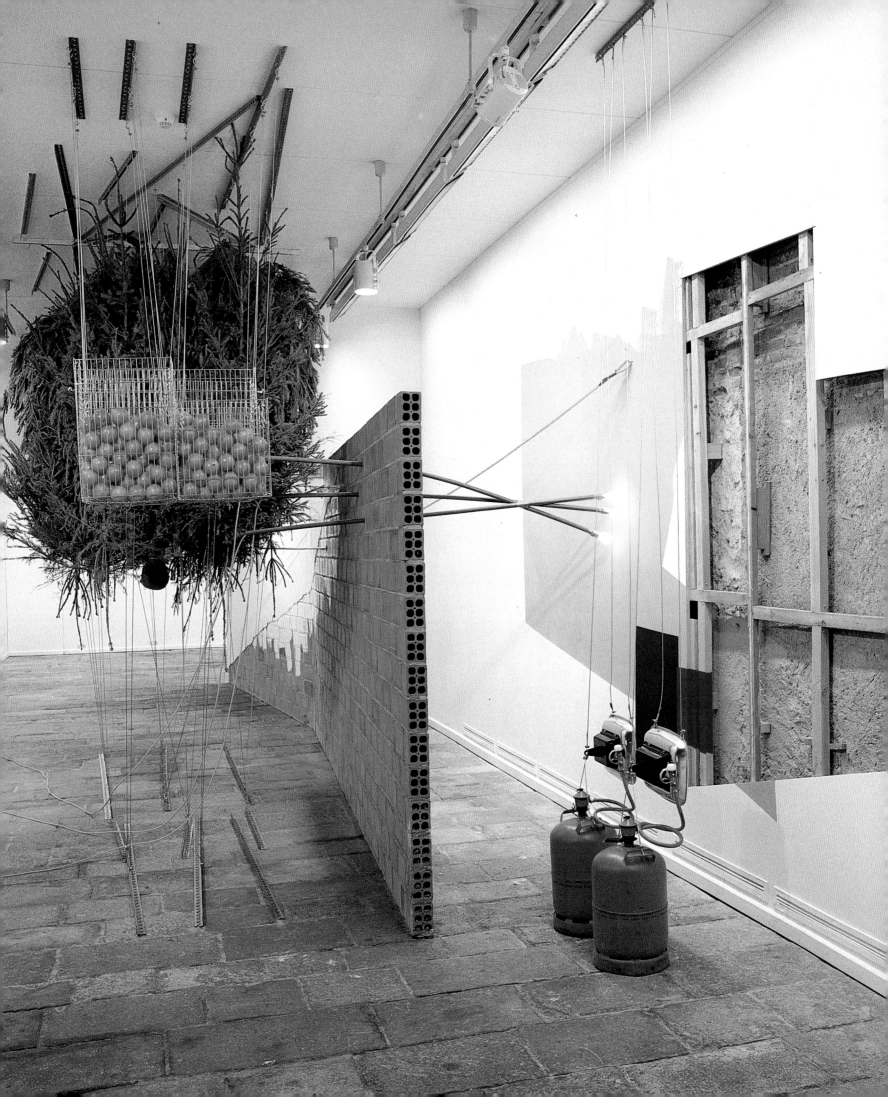

requiring the suppression of one alternative in favour of another, conjures meanings amid the disintegration of readings. 'The various parts of my work are multivalent as are the various parts of dreams', Stockholder contends: 'At best there are many ways to put the pieces together'.[3] Given the level of abstraction and formality on which her compositions function, narrative plays no role in her art. Through emphasizing what David Pagel terms 'the incommensurability … between that which exists in the material world and its unfixable (and not necessarily language based) meaning', her installations become analogues for thinking processes, even for the structure of thought itself.[4]

Earlier, in 1989, in *Making a Clean Edge*, Stockholder had scattered a number of oranges along a shelf, juxtaposing them with several fluorescent lights loosely bundled together. 'The oranges were once fed by the daylight as is the piece now', the artist wrote in the notes accompanying this work, in which she had underlined the significance of light to the installation as much by the provision of a turquoise backdrop to the fruit (which had the effect of making them appear irradiated from within) as by the functionally redundant neon tubes. To the artist the colour accents on this occasion were less worthy of remark than the fact that the piece was 'playing to the windows, the daylight, and the tall green building across the parking lot'. 'It is possible to see the painting that this drive-in movie screen displays while standing in the two foot space between it and the windows', she commented, adding 'but it would be more comfortable if you were in your car 30 feet away'.[5] That the ideal, if improbable, vantage point for this piece was arguably more accessible to the minds than to the bodies of most of the audience is not uncharacteristic in Stockholder's oeuvre.

Indoor Lighting for My Father, the installation that had preceded *Making a Clean Edge*, also incorporated oranges. This time they were embedded into the top of a block of concrete. Nearby, a clutch of green bulbs contributed not only to the overall illumination but served as the visual complement to the fruit. Among the bevy and heterogeneity of quotidian materials and artefacts included in her work over the past decade, the frequency with which citrus recurs is notable. Here, as customary in her art, a signature tension was set up between the referential capacity of the object and its more purely abstract potential.

That it is both the multivalent associations of oranges and their formal beauty and perfection that fascinates Stockholder is perhaps best demonstrated in *Sweet for Three*

Oranges. In this installation created for the Sala Montcada in Barcelona in 1995, the fruit, in effect, finally occupied centrestage. Quartered in four cages which hung suspended from the ceiling, and framed against a stand of deep green pines, the oranges dominated the viewer's initial encounter with the work. Not just visual but tactile and, above all, olfactory senses, were immediately aroused. Compared with the tangy pine odour, the citrus introduced a heavy pungent fragrance. With their glistening skins and brilliant hue it constituted the prevailing colour accent from which all else took its cue. For orange was threaded throughout this installation in a series of mutating colour chords, ranging from the deeper tones of the bricks comprising the purpose-built free-standing wall, to the vivid accents of the gas cylinders whose fierce heat seemed to threaten to melt the patches of scarlet and yellow on the wall opposite, fusing them into yet another orange zone. Warmth, colour, odour; this succulent, sensual blend invoked a world at once opulent and pleasurable, bringing to mind the fact that for centuries (in the West) citrus were prized, almost exotic, treasures, the subject of display and celebration in many a Baroque still life, and later, the staple of Christmas stockings and Yuletide festivities.

II

Suspended high above the ground the bundled firs at first appeared incongruous, displaced – an unruly, ungainly volume compared with the tightly caged fruit. Numerous linear elements further dissected the space: serpentine yellow electric cords; taut wires holding fruit and foliage in place; turquoise ropes leashing architecture to the make-shift wall that the artist had fabricated. To move along the length of this obtusely angled structure meant following the principal axis of the gallery. Yet only after reaching its end and turning back was it apparent that the key architectural feature of the otherwise generic gallery, the white cube that constitutes the Sala Montcada, is a partition suspended from the ceiling mid-way down its length.

Stockholder's installation both denigrated and capitalized on this architectural anomaly. From the threshold of the room she concealed it visually via the introduction of the fruit and foliage, simultaneously mimicking its activation of the upper zone of the space. Somewhat contrarily, she then acknowledged its gesture of bisection, for the brick wall she introduced into the gallery bent precisely at the dividing point. Seen from the rear of the

Sala Montcada this partition reasserted itself by means of a dynamic overlay of painted black shapes which melded into a similarly toned area on the top of the brick wall and which, like the adjacent cables, once again implicated the installation with its site. It was telling that from the back of the room little could be glimpsed of the trees and nothing of the fruit, though their mingled scents, respecting no boundaries, permeated the room, overlaying memory onto immediate experience. From there it was possible to return to the entrance along the narrow corridor formed to the left of the free-standing wall, yet to do so it was necessary to step around and under several elements, negotiating boundaries and implied barriers at each stage. Navigating this carefully orchestrated choreography the viewer was constantly beckoned on by the appearance of unexpected features, coaxed forward by the introduction of novel colour accents or of new chromatic relationships in a schema that counterpointed red, yellow and orange with lime, turquoise and deep green. Offering no single overview and no encompassing vantage point, *Sweet for Three Oranges* memorably embodied Stockholder's proclivity for a sequence of perceptual, visceral and somatic experiences based in change, relativity and variation.

III

In *Sweet for Three Oranges* the mixture of materials and elements relating to building and furnishing – plaster, paint, bricks, electric cords, heating appliances, even the excavation that revealed the lath and inner structure of the wall – seemed consistent with the need to modify the architecture in order to realize a site-specific project. Yet these materials and artefacts were not employed in conventional ways: rather they playfully made reference to the notion of an in situ installation while in fact operating according to a more autonomous and abstract formal logic. The yellow lights, for example, did little to illuminate the space but functioned rather like large felt-tipped pens colouring a section of the gallery wall. Within this coherent lexicon two elements stood out as untoward: the trees and the fruit. Organic entities, they, unlike the other material components, were in a state of imminent decay, of incipient death.

In numerous explicit and implicit ways ...*Three Oranges* invoked or explored duration: real time, as in the time taken to apprehend the work, was compared with the limited life span of the gas in the cylinders, the nearly imperceptible deterioration of

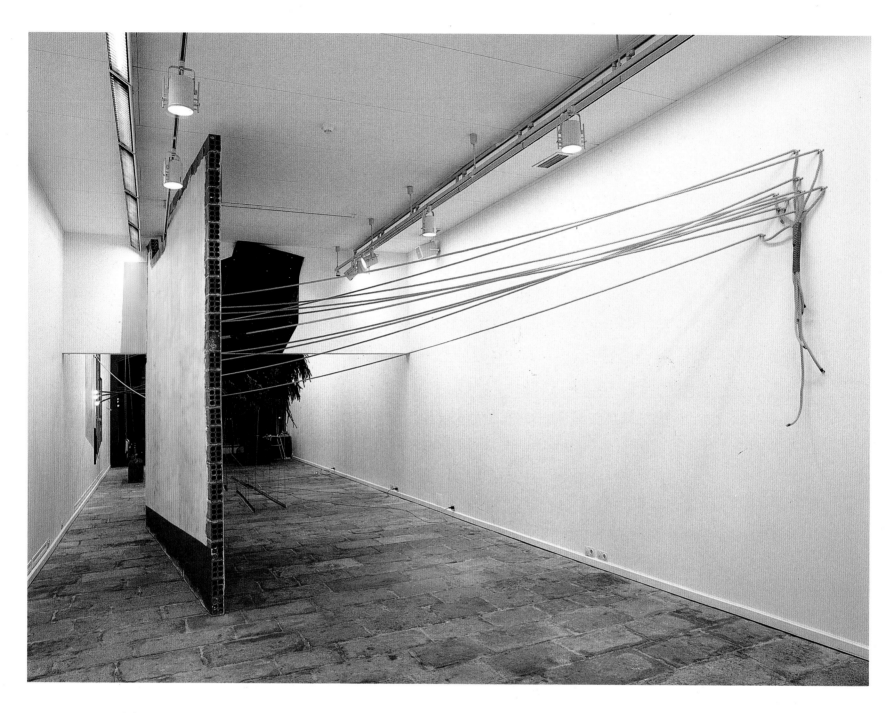

trees and fruit, the extended life of the light bulbs fuelled by electricity, the relative transience of the installation itself, and the unquantifiable timescales measured by memory. Taken together these temporal aspects reverberated in a singular way, serving to structure the work in the present and in recollection.

Nor was the metaphorical dimension of the temporal overlooked. The juxtaposition of trees with fruit recalls a certain moment in the annual calendar. With its particular rites and celebrations this moment functions as a cyclical index for the death of the old and the promise of the new. The firs inevitably evoke rituals surrounding Christmas, rituals now practiced throughout the world irrespective of climate, and even of Christian belief (just

as Christianity had previously appropriated and transmuted pagan customs). The warmth of the brilliant colour of the fruit and the warmth generated by the gas burners together synaesthetically conjured the warmth of the zones where such fruit grows, and contrasted sharply with the experience of winter, literally present outdoors and metaphorically present in Yuletide associations.[6] Georges Braque once argued that our emotions are determined less by the object itself than by the history of our mind's engagement with the object.[7] Jessica Stockholder might add that our associations and allusions are similarly generated less by the object itself than by the history of our mind's engagement with that object.

Contingent, charged, but unforced, the conjunction of firs and fruit in *Sweet for Three Oranges* floats or hovers as might an image in fantasy, a mental projection or an imaginative construct. On one level provisional, even hypothetical, on another, it is obdurately present, concretely rooted in the space, tied and tethered to the physical fabric of the building. At once literal and fictive, it eloquently bears out the artist's claim that 'the knowledge that we have invented our world does not erase the possibility that we might believe in it'.[8] In *Sweet for Three Oranges* as always in Stockholder's art, it is difficult to separate the actual and experiential from the evoked and invoked, to mark, that is, the boundary between physical and mental space. 'My work often arrives in the world like an idea arrives in your mind', she contends. 'You don't quite know where it came from or when it got put together, nevertheless it's possible to take it apart and see that it has an internal logic. I'm trying', she avers, 'to get closer to thinking processes as they exist before the idea is fully formed'.[9]

1 This dual property of pertaining to colour and object seems particular to certain citrus fruit, notably lemons, which Stockholder has also used in an installation, limes and tangerines.

2 Jack Bankowsky, 'The Obligatory Bed Piece', *Artforum*, New York, October 1990, p.142

3 Jessica Stockholder, 'Interview with Klaus Ottmann', 1991, *Journal of Contemporary Art*, New York, Spring/Summer 1991. Reprinted in this book, p.116-119

4 David Pagel, 'Jessica Stockholder', *Arts Magazine*, New York, October 1991, p.89

5 Stockholder quoted in *Jessica Stockholder*, Witte de With, Rotterdam/The Renaissance Society, Chicago, 1991, p.17

6 The exhibition was held at the Sala Montcada de la Fundacio 'La Caixa', Barcelona, January 18-February 16, 1995

7 Refer Michael Baxandall, *Patterns of Intention: On the Historical Explanation of Pictures*, Yale University Press, New Haven and London, (1985) 1988, p.45

8 Quoted in Robert Nickas, 'The State of Things. Questions to Three Object Conscious Artists', *Flash Art*, Milan, March/April 1990, pp. 132. Reprinted in this book, p.110-113

9 'Interview with Klaus Ottmann', op. cit., p.119

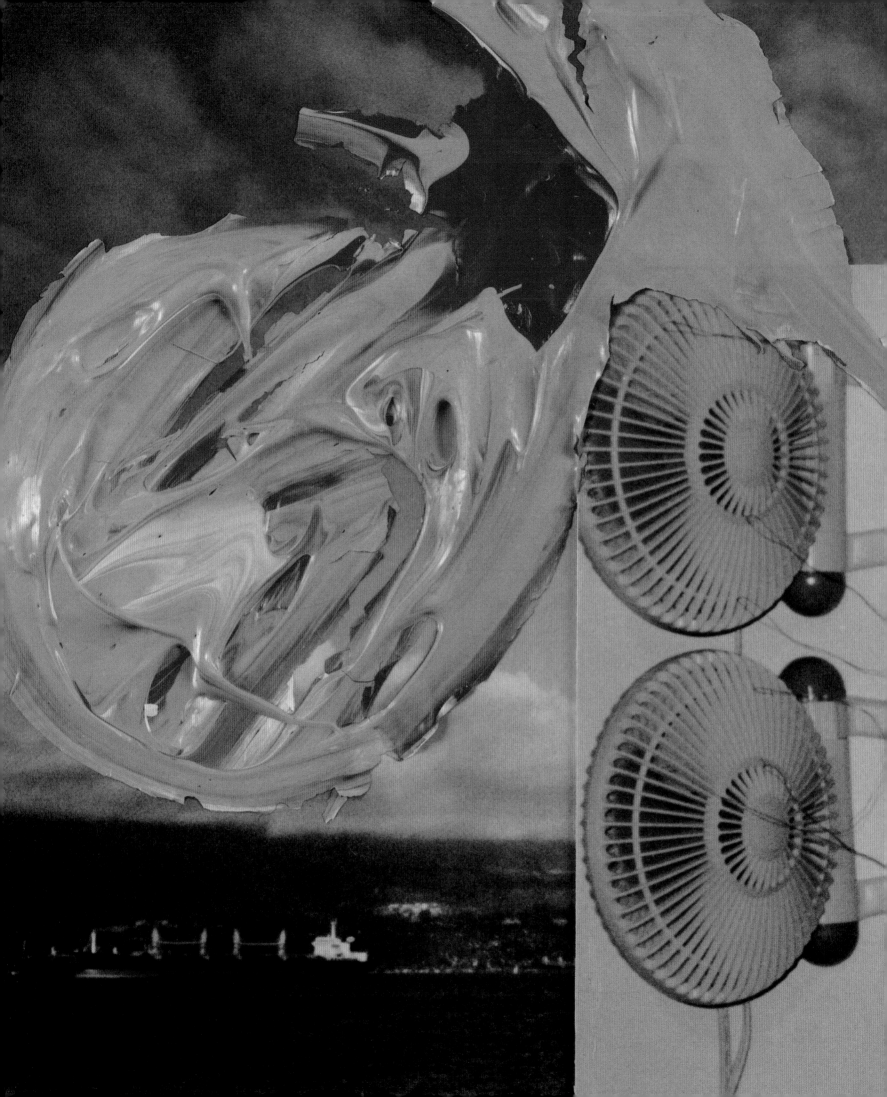

Contents

Chapter 2 Consciousness

Metaphor and Language

Let us speak of metaphor. The most fascinating property
of language is its capacity to make metaphors. But what an
understatement! For metaphor is not a mere extra trick of
language, as it is so often slighted in the old schoolbooks
on composition; it is the very constitutive ground of language.
I am using metaphor here in its most general sense: the use of
a term for one thing to describe another because of some kind
of similarity between them or between their relations to other
things. There are thus always two terms in a metaphor, the
thing to be described, which I shall call the *metaphrand*, and
the thing or relation used to elucidate it, which I shall call the
metaphier. A metaphor is always a known metaphier operating
on a less known metaphrand. I have coined these hybrid terms
simply to echo multiplication where a multiplier operates on a
multiplicand.

It is by metaphor that language grows. The common reply to
the question 'what is it?' is, when the reply is difficult or the
experience unique, 'well, it is like –'. In laboratory studies,
both children and adults describing nonsense objects (or
metaphrands) to others who cannot see them use extended
metaphiers that with repetition become contracted into labels.
This is the major way in which the vocabulary of language is
formed. The grand and vigorous function of metaphor is the
generation of new language as it is needed, as human culture
becomes more and more complex.

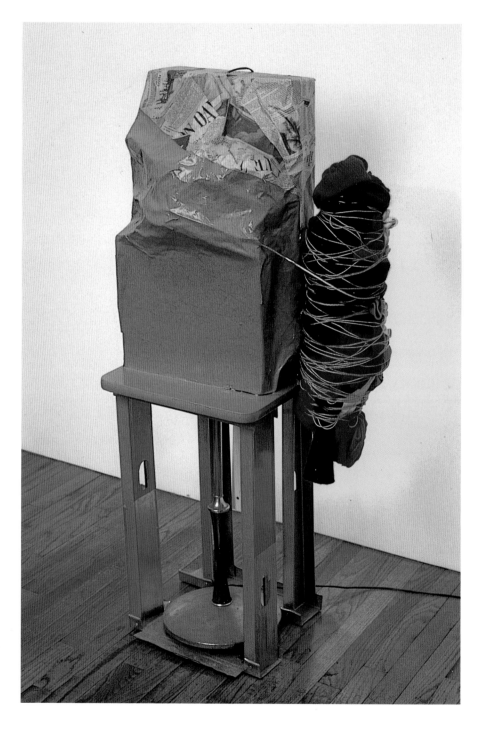

Madonna and Child
1988
Metal studs, lamp base,
newspaper, enamel paint,
fluorescent light, sweaters,
string
Approx. h. 36 cm

A random glance at the etymologies of common words in a dictionary will demonstrate this assertion. Or take the naming of various fauna and flora in their Latin indicants, or even in their wonderful common English names, such as stag beetle, lady's-slipper, darning needle, Queen Anne's lace or buttercup. The human body is a particularly generative metaphier, creating previously unspeakable distinctions in a throng of areas. The *head* of an army, table, page, bed, ship, household or nail, or of steam or water; the *face* of a clock, cliff, card or crystal; the *eyes* of needles, winds, storms, targets, flowers or potatoes; the *brow* of a hill; *cheeks* of a vice; the *teeth* of cogs or combs; the *lips* of pitchers, craters, augers; the *tongues* of shoes, boardjoints or railway switches; the *arm* of a chair or the sea; the *leg* of a table, compass, sailor's voyage, or cricket field; and so on and on. Or the *foot* of this page. Or the *leaf* you will soon turn. All of these concrete metaphors increase enormously our powers of perception of the world about us and our under- standing of it, and literally create new objects. Indeed, language is an organ of perception, not simply a means of communication.

This is language moving out synchronically (or without reference to time) into the space of the world to describe it and perceive it more and more definitively. But language also moves in another and more important way, diachronically, or through time, and behind our experiences on the basis of haptic structures in our nervous systems to create abstract concepts whose referents are not observables except in a metaphorical sense. And these too are generated by metaphor. This is indeed the nub (knob), heart, pith, kernel, core, marrow, etc. of my argument, which itself is a metaphor and 'seen' only with the mind's 'eye'.

In the abstractions of human relations, the skin becomes a particularly important metaphier. We get or stay 'in touch' with others who may be 'thick-' or 'thin-skinned' or perhaps 'touchy' in which case they have to be 'handled' carefully lest we 'rub' them the wrong way; we may have a 'feeling' for another person with whom we may have a 'touching' experience.

The concepts of science are all of this kind, abstract concepts generated by concrete metaphors. In physics, we have force, acceleration (to increase one's steps), inertia (originally an indolent person), impedance, resistance, fields and now charm. In physiology, the metaphier of a machine has been at the very center of discovery. We understand the brain by metaphors to everything from batteries and telegraphy to computers and holograms. Medical practice is sometimes dictated by metaphor. In the eighteenth century, the heart in fever was like a boiling pot, and so bloodletting was prescribed to reduce its fuel. And even today, a great deal of medicine is based upon the military metaphor of defense of the body against attacks of this or that. The very concept of law in Greek derives from *nomos*, the word for the foundations of a building. To be liable, or bound in law, comes from the Latin *ligare*, meaning to bind with cord.

In early times, language and its referents climbed up from the concrete to the abstract on the steps of metaphors, even, we may say, created the abstract on the bases of metaphors.

It is not always obvious that metaphor has played this all- important function. But this is because the concrete metaphiers become hidden in phonemic change, leaving the words to exist on their own. Even such an unmetaphorical-sounding word as the verb 'to be' was generated from a metaphor. It comes from the Sanskrit *bhu*, 'to grow, or make grow', while the English forms 'am' and 'is' have evolved from the same root as the Sanskrit *asmi*, 'to breathe'. It is something of a lovely surprise that the irregular conjugation of our most nondescript verb is thus a record of a time when man had no independent word for 'existence' and could only say that something 'grows' or that it 'breathes'. Of course we are not conscious that the concept of being is thus generated from a metaphor about growing and breathing. Abstract words are ancient coins whose concrete images in the busy give-and-take of talk have worn away with use.

Understanding as Metaphor

We are trying to understand consciousness, but what are we really trying to do when we try to understand anything? Like children trying to describe nonsense objects, so in trying to understand a thing we are trying to find a metaphor for that thing. Not just any metaphor, but one with something more familiar and easy to our attention. Understanding a thing is to arrive at a metaphor for that thing by substituting something more familiar to us. And the feeling of familiarity is the feeling of understanding.

Generations ago we would understand thunderstorms perhaps as the roaring and rumbling about in battle of superhuman gods. We would have reduced the racket that follows the streak of lightning to familiar battle sounds, for example. Similarly today, we reduce the storm to various supposed experiences with friction, sparks, vacuums, and the imagination of bulgeous banks of burly air smashing together to make the noise. None of these really exist as we picture them. Our images of these events of physics are as far from the actuality as fighting gods. Yet they act as the metaphor and they feel familiar and so we say we understand the thunderstorm.

If understanding a thing is arriving at a familiarizing metaphor for it, then we can see that there always will be a difficulty in understanding consciousness. For it should be immediately apparent that there is not and cannot be anything in our immediate experience that is like immediate experience itself. There is therefore a sense in which we shall never be able to understand consciousness in the same way that we can understand things that we are conscious of.

Most of the errors about consciousness that we have been studying have been errors of attempted metaphors. We spoke of the notion of consciousness being a copy of experience coming out of the explicit metaphor of a schoolboy's slate. But of course no one really meant consciousness copies experience; it was as if it did. And we found on analysis, of course, that it did no such thing.

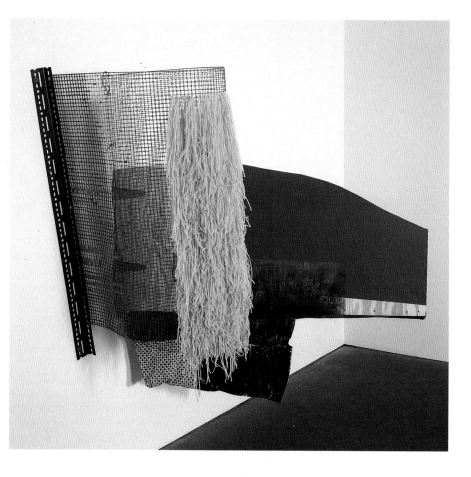

And even the idea behind that last phrase, that consciousness does anything at all, even that is a metaphor. It is saying that consciousness is a person behaving in physical space who does things, and this is true only if 'does' is a metaphor as well. For to do things is some kind of behaviour in a physical world by a living body. And also in what 'space' is the metaphorical 'doing' being done? (Some of the dust is beginning to settle.) This 'space' too must be a metaphor of real space. All of which is reminiscent of our discussion of the location of consciousness, also a metaphor. Consciousness is being thought of as a thing, and so like other things must have a location, which, as we saw earlier, it does not actually have in the physical sense.

1991
Two elements, no 1, wire mesh
acrylic yarn, wire and metal bar
101 × 74 × 31 cm
no 2, 2 pieces of plywood
laminated together with cloth
and two hinges, acrylic paint
101 × 74 × 31 cm

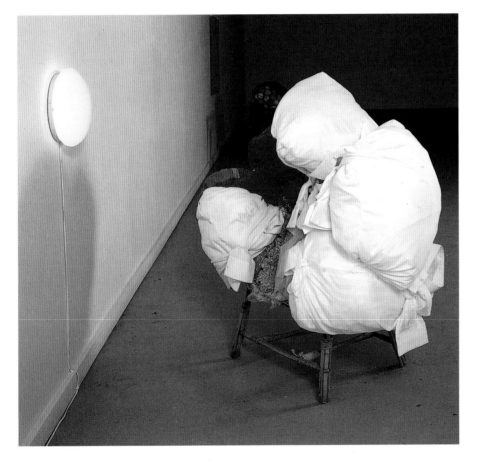

1989
Wicker chair, men's shirts stuffed
with foam wrapping material,
red oil paint, plaster, a round
fluorescent light fixture mounted
on the wall
h. 120 cm

The Metaphor Language of Mind

Subjective conscious mind is an analog of what is called the real
world. It is built up with a vocabulary or lexical field whose terms
are all metaphors or analogs of behaviour in the physical world.
Its reality is of the same order as mathematics. It allows us to
shortcut behavioural processes and arrive at more adequate
decisions. Like mathematics, it is an operator rather than a
thing or repository. And it is intimately bound up with volition
and decision.

Consider the language we use to describe conscious processes.
The most prominent group of words used to describe mental
events are visual. We 'see' solutions to problems, the best of
which may be 'brilliant', and the person 'brighter' and 'clear-
headed' as opposed to 'dull', 'fuzzy-minded', or 'obscure'
solutions. These words are all metaphors and the mind-space
to which they apply is a metaphor of actual space. In it we can
'approach' a problem, perhaps from some 'viewpoint', and
'grapple' with its difficulties, or seize together or 'com-prehend'
parts of a problem, and so on, using metaphors of behaviour to
invent things to do in this metaphored mind-space.

And the adjectives to describe physical behaviour in real space
are analogically taken over to describe mental behaviour in
mind-space when we speak of our minds as being 'quick', 'slow',
'agitated' (as when we cogitate or co-agitate), 'nimble-witted',
'strong-' or 'weak-minded'. The mind-space in which these
metaphorical activities go on has its own group of adjectives;
we can be 'broad-minded', 'deep', 'open', or 'narrow-minded';
we can be 'occupied'; we can 'get something off our minds',
'put something out of mind', or we can 'get it', let something
'penetrate', or 'bear', 'have', 'keep', or 'hold' it in mind.

As with a real space, something can be at the 'back' of our mind,
in its 'inner recesses', or 'beyond' our mind, or 'out' of our mind.
In argument we try to 'get things through' to someone, to 'reach'
their 'understanding' or find a 'common ground', or 'point out',
etc., all actions in real space taken over analogically into the
space of the mind.

Paraphiers and Paraphrands

If we look more carefully at the nature of metaphor (noticing all the while the metaphorical nature of almost everything we are saying), we find (even the verb 'find'!) that it is composed of more than a metaphier and a metaphrand. There are also at the bottom of most complex metaphors various associations or attributes of the metaphier which I am going to call *paraphiers*. And these paraphiers project back into the metaphrand as what I shall call the *paraphrands* of the metaphrand. Jargon, yes, but absolutely necessary if we are to be crystal clear about our referents.

Some examples will show that the unraveling of metaphor into these four parts is really quite simple, as well as clarifying what otherwise we could not speak about.

Consider the metaphor that the snow blankets the ground. The metaphrand is something about the completeness and even thickness with which the ground is covered by snow. The meta-phier is a blanket on a bed. But the pleasing nuances of this metaphor are in the paraphiers of the metaphier, blanket. These are something about warmth, protection, and slumber until some period of awakening. These associations of blanket then automatically become the associations or paraphrands of the original metaphrand, the way the snow covers the ground. And we thus have created by this metaphor the idea of the earth sleeping and protected by the snow cover until its awakening in spring. All that is packed into the simple use of the word 'blanket' to pertain to the way snow covers the ground.

Not all metaphors, of course, have such generative potential. In that often-cited one that a ship plows the sea, the metaphrand is the particular action of the bow of the ship through the water, and the metaphier is plowing action. The correspondence is exact. And that is the end of it.

But if I say the brook sings through the woods, the similarity of the metaphrand of the brook's bubbling and gurgling and the metaphier of (presumably) a child singing is not at all exact. It is the paraphiers of joy and dancingness becoming the paraphrands of the brook that are of interest.

Or in the many-poemed comparison of love to a rose, it is not the tenuous correspondence of metaphrand and metaphier but the paraphrands that engage us, that love lies in the sun, smells sweet, has thorns when grasped, and blooms for a season only. Or suppose I say less visually and so more profoundly something quite opposite, that my love is like a tinsmith's scoop, sunk past its gleam in the meal-bin. The immediate correspondence here of metaphrand and metaphier, of being out of casual sight, is trivial. Instead, it is the paraphrands of this metaphor which create what could not possibly be there, an enduring careful shape and hidden shiningness and holdingness of a lasting love deep in the heavy manipulable softnesses of mounding time, the whole simulating (and so paraphranding) sexual intercourse from a male point of view. Love has not such properties except as we generate them by metaphor.

We have said that consciousness is an operation rather than a thing, a repository, or a function. It operates by way of analogy, by way of constructing an analog space with an analog 'I' that can observe that space, and move metaphorically in it. It operates on any reactivity, excerpts relevant aspects, narratizes and conciliates them together in a metaphorical space where such meanings can be manipulated like things in space. Conscious mind is a spatial analog of the world and mental acts are analogs of bodily acts. Consciousness operates only on objectively observable things. Or, to say it another way with echoes of John Locke, there is nothing in consciousness that is not an analog of something that was in behaviour first.

If consciousness is this invention of an analog world on the basis of language, paralleling the behavioural world even as the world of mathematics paralleled the world of quantities of things, what then can we say about its origin?

We have arrived at a very interesting point in our discussion, and one that is completely contradictory to all of the alternative solutions to the problem of the origin of consciousness which we discussed in the introductory chapter. For if consciousness is based on language, then it follows that it is of a much more recent origin than has heretofore been supposed. Consciousness came after language! The implications of such a position are extremely serious.

1991
2 × 4s, tree, oil and acrylic paint, metal lath, papier maché, mirror
230 × 206 × 77 cm

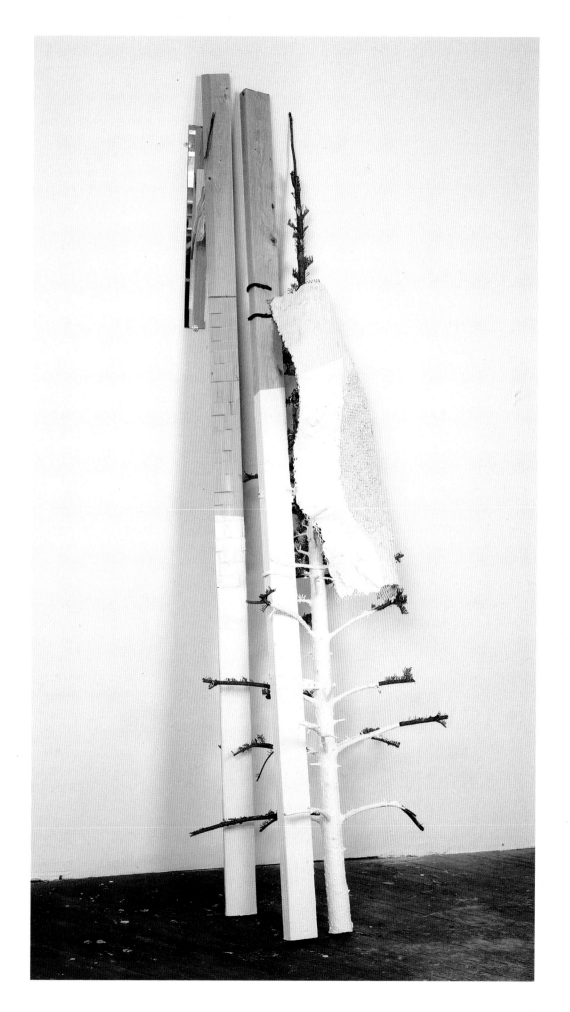

The Imaginary Institution of Society (extract)
Cornelius Castoriadis 1987

To say that the institution of society *leans on* the organization of the first natural stratum means that it does not reproduce or reflect this organization, is not *determined* by it in any way. Instead, society finds in it a series of conditions, supports and stimuli, stops and obstacles. To use the language of the preceding pages, society, like any automaton, defines its own universe of discourse. And to the extent that society is not simply the human species as a mere living or animal being, this universe of discourse is necessarily different from that of the animal, man. What is more, each society is an automaton of a different type, since (or in so far as) each establishes a different universe of discourse, since each institution of society establishes what, for the society in question, is and is not, what is relevant and what is not, the weight, the value, the 'translation' of what is relevant – and the 'response' that corresponds to this (...)

In the first place, for society there *exist* entities that correspond to no organization (whether identitary or not) of the natural stratum; to cite a few obvious examples, spirits, gods, myths and so on do *exist* for society. And what *does not exist* for society is not always, and not necessarily, pure non-being, absolute non-being, that which could never enter into the universe of discourse, even if it is only to be denied. Quite the opposite, the being of non-being, or non-being as such, always exists for society; into its universe of discourse enter entities whose being is or has to be negated, positions that must be asserted by means of explicit negations or that are presented only to be negated. The possibility of 'this does not exist' or of 'it is not like that' is always explicitly posed in the institution of society.

In the second place, for society as such there is no irrelevant information; the irrelevant exists only as a limiting case of the relevant. In other words, for society, there is no 'noise' *qua* noise; 'noise' always exists as something and at its limit is explicitly posed as noise or as irrelevant information. This takes us, by way of a seemingly minor route, to the very heart of the question of the social: everything that is, in one way or another, grasped or perceived by society has to *signify* something, has to be endowed with signification, and what is more, it is always already grasped in and through the possibility of signification, and it is only as a result of this possibility that it can finally be defined as devoid of signification, insignificant or absurd. It is clear that the absurd can appear – even, and especially, when it is irreducible – only on the basis of the absolute requirement of signification.

For an identitary automaton (or, for what amounts to the same thing, for a completely formalized calculus) to say that a term *is* means that it has a recognizable form that is determined and predetermined (it is an instance of a given *eidos*). And to say that a term 'has a meaning' (actually an abuse of language) is to say that this form determines the entry of this term into a determined and predetermined syntax of operations. (Of course, what is not or has no meaning *for* the automaton can act *on* it and, even, partly or totally destroy it.)

For a society, to say that a term *is* means that it signifies (is a signification, is posited as a signification, is tied to a signification). Once it *is*, it *always* has meaning, in the narrow sense indicated above, that is it can always enter into a syntax or can constitute a syntax in which to enter. The institution of society is the institution of a world of significations – which is obviously a creation as such, and a specific one in each case.

1993
Orange garbage pail, galvanized sheet metal, bolts, string, piece of wooden furniture, wood, paper, oil pastel, oil paint, acrylic paint, linoleum tile, electric wires, hinge
144 × 149 × 91 cm

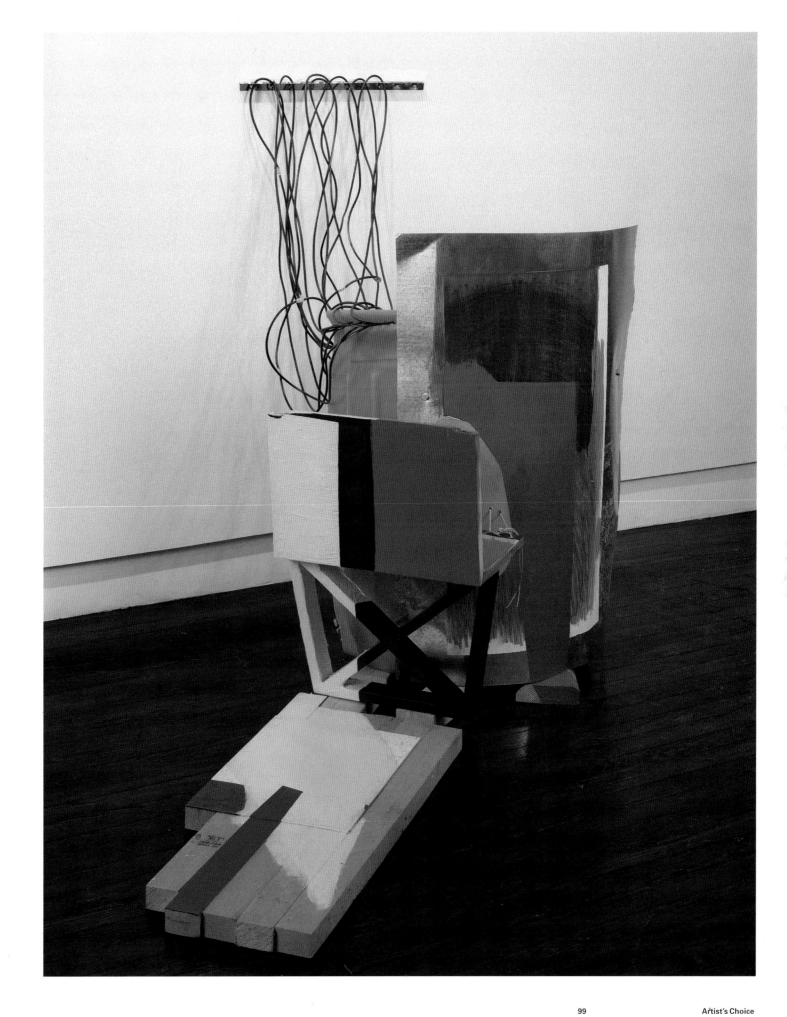

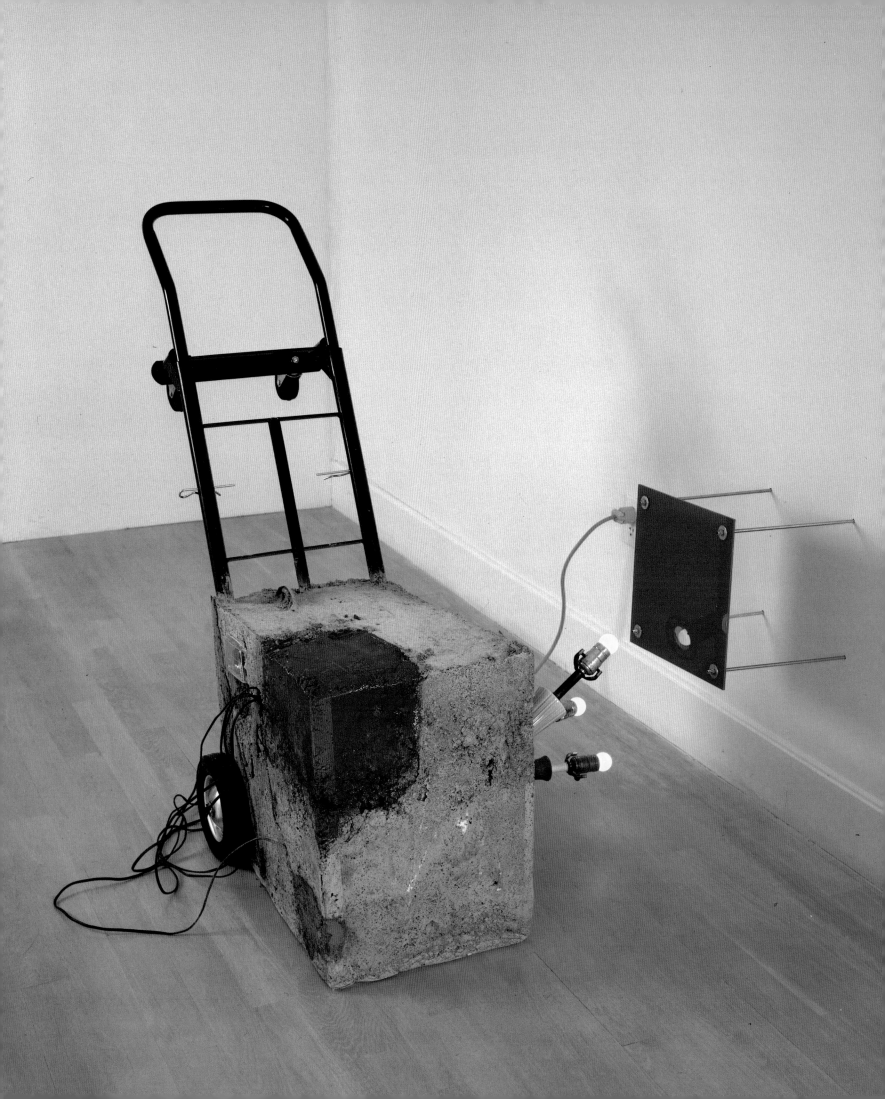

1994
Plexiglas, threaded rod, concrete,
lamps, small yellow bulbs, electric
cord, hand truck, car reflector
113 × 108 × 110 cm

1989
Piece of glass mounted on the
wall with yellow paint, wrought
iron table frame, tennis balls in
chicken wire with paint, raw
sheeps wool in net with paint
160 x 140 x 90 cm

The Mode of Being of the Unconscious

The unconscious, Freud wrote, is unaware of time and of contradiction. This dizzying thought, amplified and made even more insistent by Freud's entire work, has been almost entirely neglected – when it has not been made to say the opposite of what it states, by transforming the psychical apparatus into a real machinery or by reducing it to a logical structure. The unconscious constitutes a 'place' where (identitary) time – as determined by and as itself determining an ordered succession – does not exist, where contraries do not exclude one another; more precisely, where there can be no question of contradictory terms and which, itself, is not really a place since place implies order and distinction. Of the essential stuff of the unconscious, the representation, we can say practically nothing, if we confine ourselves to our customary logic. We are already doing violence to it when, in speaking of the unconscious (and even of consciousness) we speak of representation separating it from the unconscious effect and intention, which is impossible both *de jure* and *de facto*. The unconscious exists only as an indissociably representative/affective/intentional flux. But let us suppose this separation to be effectuable and already effected, and let us halt at representation as such. How could we fail to see that it escapes the most elementary logical schemata, that it slips past them on all sides, that it can never be subjected to any of the requirements of determinacy?

Consider, for example, Freud's dream: 'My friend R is my uncle, he wears a long yellow beard ...' Does this dream form *one* representation or *several*, and *how many*? What sort of thing is it of which we cannot say, even *with respect to* ..., whether it is one or many? Or consider the analysis of 'little Hans'; what is, *for* little Hans, the representation of his father, of the horse, of his phobia and the relation between them? We are fooling ourselves, in the last case, when, carried away by the habit of interpretation, the necessity of translating the givens of the unconscious in linguistic terms and in the relations forged in and through language, we posit *the* representation of the father and its representation or 'symbolization' by the animal of the phobia as a clear and distinct relation, a simple *quid pro quo*, the positing of one thing for another thing. To be sure, if we do not return to this world of interpretation and of the translation into waking language, we would be able to say nothing at all. But the actual situation is not really similar to what we do when we speak about it – as anyone who has ever dreamed will know. What is more, you do not even have to dream to see this. Mélanie Klein's little Richard says: 'Mama *is* the fish *and* the big fish above'; he is not saying that x is (for) y, he is saying that y *is* at once x and z (...)

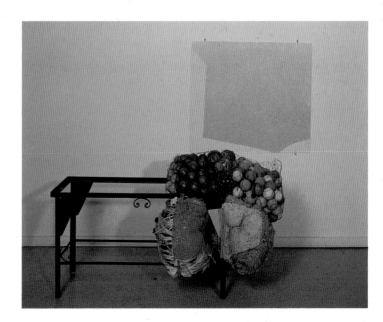

1989
Car fender with stuffed animals,
styrofoam, newspaper, cloth,
plaster, oil paint
134 × 67 × 29 cm

The Leaning of Society on Nature

How are we to understand the leaning of the first natural stratum on the ensemblizable dimension? Men and women live in society; they can be unambiguously classified (biologically) as male and female. They give birth to boys and girls who are, always and everywhere, incapable of surviving unless they are cared for by adults for a rather long period of time. All of this results neither from the legislation of transcendental consciousness nor from the institution of society. The ensembles of males and females, or children who have not yet reached a sufficient degree of biological maturation are, considered strictly as such, given in nature, as are, with certainty or extreme probability, the attributes affecting them. The institution of society is always *obliged* to take into account this division of the collectivity (considered as a set of heads) into two subsets, male and female. But they are taken into account in and through a transformation of the *natural fact* of being-male and being-female into an *imaginary social signification* of being-man and being-woman which refers to the magma of all the imaginary significations of the society considered. Neither this transformation itself nor the specific tenor of the signification in question can be deduced, produced or derived on the basis of the natural fact, which is always and everywhere the same. This natural fact puts stops or limits on the institution of society, but the consideration of these limits results in mere trivialities. When, as is the case, a certain archaic society compels the men, for weeks after the birth of a child, to mimic the woman in childbirth and to take her place, one may triumphantly point to the fact that men can never actually be obliged to give birth. But in order to know this, there is no need to study society, we could have simply looked at a herd of goats. What is important to us is, obviously, how and why a society obliges its men to mimic the situation of the other sex and what this signifies. In the same way, no society institutes men and women in such a way that they are, for one another, absolutely

undesirable. But to say that a minimal heterosexual desire must be tolerated by the institution of society, under pain of the rapid extinction of the collectivity in question, still says nothing about the unending alchemy of desire that we observe in history – and this is what is important to us. Likewise, a natural fact can provide support or stimulus for a particular institution or signification, but an abyss separates this support or stimulus from a necessary and sufficient condition. Supports and stimuli are taken into account in one case, ignored in another, cancelled out or directed uphill in a third but, everywhere they are recovered, transformed, transubstantiated by their insertion in the network of imaginary social significations. We have only to think of what becomes, in different societies, of the natural facts of the human male's superior physical strength or of female menstruation.

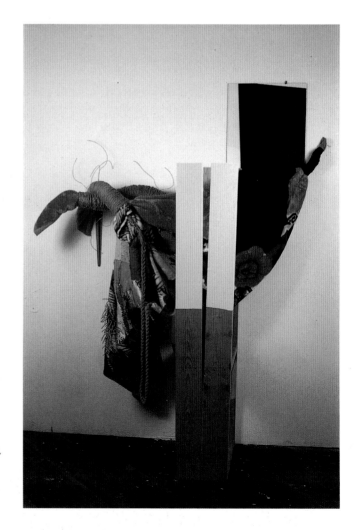

1994
Blanket, yarn, twine, sweater,
plastic watering can, acrylic paint,
tape, silicone caulking, 5 × 14
wood, glass, oil paint, 3 mirror
clips, wire, metal brackets
158 × 199 × 58 cm

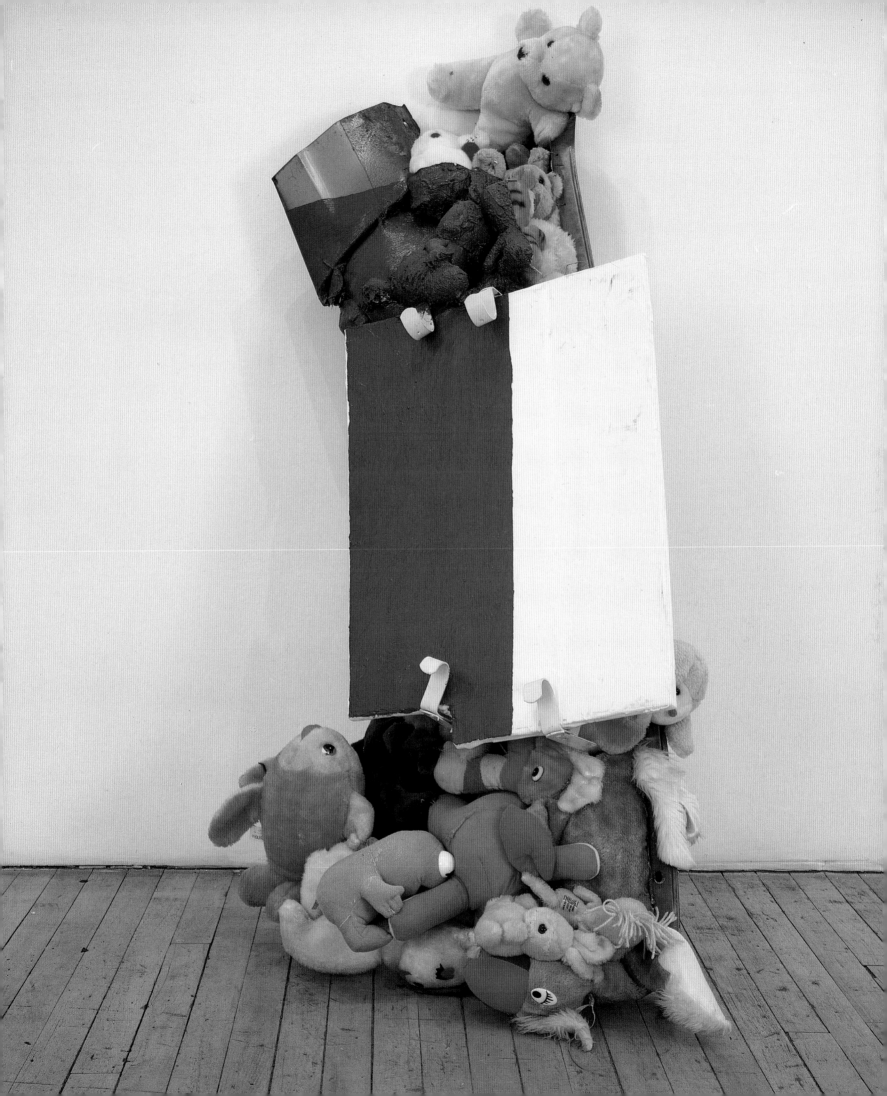

There was no carpet in
the bathroom. The bath tub was ~~close~~
to the toilet. If the shower curtain hung
too it brushed up against my leg and
~~that~~ This disturbed me. The baths did
inviting. I took showers. The problem
showers was the sticking of the sh...
I never did get used to it
unknown bodies.

When my ~~husband~~ arrived he to
what was ~~to him a sp~~ for him
bathtub. I followed suit, ~~although~~
my was the last in the tub

Contents

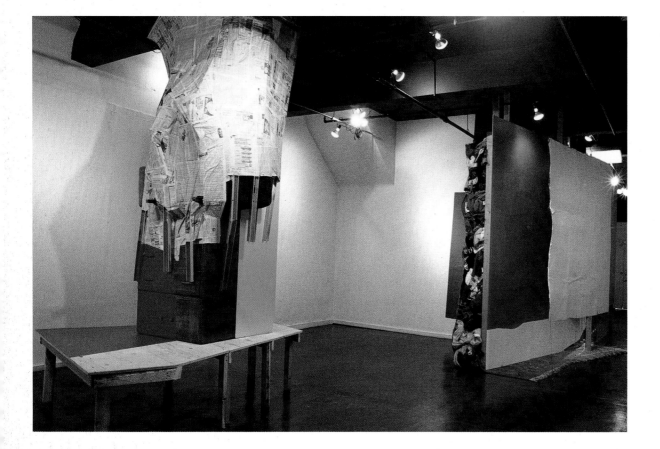

It's Not Over 'til the Fat Lady
Sings
1987
Wood, sheetrock, paint,
cardboard, paper, carpets, plaster,
clothes, furniture, papier maché
Space, l. 816 cm
Installation, Contemporary Art
Gallery, Vancouver

My work has always grown from an attempt to gain a sense of control of, or at least comfort with, the material world. This discrepancy between the ease with which I can think of building something and the effort involved in actually building it is always a shock; even so, after finishing every piece I am awed at my own accomplishment.

This piece is the first in many years I have made in Vancouver, my home town. It is literally made of objects from my past, clothes and furniture taken from my parents' basements, and is titled by my grandmother. The work organizes this collection of history and objects, the very same history and objects that, having always eluded my control and understanding, have left me to this day trying to fit the pieces together into an ever-shifting whole. Together with my rather complicated network of family and friends, I can stand back from this work and match the present to the past. I am not sure how this bit of private information will inform the work for a wider public, but I hope that these bits of information will perhaps resonate with people's experience of the work.

However that may be, more available to a general audience is the experience of the things in the gallery; the clothes packed together forming a wall with gyproc, 2 x 4s and carpets. The weight and solidity of these clothes and wall are pushed up

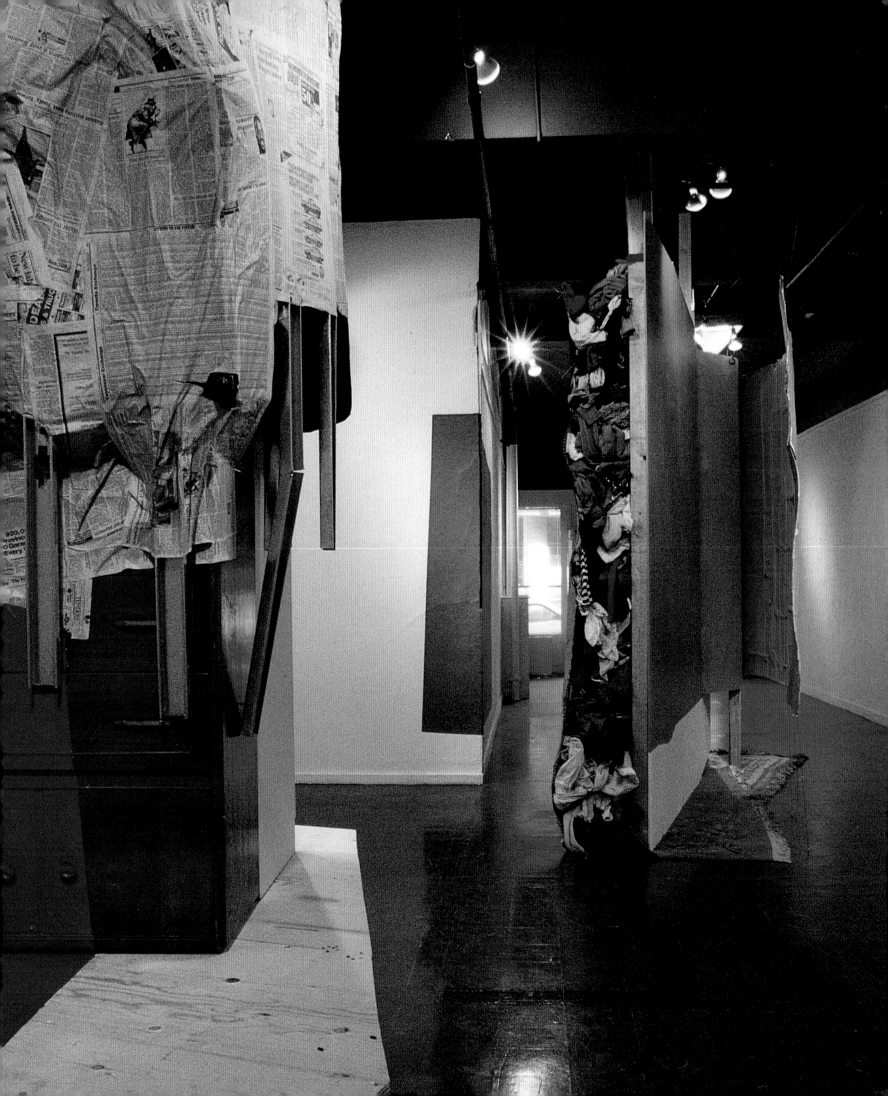

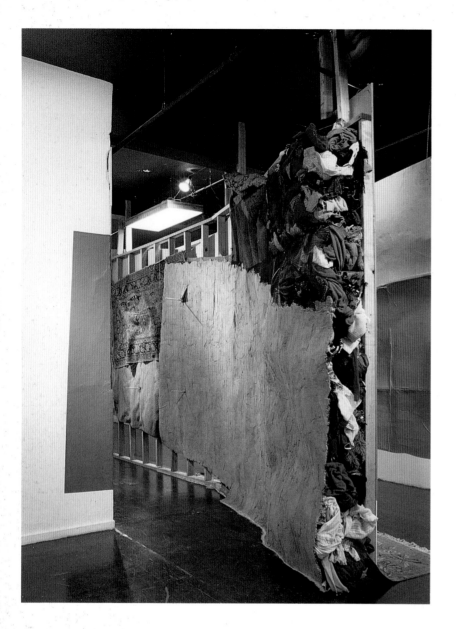

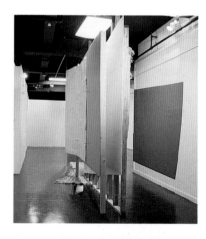

against and compared to the weight and size of the flat painted colours on it and near it. As one walks through and around the gallery, the painted colours interact with each other and form an independent composition. At the same time these painted colours interact in a more subtle way with the objects on which they are painted or sit next to. The painted green stucco blends quietly into the unpainted colours of the clothes and carpets, even while it quickly reaches out to the painted turquoise patch across from it.

Clothes act as skins over our skins; carpets act as skins on our floors; walls are the skins of our rooms; we see the outside skin of the furniture; and the paint acts like a skin on all of these skins, including that of the gallery wall. All of these skins are intermingled and woven together. As one moves through the piece, all of the parts of life thus represented form a constantly shifting but balanced composition. They do not yield the impression of a unified work, separate from one's self, until one stands at the far corner of the gallery with one's back to the wall. The work is now seen against the opposite wall of the gallery. From this position it is seen and felt as a complete whole, other from the viewer. However, this experience is informed by the memory of having moved through the piece – by the memory of how it was revealed over time.

'It's Not Over 'til the Fat Lady Sings' (cat), Contemporary Art Gallery, Vancouver, 1987

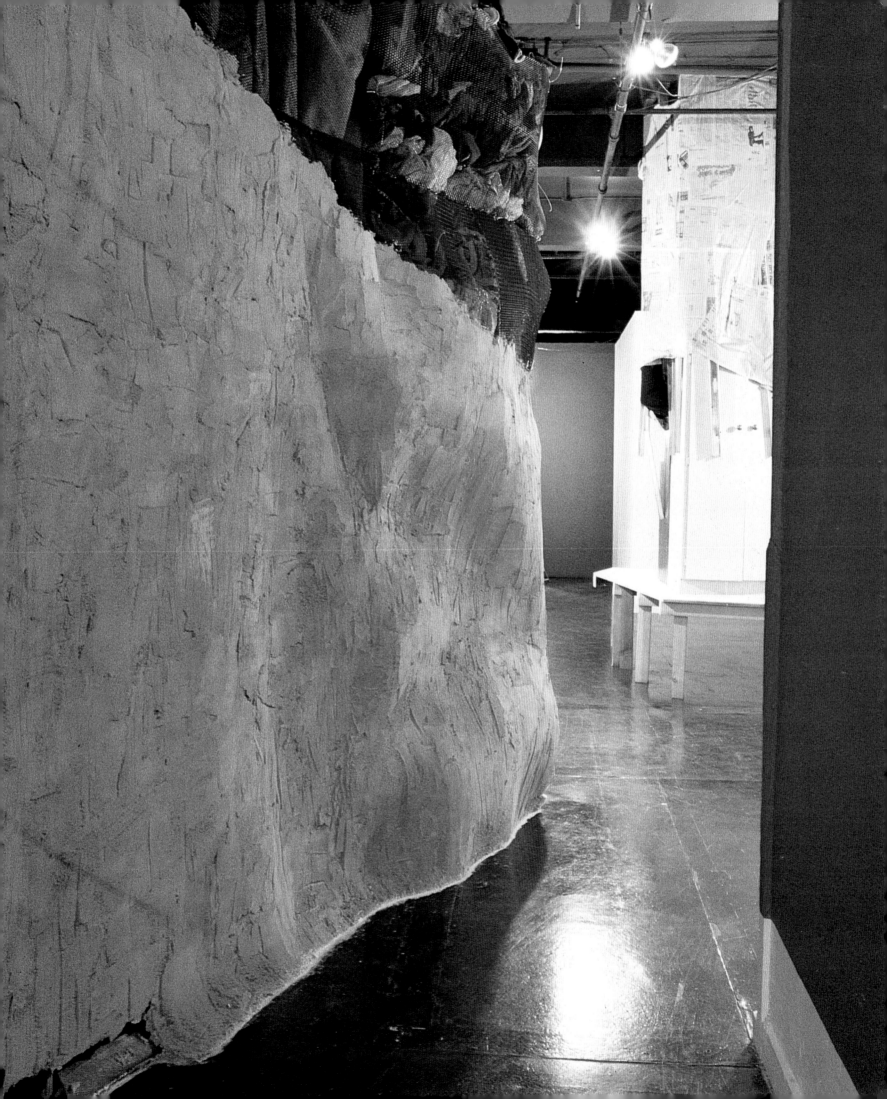

The State of Things, Questions to Three Object-Conscious Artists (extract) 1990

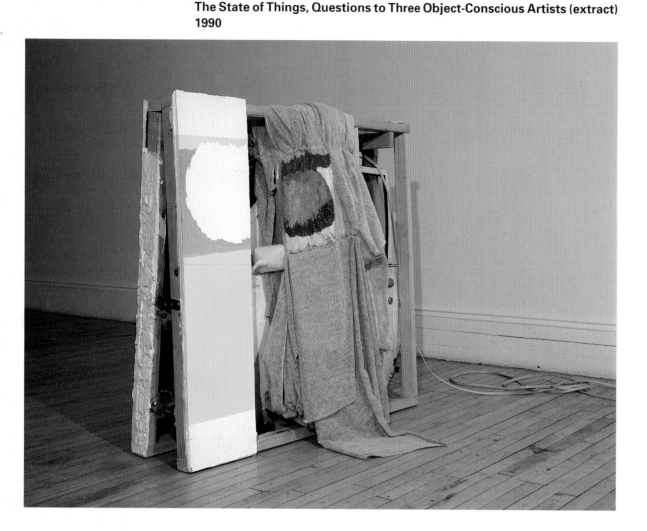

Robert Nickas 'The State of Things' applies to the way you work as well as to the work you produce. It applies to the object or objects both before and after the fact of being exhibited, presented as sculpture. In other words, these are objects that, having been brought into a studio or gallery, are not completely removed from the world from which they were taken. In your work, the original identity of the objects is preserved – even if they are radically combined with others.

Jessica Stockholder **My work makes use of the state of things. I make my work on top of what is already there. Of course the result is that the work is made of what is there. It is an interweaving of how I see things, how other people have seen things before me and how people see the work after I make it.**

By mixing together elements that most people take for granted as being part of the 'real world' with elements that I make, elements which in some way express or represent emotional experience, my work calls the 'real' elements into question. Don't they too represent and express emotional experience? And it follows then that the elements I make may be as 'real' as the rest.

Nickas In this sense, you don't seem to be solely involved with 'ideas about the thing, but the thing itself'.

Stockholder **My starting point is with real stuff in the world, whether it be raw material or some kind of a functioning object. The particular qualities of these found materials give rise to the work. But the objects I choose are not precious; other objects might have served equally well. The final work is dependent on the narratives, evocations,**

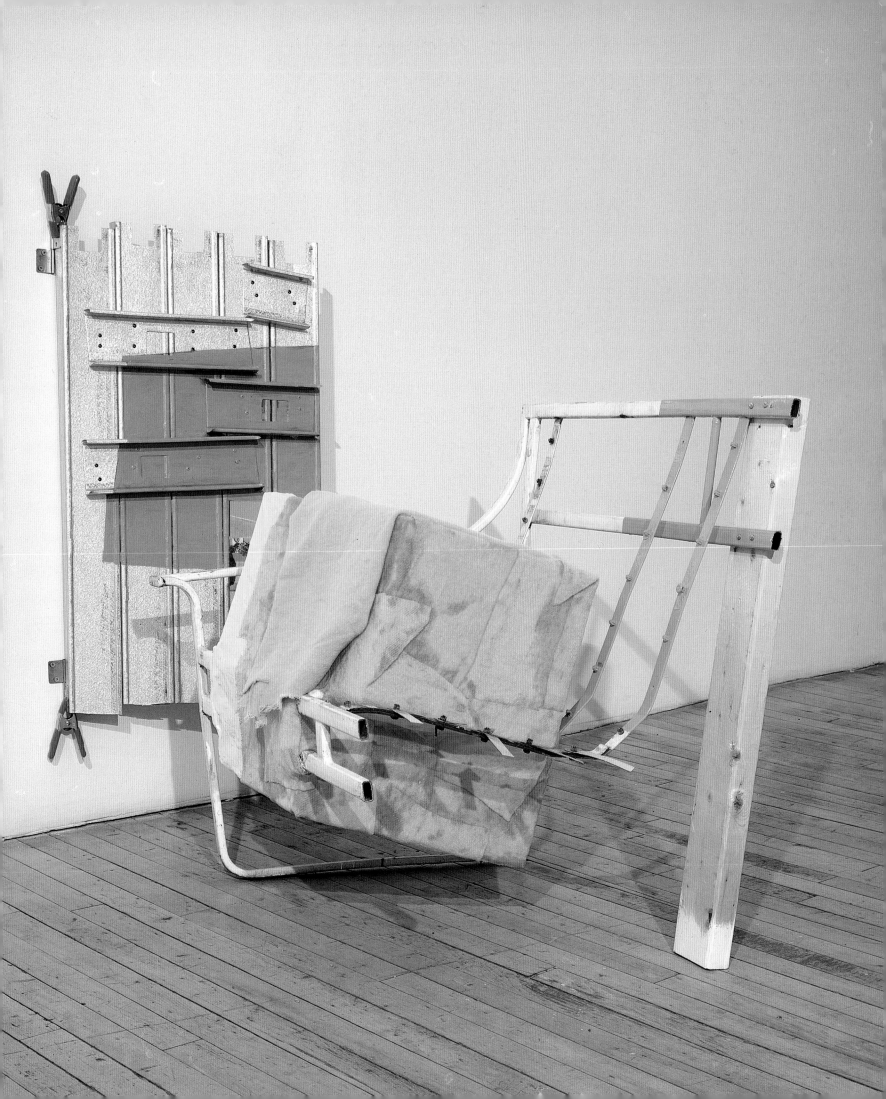

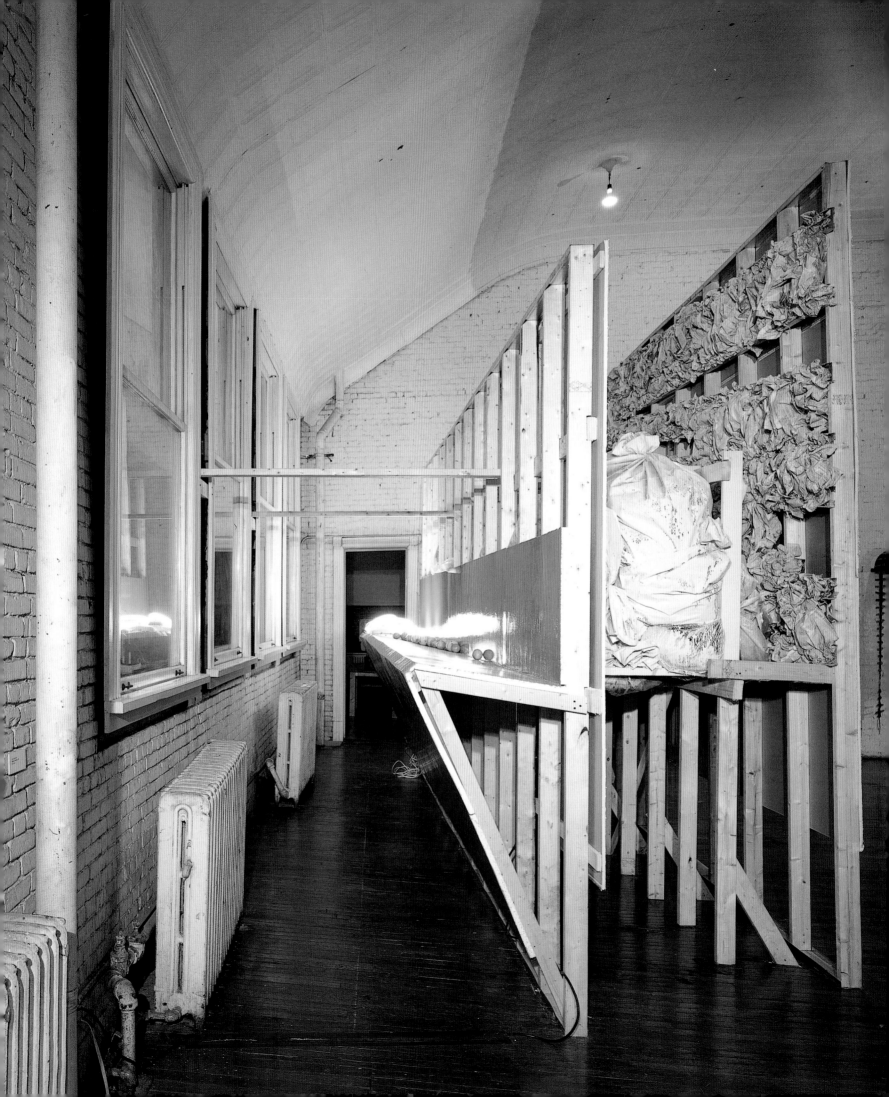

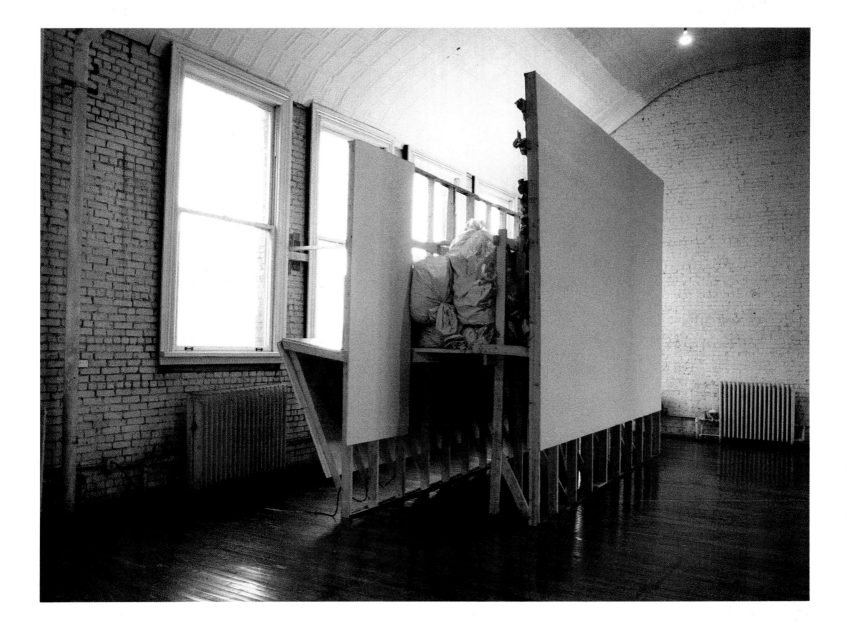

Making a Clean Edge
1989
Construction materials, garbage,
oranges, lights, paint
Approx. l. 576, h. 403.2 cm
Installation, PS.1, Long Island
City, New York

and metaphors given rise to by the found materials, while at the same time existing
as something other that might have attached itself to a different set of circumstances.
The work is formal. Meaning is generated through the method of building and as a
consequence of a knitting together of material elements.

Nickas Can we talk about the world as yielding things as raw material?

Stockholder **We certainly experience some materials as 'raw'. What that means is
always in question; isn't 'raw' just another category of our making?**

Nickas Does this have any bearing on making some order of what we might call the chaos
of the world? ... even one piece at a time?

Stockholder **Life is a process of making order. My work brings the notion of chaos to
the fore but all work, artwork and otherwise, makes order where there is little or none.**

Nickas Can we look at your work in terms of it being unfinished – not incomplete, but still

within a 'life-cycle,' so to speak?

Stockholder **I have a large interest in garbage (as we all do). I use a lot of garbage in my work because it brings with it a process that continues despite what I might do to it. The work will decay; it is not with us forever despite our desire that art might be. Garbage, on the other hand, is.**

My work is complete when the questions and discontinuities within it become tied to one another and form a circular process of referencing that excludes any further struggle from me. I move on to the next. The work contains, or perhaps it might be better to say, it elicits that same struggle that goes into the making of it. It is a struggle between stasis, or completeness and an ongoing continuation (…)

Nickas Can we talk about your sculpture as *place?* And think about what goes on 'there'?

Stockholder **When I make an installation, the place I'm working in is important but equally important is what I bring to the place; or perhaps it would be better to say that it is important to make clear that how that place is experienced is subject to wide variation dependent on how it has been treated, what I do to it and who's looking.**

The idea of place is interesting in that while a place is a physical actuality it doesn't exist as such independently of how we treat it, how we view it or how we understand it. This quality of place has been recognized by Gaston Bachelard in his book *The Poetics of Space*. Every place is highly evocative.

Nickas What of the place of the viewers – their reception of the work in terms of it being 'unfinished'?

Stockholder **My hope is that the viewer will, like me, become engaged in a struggle between viewing a static *fait accompli* and feeling as if they are participating in a series of contradictions and narratives that come to no settling conclusion. I feel that my work provides both experiences and argues for the necessity of both. The narratives and evocations my work gives rise to are intended to be wide ranging. They are the result of my personal history, the culture I live in and the histories brought to the work by all those who take an interest.**

Nickas Can we talk about behaviour as raw material?

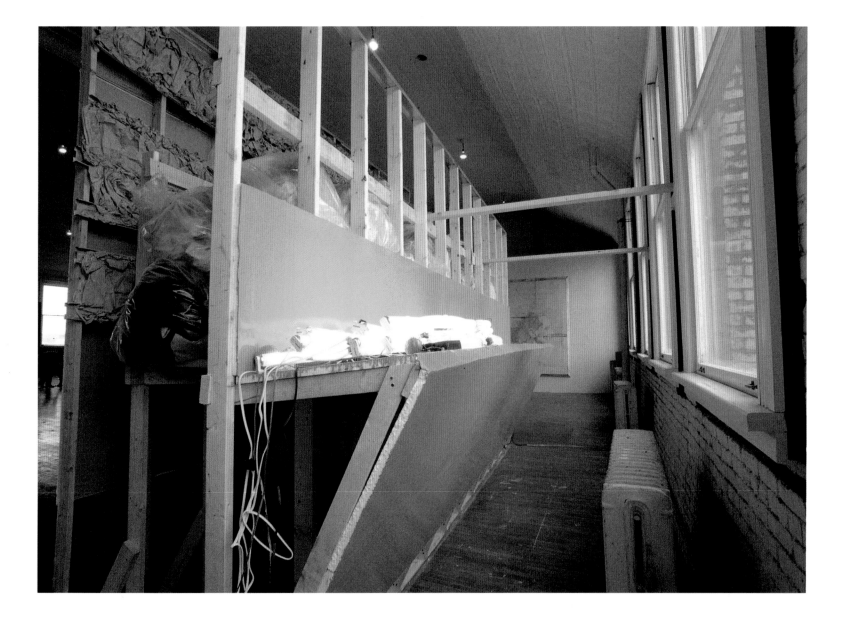

Stockholder **Behaviour as raw material. It's not how I would begin speaking of my work except to say that viewing the work is a process that takes place over time; it involves putting various pieces of information together and it takes an active human being to do that. I could also say that I would like it if my work forced recognition that that pleasant sensation of passive viewing is actually an active position.**

Nickas Having asked/said all this, how might the following apply to your work?
'It is always changing. It has order. It doesn't have a specific place. Its boundaries are not fixed. It affects other things. It may be accessible but go unnoticed. Part of it may also be part of something else. Some of it is familiar. Some of it is strange. Knowing of it changes it.' Robert Barry, *Art Work*, 1970

Stockholder **All of these things could be said of my work but I would also say that I am concerned with how our perception of art as being separate and eternal meshes with the facts stated in this paragraph.**

'The State of Things', Robert Nickas in correspondence with Gretchen Faust, Laurie Parsons and Jessica Stockholder, *Flash Art*, Milan, March/April, 1990

Interview with Klaus Ottmann 1991

Clyfford Still
Painting 1944-N
1944
Oil on unprimed canvas
264.5 × 221.4 cm

Henri Matisse
Bathers by a River
1916-17
Oil on canvas
247 × 369 cm

Richard Serra
Floor Pole Prop
1969/78
Antimonium leaden sheet propped
against the wall by rolled up
antimonium leaden sheet
sheet, 241.5 × 254.5 × 1.6 cm;
roll, 250 × diam. 15 cm

Klaus Ottmann What are the most important issues in your work?

Jessica Stockholder **My work developed through the process of making site-specific installations – site-specific sometimes in very specific ways but also just by virtue of being 'art' in a room; there's at least that much going on between the work and its context; after all, paintings don't hang on trees. In all of the work I place something I make in relationship to what's already there. With installations it's the building, the architecture, or you might say, it's the place that I work on top of; with the smaller pieces I work on top of or in relation to stuff that I collect.**

I don't see a dichotomy between formalism and something else. Form and formal relations are important because they mean something; their meaning grows out of our experience as physical mortal beings of a particular scale in relationship to the world as we find it and make it. I don't buy that formalism is meaningless.

Ottmann Is there a particular aesthetic involved when you look for materials?

Stockholder **It doesn't matter what I use. It can be anything. What's interesting is how what I'm doing meets with the stuff I use.**

But then it's not entirely true to say that. I also choose things for particular reasons though not according to a particular aesthetic. More often I avoid the development of a cohesive look that will too powerfully direct the work in only one direction.

A lot of people have written about my work in terms of junk; that I sometimes use junk doesn't seem of central importance to me. I use all kinds of things, old and new. Much of the stuff I use could be found in your living room.

Ottmann There is that danger of junk becoming 'art' by itself, without the artist adding meaning.

Stockholder **I rely on that tendency to aestheticize as I do on chance and happenstance. What's exciting is how the more clearly structured, more formal, more pictorial side of the work meets the more chaotic – sometimes very clearly and logically, then bleeding off in all kinds of directions.**

I see it as a mesh of Kaprow, Tinguely and the Surrealists on the one hand, using chaos and chance – making systems out of happenings; and on the other hand meshing that kind of thinking with formal painting and Minimalism.

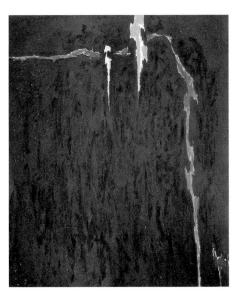

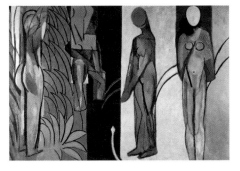

John Cage's thinking also had a lot of influence.

Ottmann Are there other influences that you would like to mention?

Stockholder **I studied with Mowry Baden in Victoria. He's a sculptor with a large appreciation for painting; he addressed my work in both points of view. That's part of how I got where I am.**

Ottmann How did painting come to the work?

Stockholder **I started as a painter and I never stopped making paintings. And still, part of what interests me is a pictorial way of looking at things. Viewing through pictures is part of our experience of the world, an experience which happens to be often associated with art.**

 Standing in front of one of my pieces, its size is important in relationship to your size, you feel how heavy it is or what the light is like in the room, and all that kind of information is seen in relation to the pictorial structure in the work. The thing cues you to measure one side against the other, trying to balance it as you would a picture, and for me, looking at things in a pictorial way includes a distancing where the thing that's pictured is far away and a little static, unchanging, without time. This distancing is exaggerated by the 'art' status of the work which brings with it a feeling of preciousness and the feeling that the work is somehow removed from or above human life. These qualities are seductive and they make me angry. So I place the pictorial in a context where it's always being poked at. The picture never stands, it's always getting the rug pulled out from under it.

 I also love colour; and colour hasn't been dealt with much in sculpture.

Ottmann Do you relate more closely to an American or a European painting tradition?

Stockholder **I relate more to an American tradition, though probably to both. Matisse, Cézanne, and the Cubists certainly are important to me. I also feel a strong affinity to Clyfford Still, Frank Stella, the New York School hard-edge painting and Minimalism, as well as Richard Serra.**

Ottmann When did you decide to make smaller, site-independent objects?

opposite, 1991
Two elements, no 1, wood,
furniture, papier maché,
newspaper, acrylic paint, cable
173 × 94 × 62 cm
no 2, wood and paint
170 × 2.5 × 2.5 cm
Overall, 173 × 55 × 200 cm

right, 1991
4 elements, no 1, plywood covered
with linoleum tiles, enamalac
paint, latex paint, oil paint,
cloth, papier maché, 2 wheels,
aluminium, metal strapping,
hardware
89 × 96 cm
no 2, escalator sleeve banded
together
Approx. 120 × 72 × 138 cm
no 3, carpets, wool, one bolt and
nut
84 × 10 cm
no 4, blue extension cord, orange
hook
Overall, 209 × 288 × 74 cm

Stockholder When I moved here I had no studio. I was working in my apartment. It didn't make sense to build installations there and I didn't want to have to find a show in order to be able to make my work. So I started to make objects. The first one I made had a light pointed at the wall making a circle of colour. The light uses electricity which is happening in time; although the work is static, a piece of art with this removed sense about it, the light gives it a sense of happening. Also, there's colour on the piece and colour on the wall from the light; the colour on the wall from the light is kind of ephemeral, and it's not physically attached to the piece, but the two things, the piece and the wall need each other to be a complete thing. So though I was making an object, it broke down a little bit. It wasn't isolated unto itself.

I also like that the smaller pieces are physically easier, more in my control. And I can work out ideas that I later use in installations.

Ottmann Could you say something about how meaning is generated within your work?

Stockholder My work often arrives in the world like an idea arrives in your mind. You don't quite know where it came from or when it got put together, nevertheless it's possible to take it apart and see that it has an internal logic. I'm trying to get closer to thinking processes as they exist before the idea is fully formed. The various parts of my work are multivalent as are the various parts of dreams. At best there are many ways to put the pieces together.

Brochure published on occasion of 'The Broken Mirror', Part Three, Center for the Arts, Wesleyan University, Middletown, Connecticut. Re-printed, *Journal of Contemporary Art*, New York, Spring/Summer 1991.

Interview with Stephen Westfall 1992

 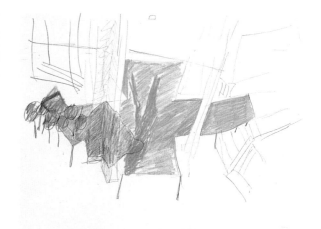

Stephen Westfall It's funny that you express nervousness over the interview process because those stages that I've described, the transcription of the interview, and the restructuring of questions to establish a certain compacted continuity, find a corollary in your work process. You talk about the power of your own work coming from overlapping systems. The interview process is a literary version of that. It is part performance, on an intimate scale, for a projected audience. When you pull your work together in an installation the art audience has also yet to arrive.

Jessica Stockholder **Yeah, and the process of making it isn't observed. I mean, right away when you turned the tape recorder on there is another part of me watching that wasn't there before. Making an installation doesn't shift that much from being in my studio.**

Westfall Even though you are manipulating, engaging and evoking feelings about yourself in the process of your work – an ongoing construction of identity. Do you think there is something very strange about the creative ego in art? There is a persona that I've become aware of in my own pile-up of work over the years.

Stockholder **I've recently become aware of the pile-up of work as intrusive. When I made a decision about something I was going to do, it used to be very charged. Whatever I chose would become incredibly important because I chose this one way out of five. But now, with a history of having made similar choices, and knowing that I am going to do it again so many times, the weight on each decision is very different and that's a little unnerving.**

Westfall Is it unnerving because there is an attachment to the idea of art being spoken from a sense of urgency or desperation?

Stockholder **Perhaps, and there is also a comfort in thinking that the one choice you made was the right choice. Now I have this whole array of choices clearly possible from past experience and an imaginary future. It is clear that any one of those, or many of those choices could take one down an equally interesting path and be equally valid. I can't believe anymore that there is one right way to do things. I'm not sure that I ever did, but I think that I would have liked to.**

Westfall Your work has an almost shocking sense of freedom of erasure and change, and uses that erasure or change as the connective tissue to a gestural extension.

Edge of Hothouse Glass, drawings
1993
Pencil, crayon on bristol board
26 × 34 cm

Stockholder **There is a covering up, a hiding of things and also an incredibly up-front quality. I don't often erase things, like make a mark and erase it the way you would on a drawing. I see it more as a covering up. It happens through a positive action rather than a negative one.**

Westfall Oh, so it's obscuring by accretion rather than by attrition.

Stockholder **Yes, exactly! I'm deciding not to show it.**

Westfall What you did before is included in the passage of surface. Nothing is lost and yet, somehow something is inherently revoked by change.

Stockholder **Well, I would agree with you but I think that it is irrevocable for my process, not for the finished product. Having noticed that I did something, that is irrevocable for me and my experience. It's not irrevocable in terms of what gets presented to the world. It is important to notice what it is you decided to do in the world.**

Westfall And your next action becomes a response to the consciousness of how you've just acted. In both our everyday lives and the presumably heightened consciousness of studio activity we have habitual actions. But to notice, in the way you are talking about, shakes us out of the conscious sleep of our habits. Does this happen in spite of the program established by your preparatory drawings?

Stockholder **It does. They don't tell me exactly where in the space something will begin and end, or exactly how material will be there, or in many cases how it will be made, how something will be held together – all of which in the end is a large part of what the work is about. So the drawings for the installations are an outline that lets me decide to order some materials, and usually determines my thinking about how I am going to address the space. Sometimes I abandon them once I start to work, or at least I change a lot. They can get in my way a little bit. I try to leave things open enough so I don't have the feeling that I know what I am doing when I get there.**

Westfall Colour becomes such an emotionally or psychologically directive element in your work and I notice that you often make basic colour decisions in your drawings. Have you ever found yourself deciding that a certain colour scheme is just not going to work in the

Monday August 3rd, 1992

Attention: Georg Kargl
From: Jessica Stockholder

Dear Georg,

Thanks for letting me know about the fans you purchased.

I now have a clearer idea of what I am going to do and I want to let you know about some of the materials I will be needing that may need to be ordered or that you may need to look for.

- I will need 250 red bricks. I am looking at some in the catalog from the Bau Welt Sochor; on page 8 it says Wienerberger Landhaus Pflasterklinker. There are two prices one for rauh and one for glatt. I think that means rough and smooth. The cheaper of the two is fine.

- I will also need some metal lath and a plaster material which is called structolite here. It is plaster mixed with perlite used as a base coat when making plaster walls. It has a working time of about 45 minutes and can be put over metal lath with a trowel. I am hoping that you have something like that in Vienna.

- I am thinking of hanging the fans and this plaster covered lath on cables strung between the ceiling and the floor. Let me know if this is a problem. I will need to put holes in the ceiling; I don't know what it is made of. And I am planning to put holes in the mortar in the floor between the stones.

We will be arriving on August 22 at 8:30 in the morning on Austrian Airlines flight 502.

Following this page I am sending you a couple of drawing.

See you soon.

All the best,

Jessica

July 21, 1992

Attention: George, Christian, & Renata,

I would like to use some fans in my installation this September and I have been thinking that it is probably much easier to get them now then it will be then.

I saw in a Baumart there just what I want. They are small turquoise fans that clamp on to shelves. The blades are open; they are not covered. I am going to try and fax you a picture a took when I was there.

If it is possible I would like to use between 20 and 30 of these.

I hope you're all having a good summer. See you soon.

All the best,

Jessica

middle of the action of the work?

Stockholder **Yeah, sometimes I just change the colour, but sometimes I start to use the colour differently. Like the piece that I have just made in Vienna. Before I got there, I was thinking about the colour green creating a kind of atmosphere or charging the air in front of it, and green doesn't do that. Yellow and red do that.**

Westfall At least certain types of green.

Stockholder **Yeah, so the way in which the piece became cohesive was entirely different than how I thought about it in the drawings. The emphasis in the work changed to one of surface, because of the particular qualities of that gallery.**

Westfall Did you keep the green?

Stockholder **Yes, I kept the green.**

Westfall And relinquished the idea of charging the atmosphere?

Stockholder **Yeah.**

Westfall And what did you gain when you let go of that original hope or intention?

Stockholder **It has something to do with time restraints, energy and physical capability. To do the whole piece again might not have been possible. I tend to take advantage of**

SpICE BOXed Project (ion)
1992
Raw sheeps wool, sand paper, concrete, metal weights, aircraft cable, tape, aerated concrete blocks, bricks, suitcases, plastic, hoses, heavy duty electrical cables, 26 fans, 4 fluorescent lights, plywood, acrylic, enamel, latex paint
264 × 168 h. 144 cm
Installation, Galerie Metropol, Vienna

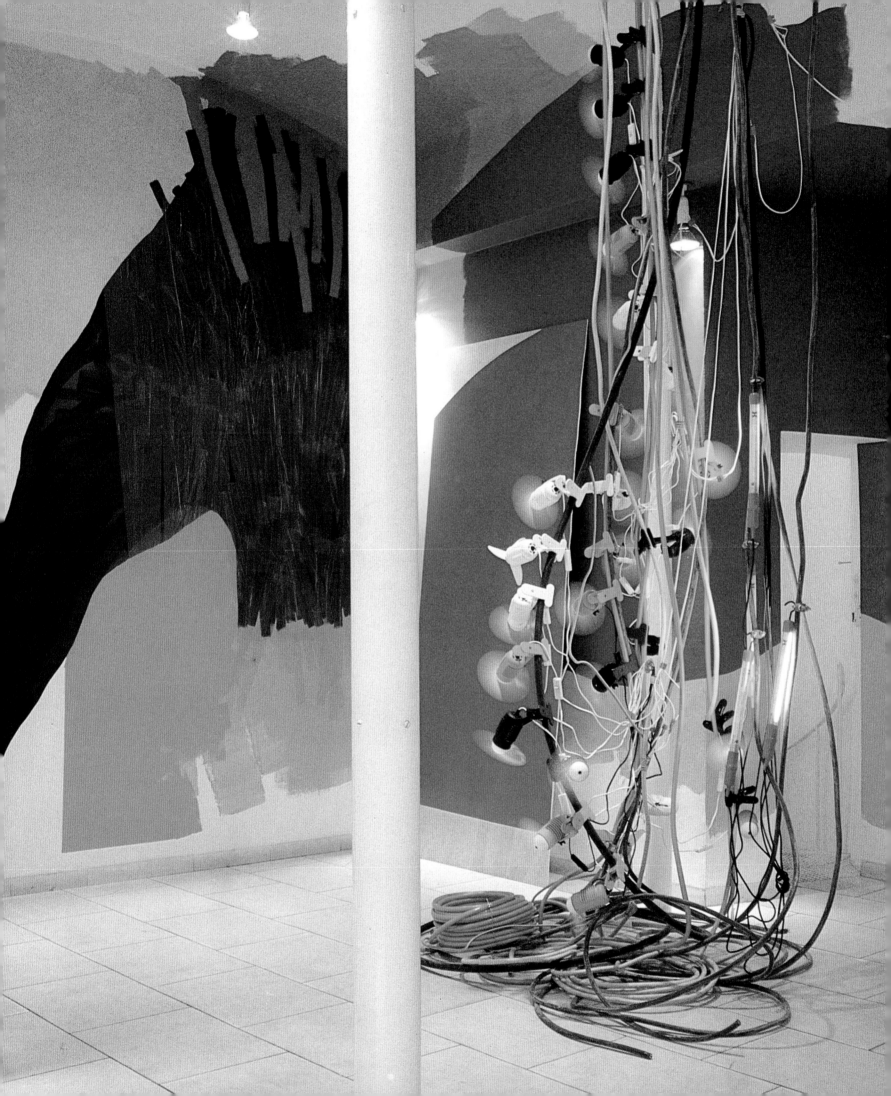

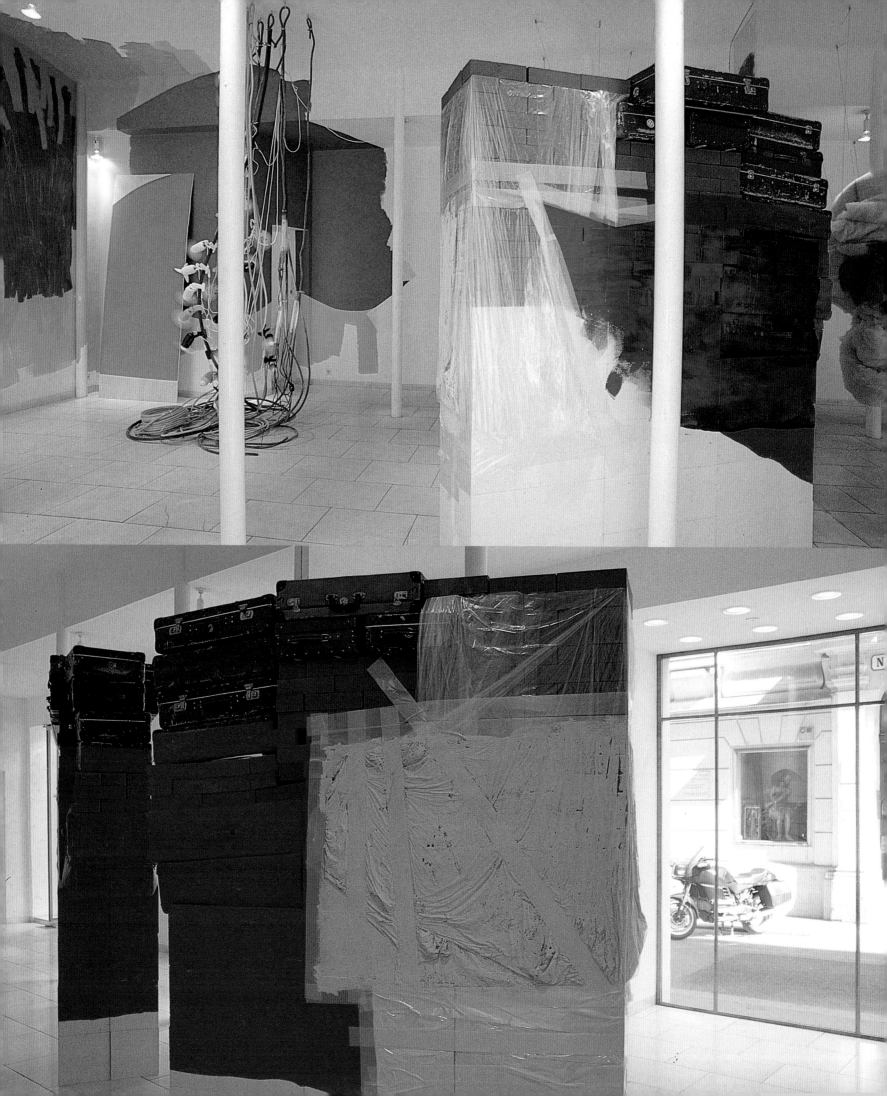

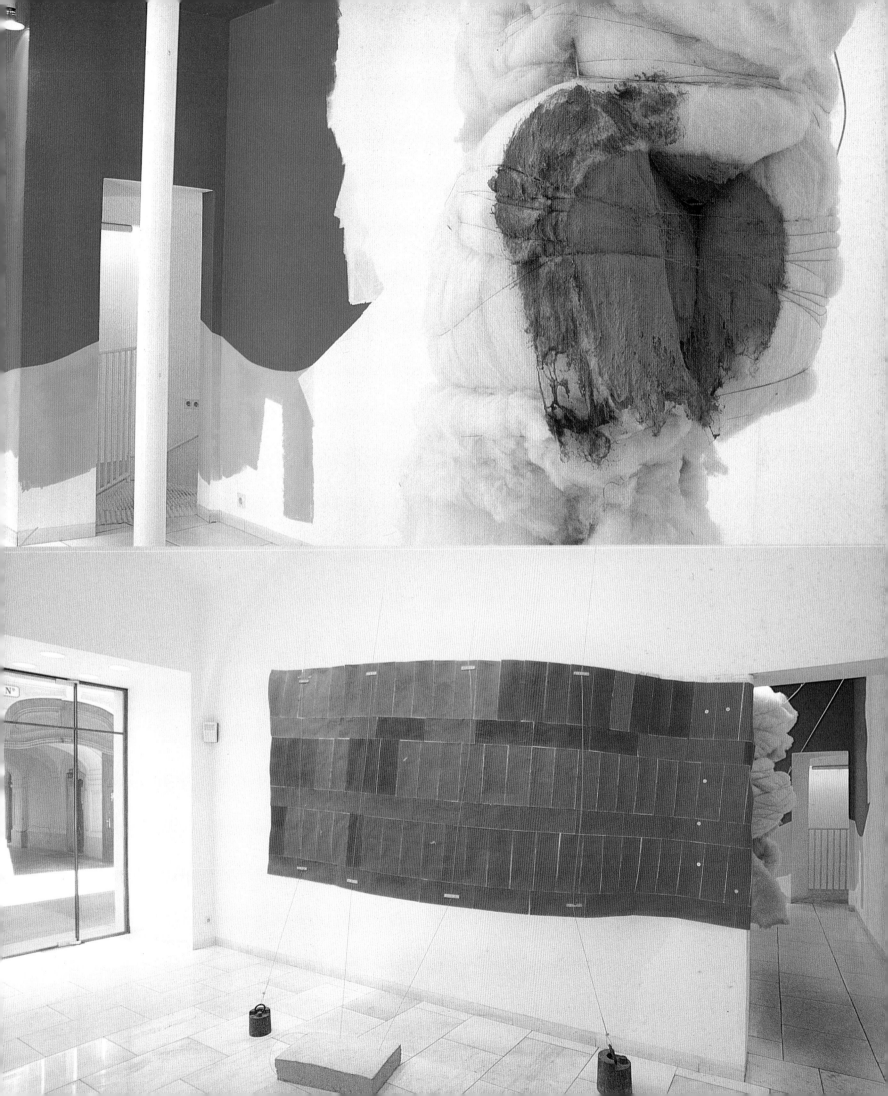

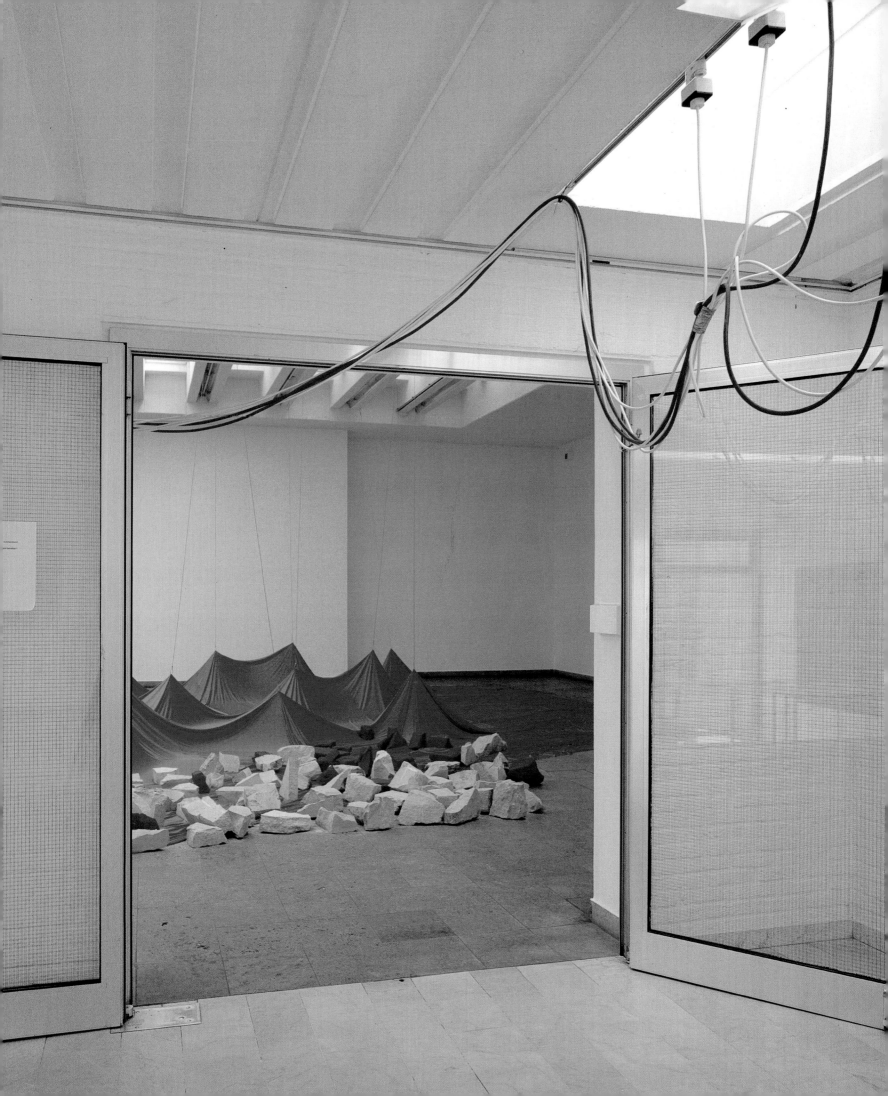

opposite and following pages,
**Growing Rock Candy Mountain
Grasses in Canned Sand**
1992
Violet bathing suit material
(23 × 12 m), sand stone native
to Munster, gaseous concrete
building blocks, plaster, basket
material, electrical wiring, 3 very
small lights, newspaper glued
to the wall, acrylic paint, metal
cables, styrofoam
Room, approx. 29 × 9 m, one wall
stepping to 13 m at the other end
Installation, Westfälischer
Kunstverein, Munster, Germany

what happens. I don't spend time getting upset if a piece of wood breaks, I figure out how to make use of the break. I would rather take what is available to me and run with it. I would rather do that than bang my head against the wall because I don't have what I need.

Westfall Are you aware that it is something you are capable of doing to yourself, a momentary depression in the face of contingencies?

Stockholder **Yes, I don't think I do it so much in terms of my work. Part of why I am an artist is that it's an arena where I am allowed to do whatever I want.**

Westfall As opposed to the rest of life.

Stockholder **Yeah, in the rest of my life I can spend a lot of time agonizing because I don't have exactly what I need. I have a script that says it should be thus and so, but for some reason I am able to abandon a script in making my art. And that's what I like about it so much. I like John Cage's and Allan Kaprow's thinking. I love that kind of philosophy, taking advantage of chance. I read their writings and everything in me warms up to that kind of thinking. I do that, but there is more of a struggle in my work around those issues than in theirs. My work isn't about just that. There is clearly some kind of imposed order, some dependence on art history and aesthetics that overlays whatever chance and happenstance I let occur.**

Westfall The whole notion of engaging chance in the creation of the work strikes me as truly outside of, or liberated from, a romantic sensibility, and yet there is so much about your work that I find romantic. I have actually made some notes here.

Stockholder **Yes, say more about that.**

Westfall Here is the question. I read a tremendous emotionality in your work. The titles such as *The Lion, the Witch and the Wardrobe*, and the pieces dedicated to your father and to the painter, Mary Hielmann, refer not only to the materials, but to the physical location of the work – *My Father's Backyard* – or shared aesthetic agendas with another artist who works in a more conventional traditional medium, but also to friendship, family ties and the imaginary life of childhood. These and other tendencies in your work, such as the often breathtaking scale of your installations, their gestural velocity and the recurring elegaic

Growing Rock Candy Mountain
Grasses in Canned Sand
1992

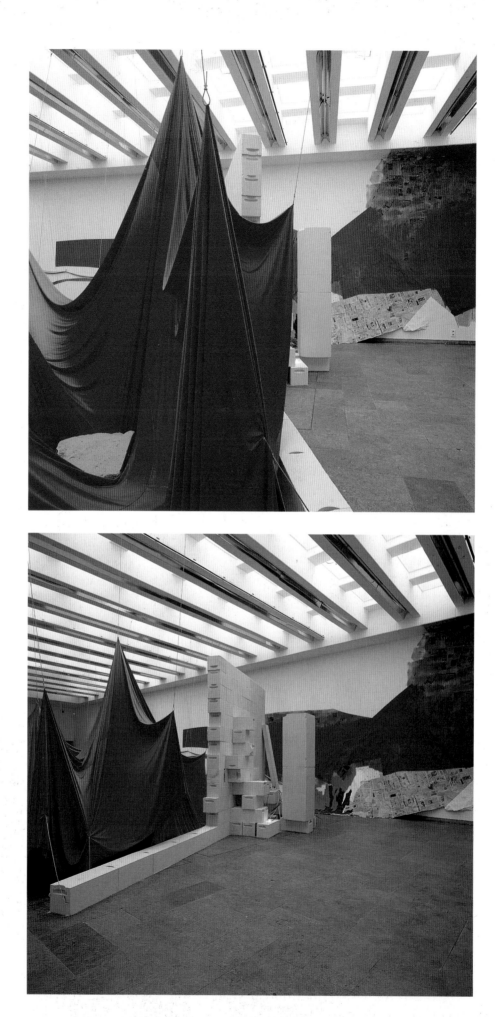

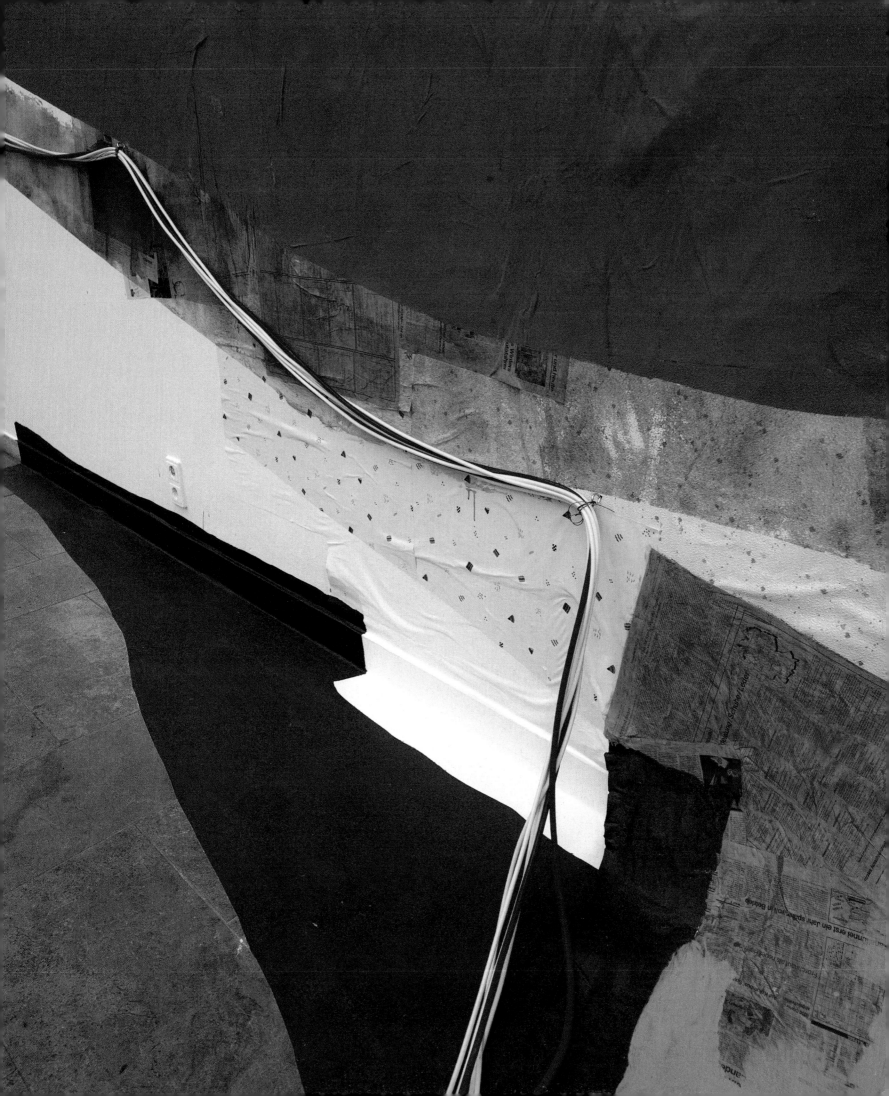

this page and following pages,
Sea Floor Movement to Rise of Fireplace Stripping
1992
Pink plexi, building materials, paint, light bulbs and fixtures, blankets, furniture, twine
Approx. l. 483 × h. 500 cm
Installation, Kunsthalle Zurich

deployment of lumbering domestic furniture such as bureaus, refrigerators, mattresses which sometimes float along the floor like icebergs and which can also be set off like some heroic landscape feature – like a butte or mesa – all these tendencies strike me as a manifestation of romantic sensibility. I am really surprised, in the face of so much current discourse, to find it there so vividly. Are you disappointed by that reading or is that OK?

Stockholder **Well no, I am not disappointed with it and I don't disagree with it but I don't know if I would have said it that way. I don't work in response to writing very much, you know, what the current critical talk is. When you talk about feelings and psychology and childhood it can become clichéd very quickly. When it becomes clichéd you have lost what it is you wanted. But my impulse to make a work begins with my feeling that emotional life isn't allowed room in the world. This feeling is personal to me and my history, but I think it is also a modern issue in that a lot of people share those worries and feelings. So my work becomes a place to make fantasy and emotional life as concrete and real and important as a refrigerator, or the room that you are in.**

Westfall There's a monumentalization of gesture and memory in your work. One of the powerful, emotional reaches of romantic art has been this notion of extension of an imaginal terrain on a scale before which carefully held self-identity begins to break down.

Stockholder **For you looking at it or for me creating it?**

Westfall Art is a dialogue between the maker and the viewer. So I would say for both, and the risk, of course, for the maker is that self-identity is so much a part of the work. The cliché about the insane artist pretty much begins with romanticism but it also applies to the viewer. That is partly what is meant by the sublime. The poet, Gerard Manley Hopkins, first talked about an 'inscape' as opposed to a 'landscape'. In romantic art, a landscape, as vast as it may be, and as located as it may be – in Yosemite with Bierdstadt's paintings, or in the Amazon with Cole – there is a sense that something more is there. There is also a projection of the artist's inner life and the infinite extension implied that dwarfs the scale of our own body sense. It is perceived as a high wire act, a risky act by the audience and, presumably, is experienced as that by the artist. That is part of the audience's perception, at least. The process of the work tends to grind down habit or intentionality and something is formulated in that action as a fuller response to the pre-conceived idea.

Stockholder **That's because it creates an experience, or creates the possibility for one. I put something in the world and then I have an experience in relationship to it that I can't control, or at least I can't totally control. So there is room for things to grow. In terms of the work being romantic, or emotional or from childhood – all the ways it is rooted in my life – all of that information is important to other people only in so far as it provides a place for them to experience those things in their own life. In many ways people's experiences are very similar, in terms of what we are capable of experiencing and the range of emotions that we have available to us. The way in which those emotions are structured or ordered is more important than that they are there. What is important in the end is whether that emotional experience is given a new frame of reference or whether the piece provides a way to experience those feelings differently.**

Westfall There is a classically modernist idea of opening up the process of the work to the viewer's imagination. That the image and the process become one in a way that it doesn't for an extended and total piece of music or a panoramic landscape painting, which are feats of technical virtuosity, is still very tied to notions of mastery that tend to exclude the audience. I look at your installations and I can hear the tape being pulled up when an edge is exposed on a plane of paint. I can hear the nails going in. I can feel the weight of things where they meet each other. In my bodily response to the work, I recreate the process of its coming together. It makes me feel that not only is it something I would want to do, but in fact I *could* do it. Part of the modernist agenda as I have always understood it has been that kind of democratization of the creative process. It says, 'Yes you can do it!' Someone says, 'Oh, my three year old kid can do that', or, 'I can do that'. The modernist would respond 'Why don't you! Yes, you could, why don't you?' One of the great joys I find in your work is that sense of exciting the mind and the body to material, to all material. Rauschenberg used to say, 'My paintings are an invitation to look someplace else'. Your installations are an invitation to get into the flow.

Stockholder **That sounds nice. I do feel like there is a rarefication of art cultivated in the art market that I am not interested in and that I fight against. I do want my work to seem like somebody could do it. That it is not a work of genius, some rare object that nobody else could do.**

Westfall Or a product of frontline technology.

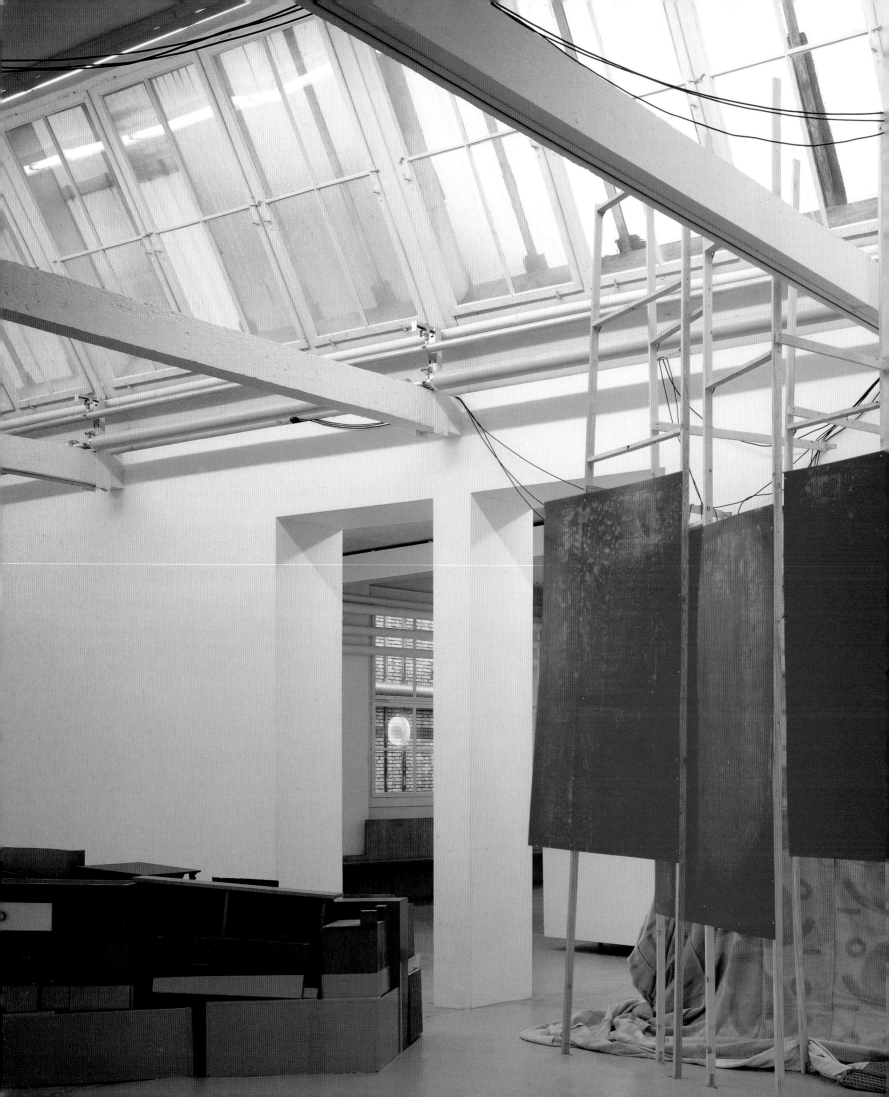

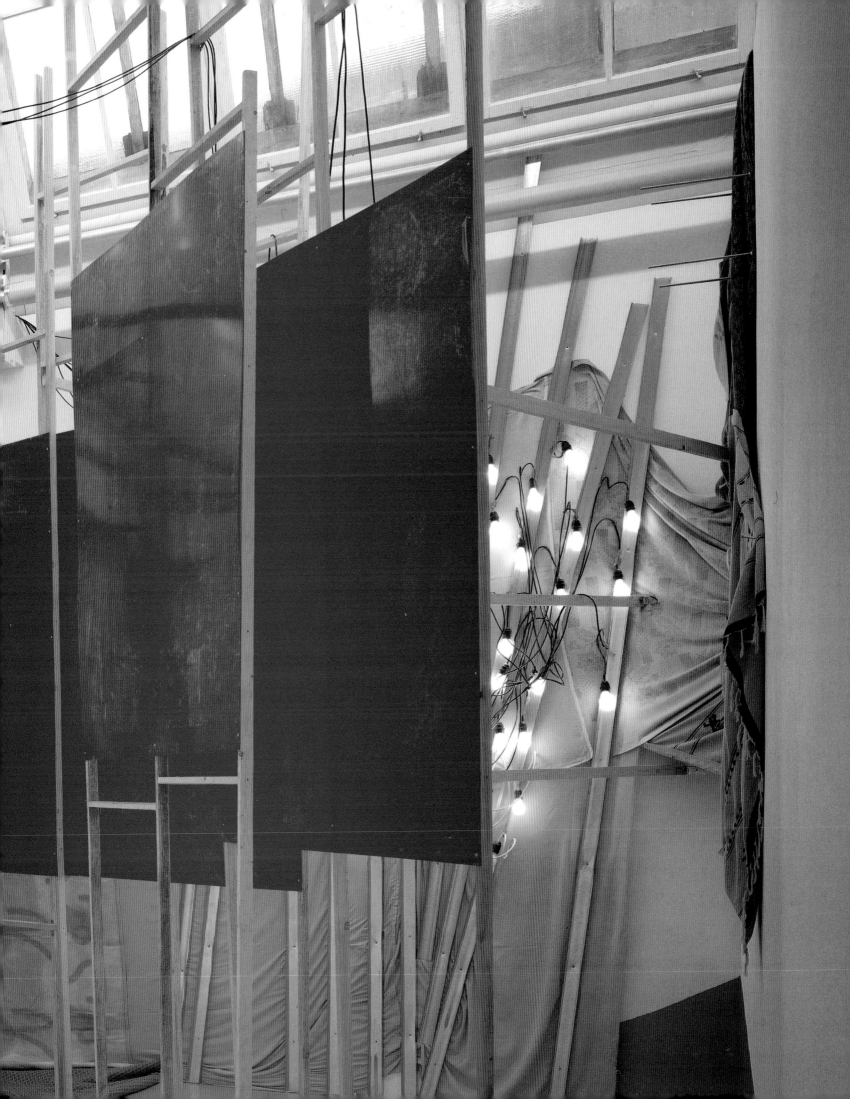

Stockholder Yeah, it's not high tech. That is what has confused me about your statement. My focus isn't on keeping things available for people in terms of skill – I don't think that ends up being the truth. It is presenting the material world in a way that is understandable. I'm not interested in using a computer because you can't look at that and have a feeling about 'stuff'. I am interested in the quality of material, whether it is a chair or a piece of concrete: that you experience it over time, that it changes with the light, that you have a particular experience of it that is separate from talking about it, taking pictures of it, or writing about it. That's where the work grows for me, and the result of that is pretty low tech. There is also something that is very particular or specific that I struggle for in each piece that is in contrast to slap dash. But it's not about skill or technology either. It's about a structure of thinking. It's very formal. As the piece gets closer to being finished there are fewer decisions, fewer possibilities. Each decision becomes more important and has more weight in terms of how the whole thing fits together. I think it has to do with strings of references and a tension between the work being finished or not finished, complete or not complete. But in so far as I want things in the work not to have a fussed over quality, I want to provide a direct experience of things, I think that's true.

Westfall In the interaction of the elements in your work, I sense a celebration of ideas that we can only term aesthetic. This seems to be something that fell into disrepute, an idea or an admittance that has seemed more and more risky or nostalgic, especially to a lot of younger artists.

Stockholder It is important to say what you mean by aesthetic. I don't think aesthetics is just about pleasure. It's to allow pleasure and any other kind of experience that goes with it.

Westfall Pleasure and play. Play is highly communicative, interactive and a movement of the mind. It's also structural; it tends to build on itself.

Stockholder All of those things have meaning. When they don't have as much meaning, they become decorative, sometimes a little clichéd, all of that is part of our life. But when things are decorative or clichéd or less challenging they function to support a way of thinking. I think about taste in that way. Some people's notion of good taste reinforces a way of understanding the world that supports the world as they want it to be. Things that introduce a new way of thinking, challenge notions of taste are, for some people,

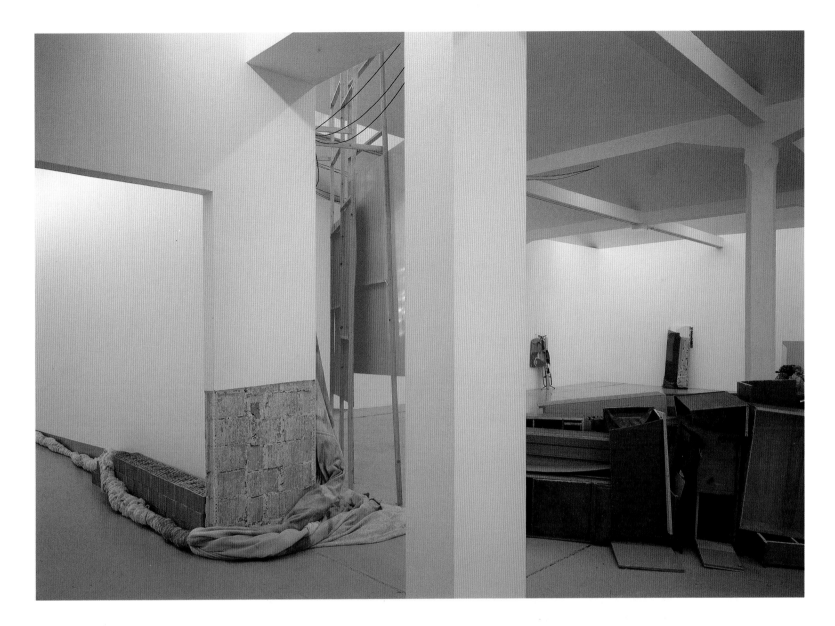

**Sea Floor Movement to Rise of
Fireplace Stripping**
1992

wonderful. They like to have the world shook up a little, to have their thinking challenged. Other people don't want that, it offends them. That's the only way I can understand the difference between taste and beauty. For me, things that are beautiful are things that are awkward and shake things up, and stretch how I can understand things as complete. As I get to understand something a little better, it is less interesting and less beautiful.

Westfall There comes a point where if taste degrades enough it can be made use of again.

Stockholder **Well, it becomes more defined. When you can isolate a certain taste then it means something for a certain time in history.**

Westfall There is not a lot between the notion of abstractness as we understand it in the visual arts and a notion of the aesthetic that tends to degrade. The will to abstractness can also be read as a will to purity or a will to the aesthetic that tends to deny the psychological or the imaginistic.

Stockholder **I don't follow what you are saying. For me, to the extent that the work is abstract and not literal or literary, it is freed up to say something. I feel trapped by the literary. I think I would feel my work more subject to degradation or emptying out if I**

were making figurative work. Things that are abstract have the possibility to include different ways of thinking. I was at the Museum of Modern Art today looking at the way figures are presented. So often, people are trying to break the presentation of the figure. Lucas Samaras' portrait of a person holding a photograph of himself holding his own portrait in a jar breaks the believability of the body as a container – this body that we all have and we are all looking at that is being represented to us in painting or sculpture or photographs. Our modern dilemma seems to be a questioning of that containment. Questioning that the presentation of our bodies can in fact be us.

Westfall Or even the idea of the body as a boundary. The boundary to what? So much political discussion the last several years has been about the social boundaries of the body. But also, aesthetically, the body as a limit of action. There is nothing in your work which can't be done by a body, accomplished by a body. So much imagery has been about this question of where the body is. Our common sense tells us our bodies are right here and yet we are abstracted out of our notions of the limitations of the body. This happens in computer space and virtual reality. A non-sensate, purely visual space that can be 3D becomes a total mental construct, like a living memory with an attendant sense of vertigo.

Stockholder And also, bodies aren't like objects. In a painting, there's the body and there is the table, and they are somehow equal. But bodies are constantly changing, the shape is changing, how it appears when the light and you turn. Especially with babies, it's so amazing, they are changing in front of your eyes because they are growing so fast. There is something about the body as an event rather than an object that is a little disconcerting. It implies our death.

Westfall Oh, definitely, and in midlife there's secondary acceleration of change. When I see a grey hair in the mirror, I am so moved that something is happening that I don't have this vain response to just pluck it out. It is mythic in a way. I feel differently, however, when the hair starts growing out of my ears. But the idea of the body as an ongoing event is a powerful one.

Stockholder I think that in my work there is both a sense of time passing, that the work is temporal; and another feeling, that I'd say goes with art in this culture. Art is a little abstracted from the rest of our life and put in a separate building and made for those buildings, and thought of as separate from time. As a result, it is static, formal, beautiful

and has a quality of timelessness happening over and through this very temporal installation.

Westfall You refer to a certain calm, a serenity. There is all this furious action in your work and yet in the viewer's freedom to experience it at different times of day and walk through it, even if that occasion is itself temporal, there is a chance for it to unfold more slowly. Another action of the work becomes its unfolding to perception after it's done. Which must be very different from the energy that's expended in erecting it.

Stockholder **Building the pieces is sometimes not much fun. There isn't the same pleasure that comes from looking at them. Building them is usually a struggle. I'm irritable, grumpy, upset and worried. It's difficult. Then looking at the piece afterward, there is still some of that, there are always difficult places in the work that make me uncomfortable. But, to the extent that the work is successful, I'm providing an experience that is not there while building it. It's an experience of being really wonderful or exciting. It keeps me moving just the right way; that is something that is very particular to its being finished. The static and timeless experience is in contrast to our own temporality. The static experience is an imaginary one and as such, full of possibility.**

Westfall Harold Rosenberg talked about visual artwork as an action of the body suspended in material. This suspension strikes me as also referring to that calm or clarity, that reference to timelessness. The funny thing about the continuity of life in a body is that there are those moments of perceptual clarity which are often too few and far between. There is this sense that life is short, but it's not that short. We change, but we don't change radically enough that you are unrecognizable the next day or the next hour, or that I don't recognize myself in the mirror the next morning.

Stockholder **Yeah, thank God. (*Laughter*)**

Westfall George Steiner says that in art no new perception cancels out old perceptions, unlike science where a new perception invalidates an old perception. But in art that's not so.

Stockholder **People try to make it so, the current conversation is always an attempt to try to invalidate what just happened. But that sounds good to me.**

Bomb, New York, Fall, 1992

Parallel Parking 1992

In my work I am always concerned with the relationship between contradictory things, with the relationship between one part of the work to another, and the relationship of the work to the building it sits in.

It used to be that artists worked within shared conventions of iconography and style. Now each artist develops her/his own individual style or relationship to style as a concept; and each artist determines what the subject of their work will be. As a result, attention to context (the physical and social circumstances within which the work is viewed) is heightened as it has become one of few elements tying many divergent activities together as 'art'. Context, replete with meaning, has become a shared point of departure.

For me context as a point of focus became important as I noticed the padded, muffled feelings that accrue to the experience of an object as it becomes 'art' and is thus elevated, protected, cleaned and removed from my life. Responding to feelings of anger and frustration at the distance which develops between me and my work, and in an attempt to bring the work forward I tie it to particularities of physical circumstance.

In response to this aspect of 'art', and to a need to explore the nature of experience

For Mary Heilmann
1990
Wood, concrete, styrofoam,
plaster, bed sheets, dried fruit, oil,
enamel, latex and acrylic paint,
toilet paper, lights, roofing tar,
mirror, plastic sheeting,
newspaper
Approx. l. 461 cm
Installation, Galerie Isabella
Kacprzak, Cologne

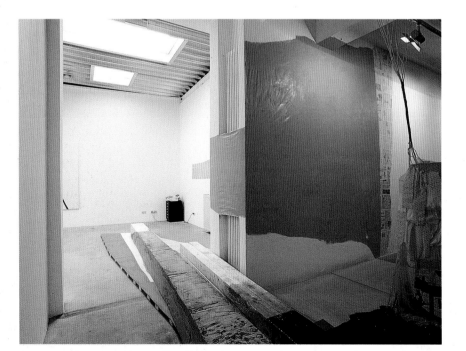

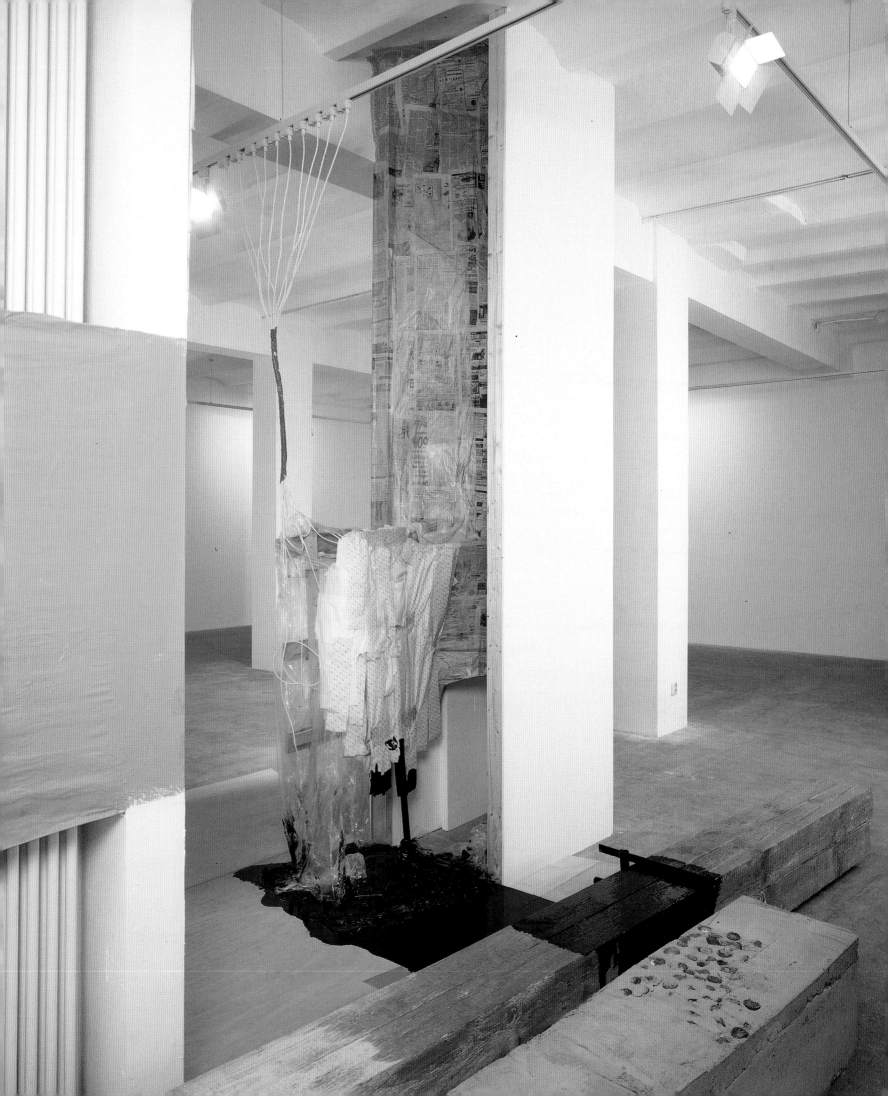

directly, my work is rooted in physical circumstances. It creates an experience, a time-bound experience happening to the body. Even so, it depends on its placement in the world as an art object, and on the history of art, to communicate at a level of intensity I relish.

The art objects of Western culture exist in an alienated space created by our framing of the work. Aside from literally framing the work or putting it on a pedestal, we frame it by placing it within the institution of the gallery; we then carry the institution with us, in mind, as the context or place for art. It becomes our 'frame' or reference; we use it to establish a 'point of view'. The resulting separation of the art object from normal time and space enables art to function as a metaphor for thinking processes. I love the level of abstraction and the freedom of action this makes possible.

My work doesn't have a frame, in the usual sense, nor a pedestal. But it often relies on its status as art to be a gestalt; it would otherwise not exist as a separate entity among everything else. Each piece relies on its context for definition and also on the idea of 'frame' that we all carry with us. We the viewers complete the work, or fill in the blanks, responding to cues in the work. There is an important contradiction here – the frame, though it is only an abstraction, functions to hold the work apart from real time and remove it to an elevated timelessness; but to the extent that the viewer participates in framing the work, the frame becomes part of real time, part of life.

I structure the work so that experience of it engenders a struggle between these different ways of viewing. This struggle presents a process of questioning rather than a *fait accompli*. It contributes to the rise of a kind of blur, a confusion of boundary, and it questions the possibility of containing bodies of information or ideas. Perhaps the best systems for knowing do not involve a stable unchanging mode of operation.

I engage in a constant process of pulling the rug out from under the ground on which my work rests. The stabs I make against this ground are doomed to fail because I am in love with what I am attacking. Nevertheless the holes or gaps created in the struggle are full of meaning. There is a feeling of fragmentation which can be aggressive, angry and uncomfortable; but it is also optimistic, hopeful and exciting in that space is left for the possibility of change and for the emergence of something new and fantastic.

My work grows through the process of making. It is an additive process where each piece is built from nothing to something clear to its foundation – by this I mean that there is no blank canvas from which to begin, no lump of stone; with each work its physical footing in the world must be invented. Instead of accepting a given physical parameter, I begin with a desire to engage in a struggle to alter what I know, or to make order and

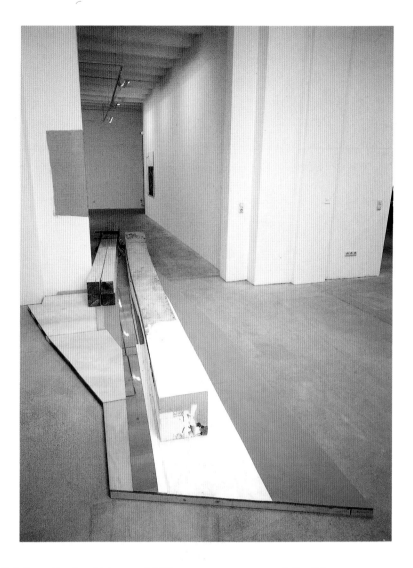

For Mary Heilmann
1990

cohesion consistent with the heap of chaotic information in which we exist. The construction of such a heap within my work involves layering or overlapping many kinds of information. This process creates a conglomeration of elements which arise from absurd relationships between things, from chance occurrences, happenstance and from objects already laden with meaning; and last but not least, from painting. Within this deliberately shifting and tangled mass of overlapping strands there is enmeshed a clear, coherent form of order.

Painting functions in my work as a pictorial entity laden with history which, among other things, is inextricably bound to the history of the frame. More simply, the painting also draws attention to surface – to skins over objects and skins of objects. The surface is simultaneously rested on and poked into. It is treated as a flat weightless, almost abstract or not physical area; at the same time it is an extension of an object and is treated as such. The paint functions both to alter existing surfaces and as a very flat object in its own right placed over or along side other objects. The surface of the object conceals the mass of the object from us; it is also the part of the object revealed to our sight, it is an area where we are vulnerable to deception and also a site poignantly ripe for the development of fiction. The surface becomes a tenuous site where fiction and reality struggle with notions of subjectivity and objectivity to find boundaries or to determine difference.

I hope that the finished object provides, if only for a brief moment, a site where myself and others can experience a confluence of inner life with concrete physical stuff. In this sense, and in other ways also, I think the work creates a static event. Visually not very much moves, except for the person viewing; but there are sparks flying through the air as electricity moves sight unseen through wires.

Turn-of-the-Century Magazine, New York, Vol. 1, No. 1 Spring 1993

BLACK AND WHITE ONLY

Part I, 'Catchers Hollow', Alternate Title, 'Feeding Station Launching Pad'

The first view is of a wall; the wall is rectangular, flat and painted. There are three square holes in the wall through which a wooden structure breaks from the other side. While the wall acts as ground for the painting, it is also a sculptural element, or figure, in its relation to the wooden structure behind.

The three square holes through the wall become figures at play with the painted pieces on the wall. A painted grey shape is covered with transparent packing tape. The grey is very close to the colour of the floor. The tape runs onto the floor and forms a rectangle of shininess. The flat paint on the wall and the painted surface of the floor become ground to the shiny tape.

From here it is possible to see the green cable antenna fixed to the roof outside the window.

The wall stands in the centre of the room like an oversized column. Moving around to the other side of the column reveals the wooden structure. It spreads from the floor through the column, and back to one of the walls that forms the room. It is an object supported by, and attached to, the room, but nevertheless a figure in the room. It is also a grid which supports another grid, affixed to it made of pieces cut from 19 bathtubs; the pieces sit together forming an awkward concave dish. As grid, this structure plays to the grids of the architecture seen through the windows; and as concave dish it plays to the green cable antenna that it faces.

Stuck onto the surface of the bathtubs is a white shape made of silicone caulking; over this is spread an orange painted shape spilling onto green. This green shape is

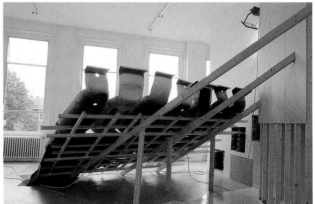

papered and painted onto the floor and climbs up the column/wall. The green is a figure on the ground of the floor; it is also the ground or pedestal for the wooden structure/ bathtub figure, which acts, in turn, as ground for the white silicone and orange painted shapes that it throws into space.

The two lights mounted on the wall enter into this play between figure and ground. They are objects, while at the same time, the light they cast 'is' or makes the wall as we see it. The wires feeding them run across the space carrying colour and electricity. Their colour jumps to the other colour in the work. The electricity they carry comes from inside the walls of the building, the ground.

The viewer's place in the work changes as her/his perception moves between an understanding of the building alternately as container, ground and object. The viewer is at times a figure in the work and at times a consciousness quite separate from the site of the action. In the process of moving back and forth between these two positions, as experience of the work is combined with expectations of closure and notions of framing, the work begins to appear complete and as a static unity.

The wall with the mounted lights, the painted pieces, the holes in the walls, and the wooden/bathtub grid are all, at times, thrown forward as figures or objects in the room, performing an action that reaches into worlds of fiction and fantasy, even while they slip back into the matter of fact building and place of Witte de With.

This is a description of *Catchers Hollow* made in Witte de With, Rotterdam, The Netherlands.

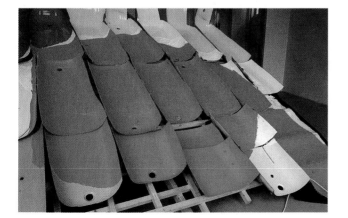

Catchers Hollow
1993
The space of Witte de With, bathtubs, lumber, silicone caulking, paint, lights and wires, coloured filter, paper, transparent tape over and under paint, yarn, a cable antenna painted green outside the window together with a quartz light
Approx. 312 × 588 × 173 cm; 38 cm wall in the centre of the room
Installation, Witte de With, Rotterdam

Part II, 'Self-Portrait'

The painting is rectangular; it hangs on the wall and the appropriate viewing distance seems to be about two and a half feet. The first information to come is that the painting is a portrait. There is a figure looking out from thick dark brown space. It seems that one can see consciousness and life in his face and eyes. The figure is looking at the viewer and one is reminded of oneself.

The figure seems to emerge from the depths of the painting; but the line between the clothes of the body and the dark space behind is very difficult to find, impossible to find, and then at times very clear. When the line can't be found, the whole painting seems to flatten and the figure becomes one with the dark background. For a time, the deep brown space disappears.

When seen as a flat thing, one's attention is drawn to the painting as an object, or figure on the wall, and again to oneself standing in front of the painting. It makes sense to move closer in order to look closely at the surface. Attention is drawn to the fact of the paint on the taut plane of the canvas. The surface of the paint is shiny and cohesive – a singular entity; but it is also clear that there are many layers of paint stacked and mingled, so that it is difficult to decipher how this occurred. Viewed from up close, these mingled layers of paint move back and forth – sometimes seeming to be flat physical entities and at others seeming to exist in a shallow space whose size is linked to the scale of the brush strokes.

With attention focused on the fact of the paint, the figure in the centre seems to be built of, or growing from, little dabs of lighter-coloured paint. These little dabs are often bumpier spots or objects on the surface of the painting. They are little objects on the canvas while at the same time they seem to be the incorporeal light which illuminates the figure. The figure is a thing lost in the background, perhaps one and the same with the background, even while emerging as figure. The little dabs that serve to illuminate the figure, which allow us to see it, are themselves figures on the flat surface of the painting.

The image of the figure looking out at us, the consciousness we imagine behind the eyes, and the light moving through the space of the painting are all dramas that dissolve into the skin of shiny paint made up of many sculptured strokes. All of this is stretched over the rectangular-canvas-covered object on the wall that is the painting. So much happens while one stands in front of this static painting that it comes as a shock to realize that one has only taken a few steps forward and back, and to realize the physical stillness of the past moments.

This is a description of Rembrandt's *Self-portrait as the Apostle Paul* (1661), seen in the Rijksmuseum, Amsterdam, The Netherlands.

Cahier 1, Witte de With, Rotterdam, 1993

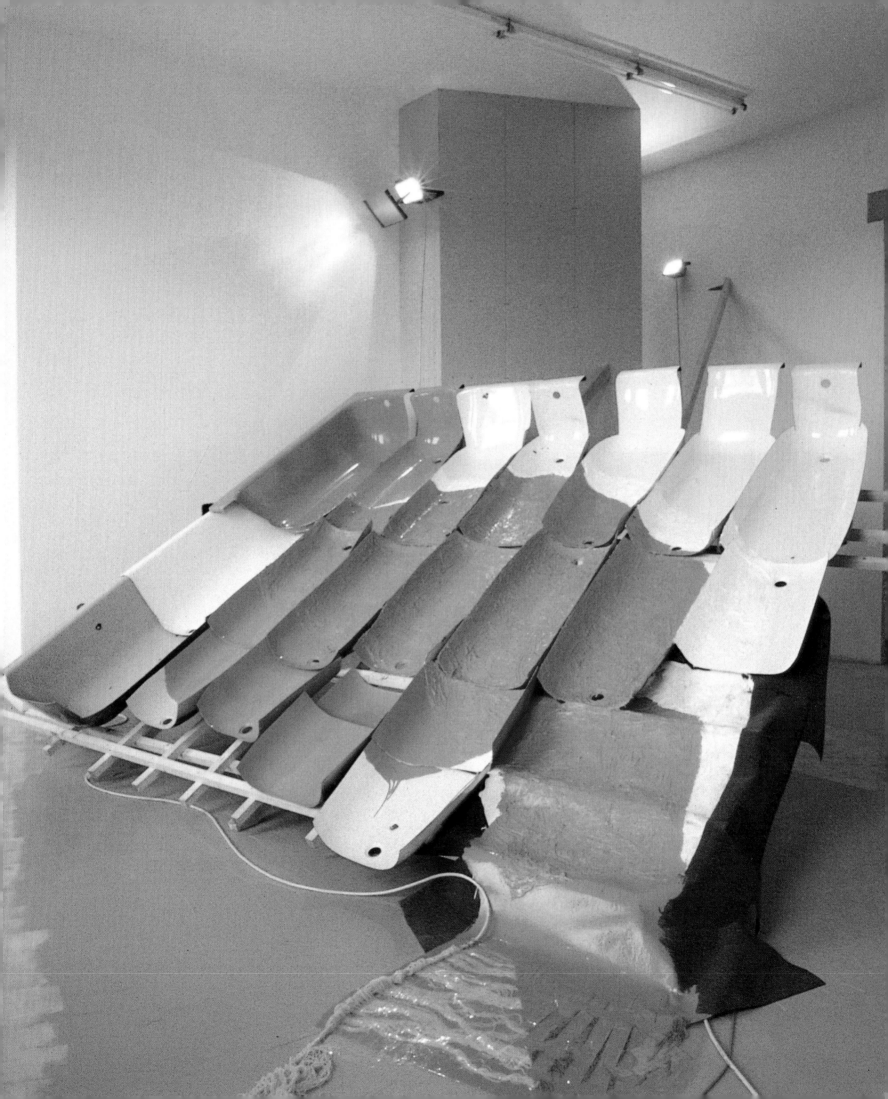

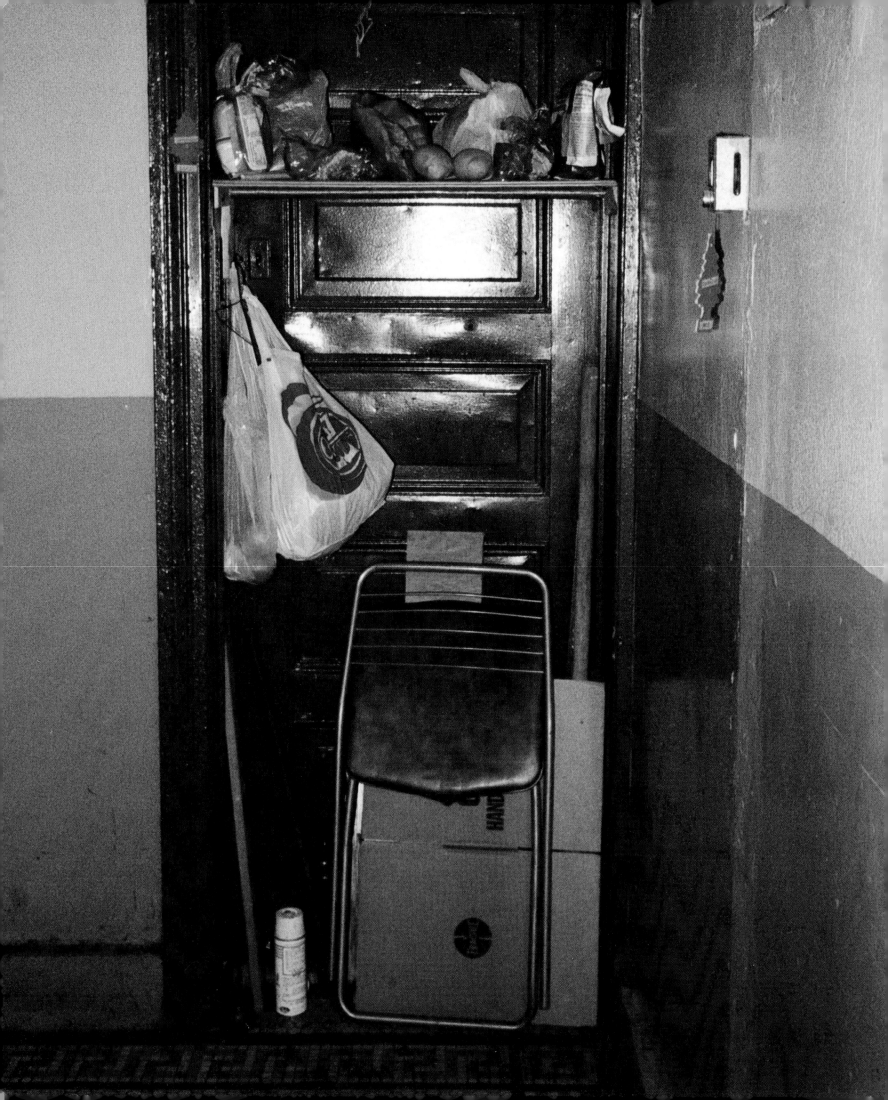

Contents

Exhibitions and projects
1963-85

Selected articles and interviews
1963-85

1963-65
Lives in Ghana, for two years and travels with parents
visiting European museums

1972-77
Through high school takes various art classes and
studies art privately with Nora Blanck and Mowry
Baden in Vancouver, British Columbia, Canada

1977-78
Studies fine art, **University of British Columbia**,
Vancouver

1978
Four month programme, **The Camden School of Art**,
London

1979-80
University of British Columbia, tuition scholarship

Studies fine art, **University of British Columbia**,
Vancouver

1980-82
Studies fine art, **University of Victoria**, Canada

1982
Lives in Toronto for winter

'Re:Constructivism',
Open Space Gallery, Victoria, Canada (group)

'Graduation Exhibit',
McPherson Gallery, University of Victoria, Canada
(group)

Burnham, Clint and Chan, Katy, 'Honest Material,
Simple Methods', *The Martlet*, University of Victoria, 28
September

'Vilio Celli, Laurie Metters, Jessica Stockholder',
Open Space Gallery, Victoria, Canada (group)

1983
'Installation in My Father's Backyard',
Private residence, Vancouver

Studies painting at **Yale University**, New Haven,
Connecticut

1984
Installation, 'In-side out',
Art Culture Resource Center, Toronto (solo)

Installation in My Father's Backyard, in progress, 1983

1984 - 1985
Studies sculpture at **Yale University**, New Haven,
Connecticut, MFA 1985

1985
Thesis Exhibition, **Yale University**, New Haven,
Connecticut (group)
Installation, 'Bath'

Beinecke Plaza, Yale University, New Haven,
Connecticut, collaboration with Mark Holmes and
Isamu Noguchi

Jessica Stockholder, 1980. Photo Roy Oxlade.

Installation, 'Wall Sandwich',
Melinda Wyatt Gallery, New York (solo)

Exhibitions and projects
1985-90

'SELECTIONS From the Artists File',
Artists Space, New York (group)
Installation, 'The Lion, the Witch, and the Wardrobe'
Cat. *Selections from the Artist's File*, Artists Space, New
York, text Kay Larson

1987
Installation, 'It's Not Over 'til the Fat Lady Sings',
The Contemporary Art Gallery, Vancouver (solo)
Cat. *It's Not Over 'til the Fat Lady Sings*, The
Contemporary Art Gallery, Vancouver,
text Mark Holmes

1988
Visiting artist, **Brock University**, Toronto

'Artists and Curators',
John Gibson Gallery, New York (group)

Installation, 'Indoor Lighting for My Father',
Mercer Union, Toronto (solo)

1989
'A Climate of Site',
Barbara Farber Gallery, Amsterdam (group)
Cat. *A Climate of Site*, Galerie Barbara Farber,
Amsterdam, text Robert Nickas

Galerie Xavier Hufkens, Brussels (group)

The Institute for Contemporary Arts, P. S. 1 Museum,
Long Island City, New York (group)
Installation, 'Making a Clean Edge'

American Fine Arts, Co., New York (group)

'Berkshire Art Association 1989 Exhibition of Painting
and Sculpture',
Berkshire Museum, Pittsfield, Massachusetts (group)
Cat. *Berkshire Art Association 1989 Exhibition of
Painting and Sculpture*, Berkshire Museum, Pittsfield,
text Lisa Philips

'Mattress Factory: Installation and Performance',
The Mattress Factory, Pittsburgh (group)
Installation, 'Mixing Food with the Bed'
Cat. *Mattress Factory: Installation and Performance*,
Mattress Factory, Pittsburgh, text Jessica Stockholder

1990
Teaching, **The University of British Columbia**,
Vancouver

'Information',
Terrain, San Francisco (group)

'Pop 90',
Postmasters Gallery, New York (group)

Smaller works and installation, 'Where it Happened',
American Fine Arts Co., New York (solo)

Selected articles and interviews
1985-90

1987
Perry, Art, 'Appreciating Creative Fun', *The Province*,
Vancouver, 11 September

'A Climate of Site', Barbara Farber Gallery, *l. to r.*, Jessica Stockholder, Jon Tower, Jon Kessler,
Peter Halley, Robert Nickas, Alfredo Jaar

Homisak, Bill, 'At 1414 Monterey, Art Moves 'Off the
Wall'', *Tribune Review*, USA, 20 October
Lowry, Patricia, 'Exhibits Range from Restrained to
Stimulating', *Pittsburgh Press*, 11 November
Miller, Donald, 'Victor Grauer, Kathleen Montgomery,
Cady Noland, Jessica Stockholder',
Pittsburgh Post-Gazette, 21 October

1990

Avgikos, Jan, *Artscribe*, London, Summer
Mahoney, Robert, 'Jessica Stockholder: Where it
Happened', *Sculpture Magazine*, New York,
November/December
Ruzicka, Joseph, *Art in America*, New York, September

Exhibitions and projects
1990-91

'Stendhal Syndrome: The Cure',
Andrea Rosen Gallery, New York (group)
Cat. *Stendhal Syndrome: The Cure*, Andrea Rosen
Gallery, texts Rhonda Lieberman, Catherine Liu,
Lawrence Rickels

Daniel Weinberg Gallery, Santa Monica, California
(group)

'Detritus',
Jack Tilton Gallery, New York (group)

'Contingent Realms',
**The Whitney Museum of American Art at Equitable
Center**, New York (group)
Cat. *Contingent Realms*, The Whitney Museum of
American Art, New York, text Adam Weinberg

'Mary Heilmann and Jessica Stockholder',
Isabella Kacprzak Galerie, Cologne
Installation, 'For Mary Heilmann' (group) (October)

'Le choix des femmes',
Le Consortium, Dijon, France
Installation, 'Recording Forever Pickled' (group)
Cat. *Le choix des femmes*, Le Consortium, Dijon, texts
Eric Colliarc, René Denizot, Xavier Douroux, Frank
Gautherot, Bernard Marcadé

'The Technological Muse',
Katonah Museum of Art, Katonah, New York (group)
Cat. *The Technological Muse*, Katonah Museum of Art,
text Susan Fillen-Yeh

'Stuttering',
Stux Gallery, New York (group)

1991
Installation, 'UNTITLED Seepage: Sandwashed,
Sundried & Shrink-wrapped',
The Ezra and Cecile Zilkha Gallery, Center for Arts,
Wesleyan University, Middletown, Connecticut, part
three of three part series titled 'The Broken Mirror',
curated by Klaus Ottmann (solo)

Teaching, **State University of New York**

'Physicality: An Exhibition on Color Dimensionality
in Painting',
The Gallery, New York (group)
Cat. *Physicality: An Exhibition on Color Dimensionality
in Painting*, The Gallery, text George Hoffman

'Whitney Biennial 1991',
Whitney Museum of American Art, New York (group)
Installation, 'Recording Forever Pickled Too'
Cat. *Whitney Biennial 1991*, Whitney Museum of
American Art, New York, texts Richard Armstrong,
John G. Hanhardt, Richard Marshall and Lisa Phillips

'The Museum of Natural History',
Barbara Farber Gallery, Amsterdam (group)
Cat. *The Museum of Natural History*, Barbara Farber

Stendhal Syndrome: The Cure John Armleder +
Richard Baim + Nancy Barton + Alan Belcher +
Gretchen Bender + Ashley Bickerton + Nayland Blake
+ Jennifer Bolande + Christian Boltanski + Maureen
Connor + Moyra Davey + Jessica Diamond + Orshi
Drozdik + Patina du Prey + Graham Durward +
Gretchen Faust + General Idea + Kenneth Goldsmith
+ Felix Gonzalez-Torres + Carter Hodgkin + Mitchell
Kane + Komar and Melamid + Ange Leccia + Liz
Larner + Simon Leung + Charles Long + Christian
Marclay + Matthew McCaslin + Annette Messager +
Marilyn Minter + Curtis Mitchell + Kirsten Mosher +
Peter Nagy + David Nyzio + Laurie Parsons + Pruitt
& Early + Aimee Rankin + Michael Scott + Wolfgang
Staehle + Haim Steinbach + Rudolf Stingel + Jessica
Stockholder + Jon Tower + Richard Tuttle + Julie
Wachtel + Joan Waltemath + Mary Weatherford + Meg
Webster Andrea Rosen Gallery 130 Prince Street
New York, New York 10012 June 29 through August
4, 1990. Catalogue available including essays by
Rhonda Lieberman + Catherine Liu + Lawrence Rickels

Jessica Stockholder

The Technological Muse
Katonah Museum of Art

Selected articles and interviews
1990-91

Siegel, Jeanne, *Arts Magazine*, New York, June

Dupont, Valerie, 'Le choix des femmes', *Art en
Bourgogne*, France, Summer

Saltz, Jerry, 'Notes on a Sculpture: Mis-appropriation,
Jessica Stockholder's Sculpture with No Name',
Arts Magazine, New York, April

1991
Decter, Joshua, *Arts Magazine*, New York, May

Smith, Roberta, *The New York Times*, 2 March

De Bruyn, Eric, 'Whitney Biennale', *Forum
International*, Antwerp, No 9, September
Johnson, Ken, 'Generational Saga', *Art in America*, New
York, June

Exhibitions and projects
1991

Gallery, Amsterdam, text Robert Nickas

'Peter Nadin and Jessica Stockholder',
Warren Adelson Gallery, New York (group)
Cat. *PICK-UP. Peter Nadin/Jessica Stockholder*, Warren
Adelson Gallery, New York, text Thea Westreich

'Outside America: Going into the 90s',
Fay Gold Gallery, Atlanta, Georgia (group)
Cat. *Outside America: Going into the 90s,* Fay Gold
Gallery, Atlanta, text Tricia Collins and Richard Milazzo

'Sculptors' Drawings',
Paula Cooper Gallery, New York (group)

Daniel Weinberg Gallery, Santa Monica,
California (solo)

Smaller works and two installations: 'Near Weather
Wall' and 'Making a Clean Edge II',
Witte de With, Rotterdam, The Netherlands (solo)
Cat. *'Formalism and Its Other, Jessica Stockholder'*,
Witte de With, Rotterdam and The Renaissance Society
at the University of Chicago, text John Miller

'Plastic Fantastic Lover (object a)',
Blum Helman Warehouse, New York (group)
Cat. *Plastic Fantastic Lover (object a),* Blum Helman
Warehouse, New York, text Catherine Liu

'Le Consortium Collectionne',
Chateau d'Oiron, Oiron, France (group)
Installation, 'Recording Forever Pickled'
Cat. *Le Consortium Collectionne*, Le Consortium,
Dijon, France

Installation: 'Skin Toned Garden Mapping',
**The Renaissance Society at the University of
Chicago**, Chicago (solo)
Cat. *'Formalism and Its Other: Jessica Stockholder'*,
Witte de With, Rotterdam and The Renaissance Society
at the University of Chicago, text John Miller

Skin Toned Garden Mapping, drawing, 1991

Project for *Bomb*, New York, Fall

Teaching, **Yale University**, Connecticut

'Jürgen Meyer, Jessica Stockholder, Franz West',
Christine Burgin Gallery, New York (group)

'American Artists of the Eighties',
Palazzo delle Albere, Museo Provinciale d'Arte,
Trento, Italy (group)
Cat. *American Artists of the Eighties,* Palazzo delle
Albere, Museo Provinciale d'Arte, Trento,
text Jerry Saltz

Selected articles and interviews
1991

Curtis, Cathy, *Los Angeles Times*, 17 May
Pagel, David, 'Jessica Stockholder', *Arts Magazine*, New
York, October

'Jessica Stockholder - St. Clair Cemin', *Kunst and
Museumjournaal*, Amsterdam, Jrg 2, No 6
Lambrecht, Luk, 'Jessica Stockholder', *Forum
International*, Antwerp, No 9, September
Tilroe, Anna, 'Het Verhevene op Krukken', *Volkskrant*,
The Netherlands, 6 September
van den Boogerd, Dominic, *Artefactum*, Antwerp,
November/December
von Graevenitz, Antje, 'Jessica Stockholder:
Making a Clean Edge', *Archis*, The Netherlands, July
Westen, Mirjam, 'De artefacten van de
consumptiecultuur', *Hervormd Nederland*,
The Netherlands, Jrg 47, No 30, 27 July

Artner, Alan G, 'Smart Choices in the University
of Chicago Centennial Shows', *Chicago Tribune*,
25 October
Gillespie, Mary, 'Arts Get Their Day at University
of Chicago', *Chicago Sun-Times*, 4 October
Glatt, Cara, 'Installation Finds Meaning in Everyday
Objects', *The Herald*, Chicago, 30 October
Hixson, Kathryn, *Arts Magazine*, New York,
January 1992

Faust, Gretchen, *Arts Magazine*, New York, March 1992

Schmidt, Eva, *Kunstforum*, Cologne, January/February
Mahoney, Robert, 'Jessica Stockholder', *Tema Celeste*,
Siracusa, March/April
Ottmann, Klaus, 'Interview with Jessica Stockholder',
The Journal of Contemporary Art, New York, Vol 4, No 1,
Spring/Summer
Sichel, Berta, 'Undomesticated Still Lifes: the Order
and Disorder of Jessica Stockholder', *Balcon No 7*,
January

1992
Teaching, **New York University**

1992

Installation, 'Growing Rock Candy Mountain Grasses in
Canned Sand',
Westfälischer Kunstverein, Münster, Germany (solo)
Cat. *Jessica Stockholder*, Westfälischer Kunstverein,
Münster, Kunsthalle Zürich, texts Friedrich Meschede,
Eva Schmidt and Antje von Graevenitz

Installation, 'Flower Dusted Prosies',
American Fine Arts Co., New York (solo)

Lecture and studio visits, **Rhode Island School of
Design**, Providence, Rhode Island

'Women Artists Not Included in Documenta IX',
Kunstlerhaus Stuttgart, Stuttgart, Germany (group)

'Cultural Fabrication',
John Good Gallery, New York (group)

'Mary Heilmann, Jack Pierson, Jessica Stockholder',
Pat Hearn Gallery, New York (group)

Smaller works and installation, 'SpICE BOXed
Project(ion),
Galerie Metropol, Vienna, Austria (solo)

Text, 'The Question of Gender in Art', *Tema Celeste*,
Milan, Autumn

Installation 'Sea Floor Movement to Rise of Fireplace
Stripping',
Kunsthalle Zürich, Zürich, Switzerland (solo)
Cat. *Jessica Stockholder*, Westfälischer Kunstverein,
Münster, Kunsthalle Zürich, texts Friedrich Meschede
Eva Schmidt and Antje von Graevenitz

'Transgressions in the White Cube: Territorial
Mappings',
Suzanne Lemberg Usdan Gallery, Bennington
College, Bennington, Vermont (group)
Cat. *Transgressions in the White Cube: Territorial
Mappings*, Suzanne Lemberg Usdan Gallery,
text Joshua Decter

Lecture and studio visits, **CalArts**, Valencia, California
Lecture and studio visits, **Bennington College**,
Bennington, Vermont

Grasskamp, Walter, 'Im Büchsensand', *Frankfurter
Allgemeine Zeitung*, Frankfurt, 13 May
Lettmann, Achim, 'Badestoff im Raum', *Scester
Anzeiger*, Germany, 11-12 April
Rochol, Hans, 'Sinnliches Seherlebnis', *Die Glock*,
Germany, 15 April

Tager, Alisa, *Tema Celeste*, Siracusa, Autumn

Installation, **Growing Rock Candy Mountain - Grasses** in Canned Sand,
in progress, Westfälischer Kunstverein, Münster, Germany

Jessica Stockholder

Growing Rock Candy Mountain
Grasses in Canned Sand

Jessica Stockholder
SpICE BOXed Project(ion)

September - Oktober 1992
Eröffnung der Ausstellung
am 3. 9. 1992 um 19 Uhr
Galerie Metropol Wien
Dorotheergasse 12
Tel. 513 22 00, 513 68 38
Fax 513 99 63

SpICE BOXed Project(ion), in progress, Galerie Metropol,
Vienna

Myers, Terry R, 'Heilmann, Pierson, Stockholder',
Flash Art, Milan, November/December

Frehner, Matthias, *Neue Zürcher Zeitung*, Germany,
6 November
Kurjakovic, Daniel, *Flash Art*, Milan, January/February
1993
Maurer, Simon, *Kultur*, Germany, 7 November
Oberholzer, Von Niklaus, *Luzerner Zeitung*, Luzern,
5 November
Polzer, Brita, *Kunstbulletin*, Germany, December

JESSICA STOCKHOLDER

KUNSTHALLE ZÜRICH

Obrist, Hans-Ulrich, 'The Installation Is Coming
Through the Backdoor', *Meta 1 Die Kunst und Ihr Oht*,
Germany, January
Jaeckel, Claudia, *Art Das Kunstmagazin*, Germany, May

Exhibitions and projects
1992-93

1993
Teaching, **The Cooper Union**, New York

'Mettlesome & Meddlesome: Selections from the
Collection of Robert J. Schiller'
Contemporary Arts Center, Cincinnati, Ohio (group)
Cat. *Mettlesome and Meddlesome: Selections from the
Collection of Robert J. Schiffler*, The Contemporary Arts
Center, Cincinnati, texts Elaine King, Jan Riley, Robert
Schiffler and Marcia Tucker

American Fine Arts Co., New York (group)

'Simply Made in America',
The Aldrich Museum of Contemporary Art, Ridgefield,
Connecticut (group)
Cat. *The World As We Find It*, The Aldrich Museum of
Contemporary Art, Ridgefield, Connecticut, text
Barry Rosenberg

Text, 'Parallel Parking', *Turn-of-the-Century Magazine*,
New York, Vol 1, No 1, Spring

'Anniversary Exhibition',
Daniel Weinberg Gallery, Santa Monica (group)

John Good Gallery, New York (group)

'The Good, the Bad, and the Ugly ... a Modest Proposal',
Galerie Jousse Seguin, Paris (group)

'Ordnung und Zerstorung',
Lothringer Strasse 13, Munchen (group)

Installation, 'Edge of Hothouse Glass',
**Galerie des Arènes, Carre d'Art, Musée d'Art
Contemporain de Nîmes**, France (solo)
Cat. *Jessica Stockholder*, Carre d'Art Musée d'Art
Contemporain de Nîmes, France, texts Jessica
Stockholder, Olivier Mosset, Jan Avgikos

Teaching, **Bard College**, Annandale-on-Hudson,
New York

'Jours Tranquilles a Clichy',
40, Rue de Rochechouart, Paris, **Tennisport Arts**, New
York (group)

'As Long As It Lasts',
Witte de With, Rotterdam, The Netherlands (group)
Installation, 'Catcher's Hollow'
Publication, *Cahier 1*, Witte de With, Rotterdam,
texts Patrick Chamberlain and Jessica Stockholder

Galerie George Ludwig, Krefeld, Germany (solo)

'Testwall: Small 3 Dimensional Multiples',
TZ'Art & Co (group)

Selected articles and interviews
1992-93

Westfall, Stephen, 'Interview with Jessica
Stockholder', *Bomb*, New York, September

1993

Simply made
in America

The Aldrich Museum of Contemporary Art
258 Main Street, Ridgefield, CT 06877

'Jessica Stockholder, création pour un lieu donné',
Marseillaise, Marseille, 6 August
'L'Objet dans L'Art', *L'Provençial*, France, 19 July

JESSICA STOCKHOLDER

Pontzen, Rutger, 'Geschilder in de ruimte',
Vrij Nederland, The Netherlands, 10 July
Tilroe, Anna, 'Negen schilders en de grote wereld',
De Volkskrant, The Netherlands, 25 June
'Euromast als Kunstwerk', *De Avantgarde*,
The Netherlands, August
van den Boogerd, Dominic, 'As Long As It Lasts',
Metropolis M, The Netherlands, August
Welling, Dolf, 'Kunst als zallsport in Witte de With',
Rotterdams Dagbladet, 22 June

"The Good, the Bad, and the Ugly..."
A Modest Proposal

L. C. ARMSTRONG John MILLER
Peter HOPKINS Jessica STOCKHOLDER
Jutta KOETHER Royce WEATHERLY

May 25 - June 30, 1993
Opening on Tuesday 25 th from 06.00 p.m.
GALERIE JOUSSE SEGUIN 34 RUE DE CHARONNE 75011 PARIS. TEL. 47.00.32.35 - FAX 40.31.82.95

"Le Bon, la Brute et le Truand..."
Une modeste proposition

L. C. ARMSTRONG John MILLER
Peter HOPKINS Jessica STOCKHOLDER
Jutta KOETHER Royce WEATHERLY

25.05. - 30.06.1993
Vernissage mardi 25 mai à 18 heures
GALERIE JOUSSE SEGUIN 34 RUE DE CHARONNE 75011 PARIS. TEL. 47.00.32.35 - FAX 40.21.82.95

Exhibitions and projects

1993-94

Galerie Nathalie Obadia, Paris (group)

1994

'The Beauty Show',
Four Walls, Brooklyn, New York (group)

'Possible Things: A Drawing Show',
Bardamu Gallery, New York (group)
Cat. *Possible Things: A Drawing Show*, Bardamu Gallery
Publishing House, text Vik Muniz

'don't look now',
Thread Waxing Space, New York (group)
Cat. *don't look now*, Thread Waxing Space, New York,
text Joshua Decter

'Joan Snyder and Jessica Stockholder',
Jay Gorney Modern Art, New York (group)

'Reveillon '94',
Stux Gallery, New York (group)

'Unbound: Possibilities in Painting',
Hayward Gallery, London (group)
Installation, 'Fat Form and Hairy: Sardine Can Peeling'
Cat. *Unbound: Possibilities in Painting*, The Hayward
Gallery, London, text Adrian Searle

Lecture and studio visits, **Carnegie Mellon University**,
Pittsburgh, Philadelphia

'Untitled...',
Postmasters Gallery, New York (group)

'Information Service',
Goethe House, New York (group)

'Blast Art Benefit',
TZ'Art & Co., New York (group)

Selected articles and interviews

1993-94

Butler, Connie, 'Terrible Beauty and the Enormity
of Space', *Art & Text*, Sydney, No 46, September
Donegan, Cheryl, 'One Portrayal, Four Portraits',
Tema Celeste, Milan, Winter
Liebman, Lisa, 'Junk Cultured', *frieze*, London,
March/April

1994

Harris, Susan, 'Joan Snyder and Jessica Stockholder',
Art Press, Paris, April
Hess, Elizabeth, 'Fem Fatale', *The Village Voice*,
New York, 25 January
Kimmelman, Michael, 'Joan Snyder and Jessica
Stockholder', *The New York Times*, 4 February
Levin, Kim, 'Voice Choice: Joan Snyder/Jessica
Stockholder', *The Village Voice*, New York, 1 February
Slatin, Peter, 'Joan Snyder, Jessica Stockholder',
Artnews, New York, May

Bachelor, David, 'Behind a Painted Smile:
...'Unbound'...', *frieze*, London, May
Cork, Richard, 'Painting is Back in the Picture',
The Times, London, 7 March
Dannatt, Adrian, 'London by Numbers: Three Painting
Shows', *Flash Art*, Milan, July
Graham-Dixon, Andrew, 'Sort of, Almost, in a Way,
Nearly', *The Independent*, London, 15 March
Hilton, Tim, 'Every Which Way But Forwards',
The Independent, London, 6 March
Morley, Simon, 'Unbound: Possibilities in Painting', *Art
Monthly*, London, April
Myerson, Clifford, 'On Painting 1', *Art Monthly*,
London, September
Norman, Geraldine, 'Exhibition Highlights New Wave of
Painting "Unbound" for Success', *The Independent*,
London, 14 March

Smith, Roberta, 'Group Shows of Every Kind...:',
The New York Times, 25 February

UNBOUND
Possibilities in Painting

3 March - 30 May 1994

Hayward Gallery
London

Presented by the South Bank Centre

Exhibitions and projects
1994-95

'John Dunn, Adelheid Mers, Carla Preiss, Jessica Stockholder',
N.A.M.E. Gallery, Chicago (group)

Lecture and studio visits, **Cranbrook Academy of Art**, Bloomfield Hills, Michigan

Smaller works and installation, 'Pink Lady',
Weatherspoon Art Gallery, The University of North Carolina, Greensboro, North Carolina (solo)
Cat. *Pink Lady: Jessica Stockholder*, Weatherspoon Art Gallery, Greensboro, North Carolina, text Trevor Richardson

'Herr Schleiermachers Sista Dröm: Förestäl-lningar om Måleriet',
Galerie Nordenhake, Stockholm (group)

'Country Sculpture',
Le Consortium, Dijon, France (group)
Installation, 'House Beautiful'

'Balkenhol, Dunham, Gilliam, Hirst, McCaslin, Stockholder, Weinstein'
Baumgartner Galleries, Washington, DC (group)

'The Little House on the Prairie',
Marc Jancou Gallery, London (group)

'Symphonie en Sous-Sol',
Galerie Renos Xippas, Paris (group)

'Ethereal Materialism',
Apex Art, New York (group)

'Joe's Garage',
TZ'Art & Co., New York (group)

1995
Sala Montcada de la Fundación 'la Caixa', Barcelona (solo)
Installation, 'Sweet for Three Oranges'
Cat. *Sweet for Three Oranges*, Fundació 'la Caixa', Barcelona, texts Jeffrey Swartz and Jessica Stockholder

Conference , Facultat de Belles Arts, **University of Barcelona**

'On Target',
Horodner Romley Gallery, New York (group)
(project: artists alterations on 'Target', 1970 print by Jasper Johns)

'Smaller Works',
S. L. Simpson Gallery, Toronto (solo)

Selected articles and interviews
1994-95

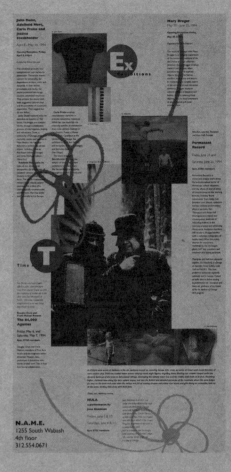

Jonaes, Abe, 'Sculptor's Work Explores the Material World', *News & Record*, Greensboro, North Carolina, 27 March
Patterson, Tom, 'Jessica Stockholder's Works Hold Attention, Test the Mind', *Winston-Salem Journal*, North Carolina, 1 May

Birnbaum, Daniel, 'Rahet och mangfald', *Dagens Nyhter*, Stockholm, December

Bouisset, Maïten, 'Le Consortium: Deux Collections à l'Université', *Art Press*, Paris, February
Bouley, Nathalie, 'Blancheurs lyriques ou Country Sculptures', *Le Bien*, France, 9 June

Hess, Elizabeth, 'Garage Sale', *The Village Voice*, New York, December

Troncy, Eric, 'Painting from All Over to All Round: Lauren Szold and Jessica Stockholder Start Gigging', *Flash Art*, Milan, January/February

1995
'Jessica Stockholder instalacion en la Sala Montcada', *Guia del Ocio*, Barcelona, 13-19 January
'La Ilum, el color i el volum, ordenats en un espai abstracte dins la sala Montcada', *Avui*, Barcelona, 20 January
Spiegel, Olga, 'La Norteamericana Jessica Stockholder abre temporada en la sala Montcada', *La Vanguardia*, Barcelona, 21 January
Juncosa, Enrique, 'Abetos y naranjas', *El Pais*, Barcelona, 4 February

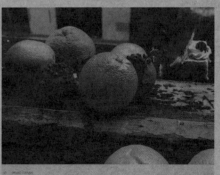

Levin, Kim, 'The Joy of Curating', *The Village Voice*, New York, 29 February

Taylor, Kate, 'Of Green Shower Curtains and Lavender Fuzzy Fur', *The Globe and Mail*, Toronto, 11 February

Exhibitions and projects
1995

Project, 'A Project for *Artforum* by Jessica Stockholder',
February

Jay Gorney Modern Art, New York (solo)

Jessica Stockholder
25 March to 20 April 1995

Jay Gorney Modern Art
100 Greene Street, New York, NY 10012
Tel 212 966 4480 Fax 212 905 1230

'Pittura - Immedia: Malerei in den 90er Jahren',
Neue Galerie am Landesmuseum Joanneum, Graz,
Austria (group)
Installation, 'Recording Forever Pickled Too'
Cat. *Pittura - Immedia: Malerei in den 90er Jahren*,
Neue Galerie am Landesmuseum Joanneum, Graz,
text Peter Weibel and Thomas Dreher

'New York – Positionen Aktueller Malerei',
Studiogalerie der Kunstverein Schloß Morsbroich,
Leverkusen, Germany (group)
Cat. *New York – Positionen Aktueller Malerei*,
Studiogalerie der Kunstverein Schloß Morsbroich,
Leverkusen, text Georg Ludwig

Member of panel discussion, **Hunter College**,
New York; 'The Position of Painting Today: Mary
Heilmann, Jessica Stockholder, Terry Winters'

'1995 Collectie Presentatie Moderne Kunst',
Centraal Museum Utrecht, Utrecht, The Netherlands
(group)

'Color in Space: Pictorialism in Contemporary
Sculpture',
David Winton Bell Gallery, List Art Center, Brown
University, Providence, Rhode Island (group)
Cat. *Color in Space: Pictorialism in Contemporary
Sculpture*, David Winton Bell Gallery, Brown University,
Providence, Rhode Island, text George Hofmann

Dia Center for the Arts, New York (solo)
Cat. *Jessica Stockholder*, Dia Center for the Arts,
New York, texts Lynne Cooke, Constance de Jong,
Jessica Stockholder, Lynne Tillman

'44th Biennial Exhibition of Contemporary American
Painting',
The Corcoran Gallery of Art, Washington, DC (group)
Cat. *44th Biennial Exhibition of Contemporary American
Painting*, Corcoran Gallery of Art, Washington, DC, text
Terrie Sultan

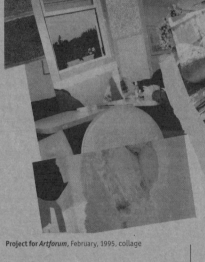

Project for *Artforum*, February, 1995, collage

Selected articles and interviews
1995

Myers, Terry R., 'Jessica Stockholder', *New Art
Examiner*, Chicago, June
'Jessica Stockholder', *The New Yorker*, 24 April
Smith, Roberta, 'Jessica Stockholder', *The New York
Times*, 14 April
Servin, James, 'Abstract Artist Brings Home the
Familiar', *Associated Press*, USA, 14 April
Servetar, Stuart, 'Jessica Stockholder', *N. Y. Press*,
30 March

Vogel, Sabine B., 'In der Satelitenschussel', *Frankfurter
Allgemeine Zeitung*, 23 March

Schwenke, Runkel, Ingeborg, 'Knalbuntes aus New
York', *Kölner Stadt-Anzeiger*, Leverkusen, 21 March
Klein, Minke, 'Sieben New Yorker Maler stellen in der
'Studiogalerie aus', *Rheinische Post & Rhein-Wupper-
Zeitung*, 21 March

Wachtmeister, Marika, 'Interview, Jessica
Stockholder', *Femina*, Stockholm, October
van Ulzen, Patricia, 'Jessica Stockholder', *Jong
Holland, Tijdschrift voor kunst en vormgeving na 1850*,
Rotterdam, No. 2
Birnbaum, Daniel, 'Interview', *Dagens Nyhter*,
Stockholm

Armstrong, Richard, *Whitney Biennial 1991*, Whitney Museum of American Art, New York, 1991

Avgikos, Jan, *Artscribe*, London, Summer, 1990

Avgikos, Jan, *Jessica Stockholder*, Carre d'Art Musée d'Art Contemporain de Nîmes, France, 1993

Bachelor, David, 'Behind a Painted Smile:...'Unbound'...', *frieze*, London, May, 1992

Birnbaum, Daniel, 'Interview', *Dagens Nyhter*, Stockholm, 1995

Butler, Connie, 'Terrible Beauty and the Enormity of Space', *Art & Text*, Sydney, No 46, September 1993

Chamberlain, Patrick, 'On an Antidote', Witte de With, *Cahier 1*, Rotterdam, October, 1991

Colliarc, Eric, *Le choix des femmes*, Le Consortium, Dijon, France, 1990

Cooke, Lynne, *Jessica Stockholder*, Dia Center for the Arts, New York, 1995

Cork, Richard, 'Painting is Back in the Picture', *The Times*, London, 7 March, 1994

De Bruyn, Eric, 'Whitney Biennale', *Forum International*, Antwerp, No 9, September, 1991

Decter, Joshua, *Arts Magazine*, New York, May, 1991

Decter, Joshua, *Transgressions in the White Cube: Territorial Mappings*, Suzanne Lemberg Usdan Gallery, 1992

Decter, Joshua, *don't look now*, Thread Waxing Space, New York, 1994

De Jong, Constance, *Jessica Stockholder*, Dia Center for the Arts, New York, 1995

Donegan, Cheryl, 'One Portrayal, Four Portraits', *Tema Celeste*, Milan, Winter, 1993

Dreher, Thomas, 'Antiquiertheit der Malerei?', *Pittura - Immedia: Malerei in den 90er Jahren*, Neue Galerie am Landesmuseum Joanneum, Graz, Austria, 1995

Dupont, Valerie, 'Le choix des femmes', *Art en Bourgogne*, France, Summer, 1990

Faust, Gretchen, *Arts Magazine*, New York, March 1992

Hanhardt, John G., *Whitney Biennial 1991*, Whitney Museum of American Art, New York, 1991

Harris, Susan, 'Joan Snyder and Jessica Stockholder', *Art Press*, Paris, April, 1994

Hess, Elizabeth, 'Fem Fatale', *The Village Voice*, New York, 25 January, 1994

Hess, Elizabeth, 'Garage Sale', *The Village Voice*, New York, December, 1994

Hixson, Kathryn, *Arts Magazine*, New York, January 1992

Hoffman, George, *Physicality: An Exhibition on Color Dimensionality in Painting*, The Gallery, New York, 1991

Hoffman, George, *Color in Space: Pictorialism in Contemporary Sculpture*, David Winton Bell Gallery, Brown University, Providence, Rhode Island, 1995

Holmes, Mark, *It's Not Over 'til the Fat Lady Sings*, The Contemporary Art Gallery, Vancouver, 1987

Johnson, Ken, 'Generational Saga', *Art in America*, New York, June, 1991

Kimmelman, Michael, 'Joan Snyder and Jessica Stockholder', *The New York Times*, 4 February, 1994

King, Elaine, 'Foreword', *Mettlesome and Meddlesome: Selections from the Collection of Robert J. Schiffler*, The Contemporary Arts Center, Cincinnati, 1993

Kravagna, Christian, *Artforum*, New York, January 1993

Kurjakovic, Daniel, *Flash Art*, Milan, January/February 1993

Lambrecht, Luk, 'Jessica Stockholder', *Forum International*, Antwerp, No 9, September, 1991

Larson, Kay, *Selections from the Artist's File*, Artists Space, New York, 1985

Levin, Kim, 'Voice Choice: Joan Snyder/Jessica Stockholder', *The Village Voice*, New York, 1 February, 1994

Lieberman, Rhonda, *Stendhal Syndrome: The Cure*, Andrea Rosen Gallery, New York, 1990

Liebman, Lisa, 'Junk Cultured', *frieze*, London, March/April, 1993

Liu, Catherine, *Stendhal Syndrome: The Cure*, Andrea Rosen Gallery, New York, 1990

Liu, Catherine, *Plastic Fantastic Lover (object a)*, Blum Helman Warehouse, New York, 1991

Ludwig, Georg, *New York – Positionen Aktueller Malerei*, Studiogalerie der Kunstverein Schloß Morsbroich, Leverkusen, 1995

Mahoney, Robert, 'Jessica Stockholder: Where it Happened', *Sculpture Magazine*, New York, November/December, 1990

Mahoney, Robert, 'Jessica Stockholder', *Tema Celeste*, March/April, 1991

Marshall, Richard, *Whitney Biennial 1991*, Whitney Museum of American Art, New York, 1991

Meschede, Friedrich, *Jessica Stockholder*, Westfälischer Kunstverein, Münster, Kunsthalle Zürich, 1992

Miller, John, *'Formalism and It's Other: Jessica Stockholder'*, Witte de With, Rotterdam and The Renaissance Society at the University of Chicago, 1991

Morley, Simon, 'Unbound: Possibilities in Painting', *Art Monthly*, London, April, 1994

Mosset, Olivier, *Jessica Stockholder*, Carre d'Art Musée d'Art Contemporain de Nimes, France, 1993

Myers, Terry R., 'Heilmann, Pierson, Stockholder', *Flash Art*, Milan, November/December, 1992

Myers, Terry R., 'Jessica Stockholder', *New Art Examiner*, Chicago, June, 1995

Nickas, Robert, *A Climate of Site*, Barbara Farber Gallery, Amsterdam, 1989

Nickas, Robert, *The Museum of Natural History*, Barbara Farber Gallery, Amsterdam, 1991

Obrist, Hans-Ulrich, 'The Installation is Coming Through the Backdoor', *Meta 1 Die Kunst und Ihr Oht*, Germany, January, 1992

Ottmann, Klaus, 'Interview with Jessica Stockholder', *The Journal of Contemporary Art*, New York, Vol 4, No 1, Spring/Summer, 1991

Pagel, David, 'Jessica Stockholder', *Arts Magazine*, New York, October, 1991

Phillips, Lisa, *Whitney Biennial 1991*, Whitney Museum of American Art, New York, 1991

Polzer, Brita, *Kunstbulletin*, Germany, December, 1992

Rickels, Lawrence, *Stendhal Syndrome: The Cure*, Andrea Rosen Gallery, New York, 1990

Richardson, Trevor, *Pink Lady: Jessica Stockholder*, Weatherspoon Gallery, Greensboro, North Carolina, 1994

Riley, Jan, 'Introduction', *Mettlesome and Meddlesome: Selections from the Collection of Robert J. Schiffler*, The Contemporary Arts Center, Cincinnati, 1993

Rosenberg, Barry, *The World as We Find It*, The Aldrich Museum of Contemporary Art, Ridgefield, Connecticut, 1993

Saltz, Jerry, 'Notes on a Sculpture: Misappropriation, Jessica Stockholder's Sculpture with No Name', *Arts Magazine*, New York, April, 1990

Schiffler, Robert, 'Mettlesome and Meddlesome', *Mettlesome and Meddlesome: Selections from the Collection of Robert J. Schiffler*, The Contemporary Arts Center, Cincinnati, 1993

Schmidt, Eva, *Jessica Stockholder*, Westfälischer Kunstverein, Münster, Kunsthalle Zürich, 1992

Searle, Adrian, *Unbound: Possibilities in Painting*, The Hayward Gallery, London, 1994

Slatin, Peter, 'Joan Snyder, Jessica Stockholder', *Artnews*, New York, May, 1994

Smith, Roberta, 'Jessica Stockholder', *The New York Times*, 14 April, 1995

Stockholder, Jessica, *Mattress Factory: Installation and Performance*, Mattress Factory, Pittsburgh, 1989

Stockholder, Jessica, 'The Question of Gender in Art', *Tema Celeste*, Milan, Autumn, 1992

Stockholder, Jessica, *Jessica Stockholder*, Carre d'Art Musée d'Art Contemporain de Nîmes, France, 1993

Stockholder, Jessica, *Tema Celeste*, Siracusa, Autumn, 1992

Stockholder, Jessica, 'Figure Ground Relations, Part 1: Catchers Hollow' and 'Part 2: Self Portrait', Witte de With, *Cahier #1*, Rotterdam, 1993

Stockholder, Jessica, *Sweet for Three Oranges*, Fundació la Caixa, Barcelona, 1995

Sultan, Terrie, *44th Biennial Exhibition of Contemporary American Painting*, Corcoran Gallery of Art, Washington, DC, 1995

Swartz, Jeffrey, *Sweet for Three Oranges*, Fundació la Caixa, Barcelona, 1995

Taylor, Kate, 'Of Green Shower Curtains and Lavender Fuzzy Fur', *The Globe and Mail*, Toronto, 11 February, 1995

Tillman, Lynne, *Jessica Stockholder*, Dia Center for the Arts, New York, 1995

Tilroe, Anna, 'Negen schilders en de grote wereld', *De Volkskrant*, The Netherlands, 25 June, 1993

Troncy, Eric, 'Painting from All Over to All Round: Lauren Szold and Jessica Stockholder Start Gigging', *Flash Art*, Milan, January/February, 1994

Tucker, Marcia, 'Collecting: The Strategy of Desire', *Mettlesome and Meddlesome: Selections from the Collection of Robert J. Schiffler*, The Contemporary Arts Center, Cincinnati, 1993

van den Boogerd, Dominic, *Artefactum*, Antwerp, November/December, 1991

van den Boogerd, Dominic, 'As Long as it Lasts', *Metropolis M*, The Netherlands, August, 1993

von Graevenitz, Antje, 'Jessica Stockholder: Making a Clean Edge', *Archis*, The Netherlands, July, 1991

von Graevenitz, Antje, *Jessica Stockholder*, Westfälischer Kunstverein, Münster, Kunsthalle Zürich, 1992

Wachtmeister, Marika, 'Interview, Jessica Stockholder', *Femina*, Stockholm, October, 1995

Weibel, Peter, *Pittura - Immedia: Malerei in den 90er Jahren*, Neue Galerie am Landesmuseum Joanneum, Graz, Austria, 1995

Weinberg, Adam, *Contingent Realms*, The Whitney Museum of American Art, New York, 1990

Westfall, Stephen, 'Interview with Jessica Stockholder', *Bomb*, New York, September, 1992

Westreich, Thea, *PICK-UP. Peter Nadin/Jessica Stockholder*, Warren Adelson Gallery, New York, 1991

Public Collections

Le Consortium, Dijon, France

Whitney Museum of American Art, New York

Carre d'Art, Musée d'Art, Contemporain de Nîmes, France

Centraal Museum, Utrecht, The Netherlands

office

A

B

C

D E

11'

22.5'

window

front
door

JESSICA STOCKHOLDER

August.1985

Sculpture Installation at
Melinda Wyatt Gallery
202 East 10th St.
N.Y., N.Y.10003

Scale - 3/8"
Ceiling - 13'

A - layers of white styro
 foam 1" held between
 steel studs. Red pai
 on the front side.

B - Pile of furniture 3'
 high. Concrete slab
 cast on top.

C - 26" wide strip of
 lath covered in struc
 lite held 34" above
 the ground.

D - Sheet-rock on wooden
 2x4's.

E - Plywood on steel
 studs.